Beyond
Monochrome

A FINE ART PRINTING WORKSHOP

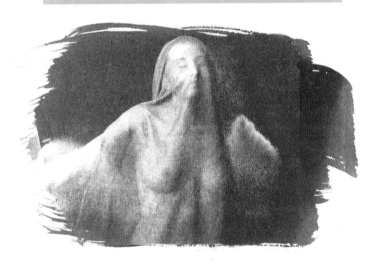

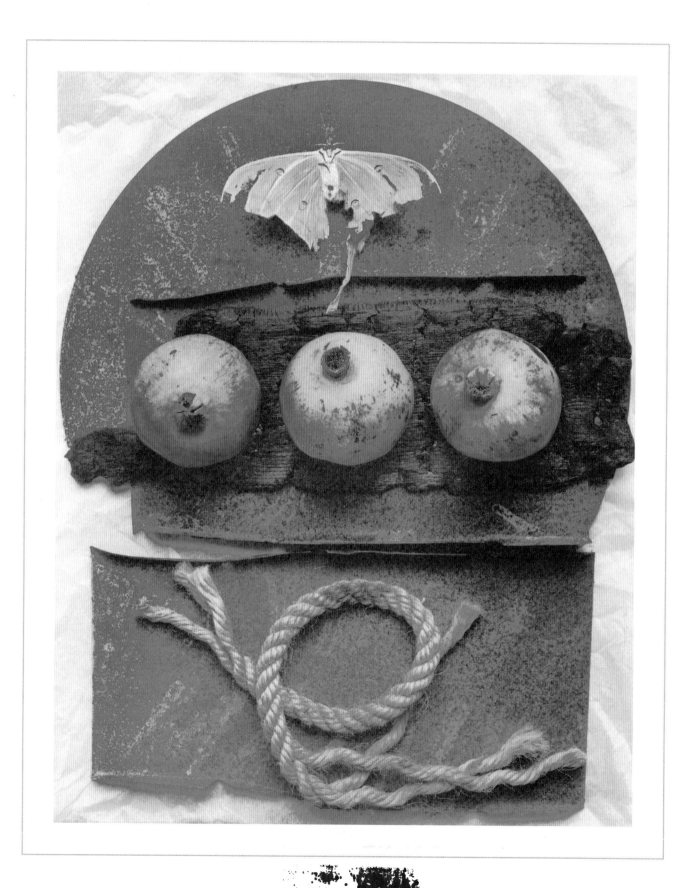

Beyond Monochrome

A FINE ART PRINTING WORKSHOP

TEXT AND PHOTOGRAPHS BY

Tony Worobiec & Ray Spence

DESIGNED BY
GRANT BRADFORD

FOUNTAIN PRESS

Dedication
For my wife Eva, and for my sisters Barbara and Tina.
TONY WOROBIEC

For Josef, Lucas and Kate.
RAY SPENCE

Published by
FOUNTAIN PRESS LIMITED
Fountain House
2 Gladstone Road
Kingston-upon-Thames
Surrey KT1 3HD

© Fountain Press Ltd 1999

Original Images
© TONY WOROBIEC & RAY SPENCE

Text & Photographs
TONY WOROBIEC & RAY SPENCE

Design & Layout
GRANT BRADFORD
Design Consultants
Tunbridge Wells, Kent

Origination
Setrite Digital Graphics
Hong Kong

Printing & Binding
Die Keure n.v.
Belgium

ISBN 0 86343 313 8

INTRODUCTION

The art of photography is not just about accurate metering, informed film processing and deft printing, because even with these vitally important elements, the print is still lacking one very important ingredient; the photographer's input. At the heart of all good photography is the photographer's vision which is essentially a subjective experience. The process of photography is, by its very nature, objective, which leaves the printer with the difficult task of producing an image which in some way recaptures the subjectivity of the initial 'seeing'. Fortunately, there has been a rich diversity of materials, processes and techniques developed over the last 150 years, offering the printer considerable scope. As photographic artists we need to be eclectic and use techniques and processes which help to convey our initial thoughts and emotions. By opening up our minds to alternative ways of working, we are in a position to print in a manner which is in tune with our vision.

Tony Worobiec and Ray Spence have explored and developed a variety of techniques over a number of years, and whilst initially it would appear that each was treading a different path, they quickly appreciated that their work was complementary. Ray Spence has been concerned with examining the different ways of using light-sensitive material to produce a recognisable and permanent image, this has taken him back to some of the very earliest photographic processes, such as salt printing and platinum printing. By way of contrast, Tony Worobiec has welcomed some of the newer innovations afforded by changes in film and paper technology and has also explored ways of toning and tinting monochrome images using contemporary materials.

"No amount of toying with shades of print or with printing papers will transform a commonplace photograph into anything other than a commonplace photograph." Bill Brandt *World Photography*

Mindful of the old adage "you cannot make a silk purse out of a sow's ear" the authors begin by discussing various ways of producing a perfect negative, including two-bath development processes, which are designed to make all negatives more printable. They then examine ways of producing a fine print using both traditional and current printing practices. The authors have been concerned to place the art of photography within its historical context, and examine the many beautiful and varied techniques that were developed and used in the last century, and yet still have enormous relevance to today's monochrome worker.

It has been the expressed aim of the authors to take the mystery out of many of the techniques covered. Both Tony Worobiec and Ray Spence work in the field of education, and they are accustomed to explaining ideas and concepts in a clear and methodical fashion. This book is aimed at both the newcomer to monochrome photography and to the more experienced worker; it is designed as a printer's manual which can be referred to as the need arises. This book is comprehensively illustrated with diagrams and photographs which are aimed to help the reader fully understand all aspects of the techniques and processes covered. Trial and error, the work of other photographers and artists and extensive background research all play their part in coming to a final solution. It was the stated aim of both authors at the inception of this publication that nothing would be covered unless one or other has direct and immediate experience of working in that area, therefore all the photographs contained are examples of work done specifically to illustrate what can be achieved.

The authors have attempted to draw together in an understandable form, ways to help you progress from the basic monochrome image and use some of the myriad techniques which will help you to clarify and achieve your own vision. One book cannot hope to answer every question, but here we have in a single volume a means by which the photographer can progress from a basic monochrome image to one which has evidence of personal input and control.

"Technique and vision are inseparably linked. Any decision which one makes at any point in the process... can significantly alter its expressive qualities, its meaning." John Blakemore *World Photography*

CONTENTS

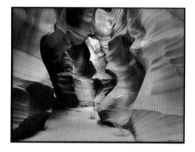
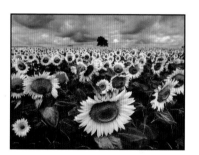

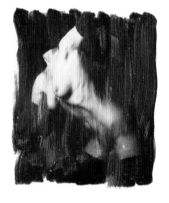

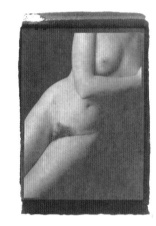
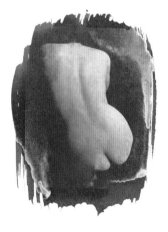
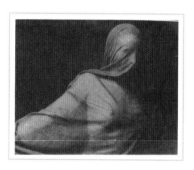

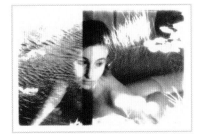

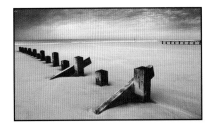
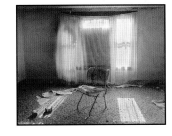

CHAPTER ONE

The Negative

To some it will be stating the obvious, but it is worth emphasising all the same; in order to achieve a truly fine print, it really is essential to produce an excellent negative in the first place. No matter how good your printing techniques may be, if you are producing poor negs, you are unlikely to produce truly satisfying prints.

EQUIPMENT

There are, of course, two stages to producing a really fine negative; the first requires precise exposure, whilst the second needs good film processing techniques, but it is also worth giving serious thought to the equipment you use. The choice of camera, or at least the camera format, is a matter of 'horses for courses'. A 35mm camera is an entirely different piece of apparatus from say a 5x4 studio camera but if used properly, will produce the goods for which it is intended. There have been numerous technological advances, especially within the realms of 35mm cameras, and for many photographers it is the ideal choice for the kind of work they do. Reportage, sports photography, photojournalism, and possibly even natural history, (in fact any situation where the photographer needs to work speedily, or needs to work with a very wide range of lenses), all leave little choice but to use 35mm. If, on the other hand, you are photographing subject matter which allows you time, and where richness of detail is a key element, i.e still life or landscape work, then moving up to medium or large format may well prove more appropriate.

Expense may well be a major consideration, and undoubtedly when you do move up to 5x4 (or larger) things can get rather pricey, so working with medium format may remain the best option for most non-commercial photographers (and I make this point again) if quality and detail are essential. This format comes in four sizes, 6cm x 4.5cm, 6cm x 6cm, 6cm x 7cm, and 6cm x 9cm, although most photographers are capable of getting excellent results from any of these.

Whilst medium format hardware is more expensive than 35mm, it is surprising to discover how similar the prices are if one considers buying second-hand, as most medium format cameras are designed for professionals and are generally fairly robust. When you also consider that the price of roll film is slightly cheaper than 35mm, (albeit you get fewer shots per film), medium format photography really is within the financial means of most serious photographers.

Another apparently compelling reason for continuing to work in 35mm is that as film technology improves, some of the very fine slow films (e.g. Kodak Technical Pan, Agfapan 25) give results which rival a moderately fast film taken on a medium format camera. That's true, but just imagine what could be achieved if that same film is used in a medium format camera. Many photographers are mindful that superb results can be achieved when shooting 35mm on a tripod, but once again if you transpose this argument and use a medium format camera, the results are even more impressive. What is not in dispute is that irrespective of the format that you choose, using a tripod in conjunction with a slow, high definition film helps produce a sharp and detailed negative.

METERING

Irrespective of your choice of format, getting your exposure right is a critical part of achieving the 'perfect' negative. Most modern 35mm cameras have a built-in TTL metering system. The metering patterns vary; e.g. 'centre-weighted' and 'spot', and some are 'multi-patterned', allowing the user to choose the preferred metering pattern for a given situation or subject. Many medium format cameras do not have a built-in system, although this option is often available. Some photographers choose to use a hand-held meter instead, and once you get used to them you will quickly find that they are far more flexible than built-in meters. Whichever metering system you use, it is necessary to understand it and learn how to use it to optimum effect.

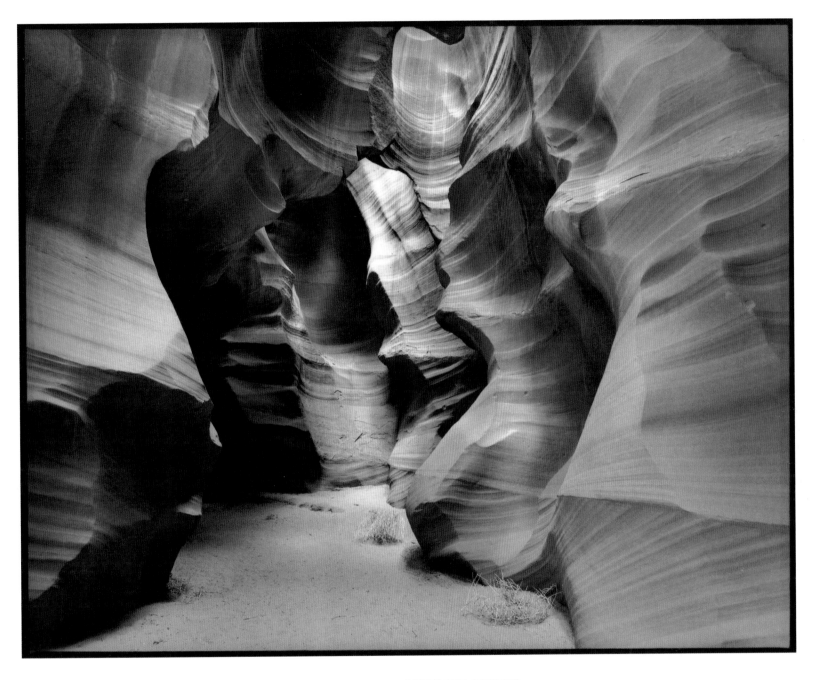

ANTELOPE CANYON

Many photographers are familiar with this extremely photogenic area of Utah, and will no doubt be aware of the very contrasty lighting it offers. This poses problems for colour workers, but is especially difficult for those choosing to use a high definition monochromatic film such as Agfapan 25. In order to get reasonable shadow detail, I needed to expose this shot for up to three minutes, which potentially could have resulted in an extremely contrasty negative. To overcome this, I opted to use a two-bath development technique – a process which will be covered later.

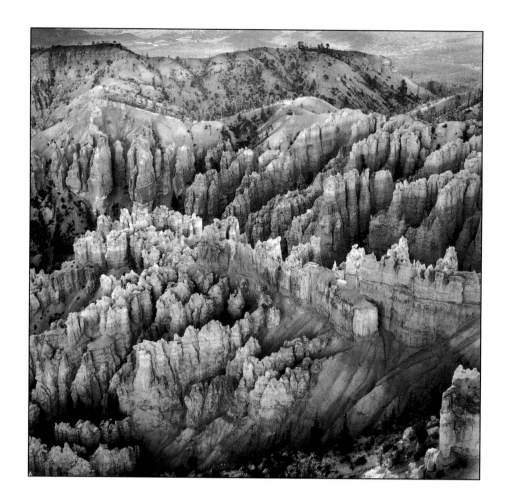

BRYCE CANYON, UTAH

It is often assumed that medium format photography needs to be expensive, but nothing is further from the truth. This shot was taken on a 34-year-old Rolleiflex with a 75mm Planar 3.5 lens. The quality of these cameras is legendary, and one in excellent condition cost a modest £360 just three years ago.

Hand-held meters, because they are independent from the camera, offer the ability to make light readings with far greater accuracy. It is possible to leave the camera on a tripod, but move in closer to take a light reading from a particular part of the subject.

Also, when you encounter a complex lighting situation, most hand-held light meters offer the opportunity of making either a 'reflected' light reading, (i.e. the light which is reflected from the area you wish to photograph), or it is able to give you an 'incident' light reading, (that is a measurement of the source of the light). In order to take an incident light reading, it is usually necessary to fit a translucent plastic cone over the meter cell and point the meter towards the camera. In particularly difficult lighting circumstances, it may also be necessary to take a 'duplex' reading.

Reflected light readings work well when the lighting is not too contrasty, and when there is a reasonable balance between dark and light tones. In a landscape situation, it is usually advisable to dip the light meter and take a reading reflecting more land than sky. If you are using a filter, it is essential that you take this into account in your final calculation, because unlike a TTL system, the meter only measures unfiltered light.

When measuring the incident light, you need to be aware that you are gathering light from a 180° view, and that your meter is averaging out your highlights and generally ensuring that your highlights are correctly exposed. It is especially helpful in fairly contrasty situations.

A duplex light reading is particularly useful in very contrasty back-lit situations. When reading the reflected light, the meter is prone to under-expose, because it is taking account of the excessively bright highlights; by contrast, an incident light reading is likely to over-expose the highlights. The answer is to take two light readings, with the plastic cone over the cell; one a reflected light reading and the other an incident light reading, and then average out the two readings. Using a hand-held meter in this way takes time but with many subjects and situations, working a little more slowly can be an advantage. There are circumstances, however, when irrespective of the sophistication of your meter, the reading

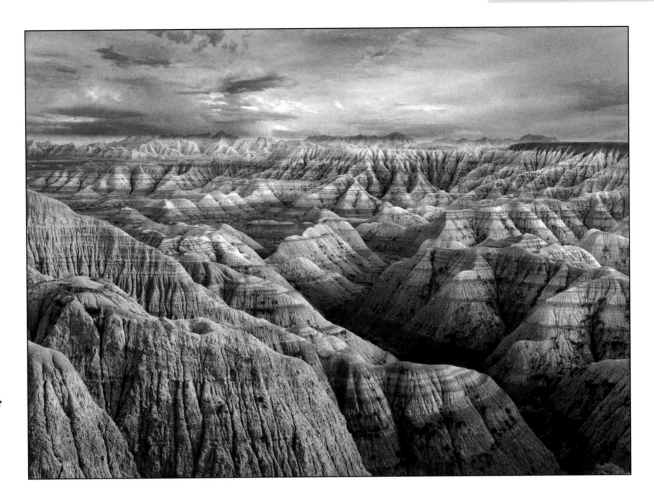

BADLANDS, SOUTH DAKOTA

Occasionally, we come across a landscape in which the minutiae of detail is an essential element of the picture. Ideally, such shots should be taken on a medium or large format camera, but if that is not possible, you do have the option of using a slow film and a very sturdy tripod.

will be wrong. Reciprocity not only affects colour film, but monochrome film also. It does not become an issue until exposures of a second or more are required. If your meter suggests a reading of a second, it may well be worth your while to increase that to two; however, the longer your meter suggests, the greater the compensation needs to be.

As a rule-of-thumb, I have found the following chart to be extremely useful:

TO AVOID RECIPROCITY FAILURE			
When your meter reads	1 sec	–	try 2 sec
When your meter reads	2 sec	–	try 5 sec
When your meter reads	4 sec	–	try 11 sec
When your meter reads	8 sec	–	try 35 sec
When your meter reads	15 sec	–	try $1^1/_4$ min
When your meter reads	30 sec	–	try 3 min
When your meter reads	1 min	–	try 6 min

As I frequently use exposures in excess of a second, I have this information taped to the back of all my cameras.

I suppose this would be an appropriate time to mention the 'Zone System', a technique developed by the American landscape photographer, Ansel Adams. It is a method for visualising a scene in terms of its constituent tones, and it helps the photographer to pitch the exposure to best maximise the available tonal range. It works – there is no doubt about that – but the technique does possess a mystique which is quite off-putting to some; also, with the vastly improved meters that are available today coupled with infinitely more flexible films and processing methods, I am no longer convinced that it is the essential technique that it once was. Add to that the sheer flexibility of multi-contrast papers which allow the printer to use different grades on the same piece of paper, and I am left wondering whether this technique is just a little past its sell-by date.

The chemistry of film emulsions, in particular, has changed considerably over recent years, especially chromagenic films such as Ilford's XP2 and the very recently released wonder film from Kodak, T Max 400CN. Whilst great play is made of the fact that these films are processed in C-41 chemistry, and therefore can be

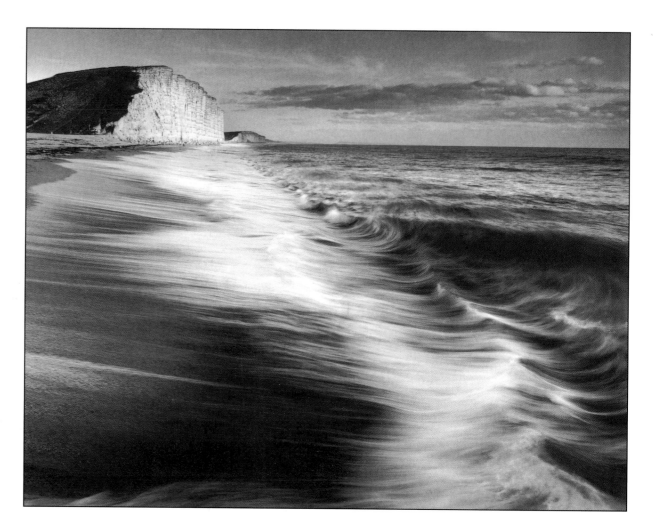

WEST BAY, DORSET

One of the advantages of using a hand-held meter is that you have the option of taking either a 'reflected' or 'incident' light reading. In this case, the moderate contrast of the subject matter allowed me to take a reflected light reading.

handled by any high street mini-lab, it is sometimes forgotten just how flexible some of these films are. Some critics have complained that these films 'lack character', but I suspect what they mean is that they lack grain. But when you balance that against Kodak's claim that its new film has an exposure latitude of ISO 25 to 800, all should be able to achieve accurate tonal definition, even in fairly contrasty situations, especially if the film is correctly rated at 400 ISO. It is so easy to regard such films as inferior in some way (no doubt it is the lack of silver that some traditionalists distrust), but at the end of the day, the film is only a means to an end, and if it is delivering excellent negatives with good shadow and highlight detail, then it definitely gets my vote.

CONTRAST CONTROL

Most photographers' printing problems start from the negatives having too little or too much contrast. Generally speaking it is usually the latter which creates the greatest difficulties. Some

photographers are insistent that good photos can only be taken in strong sunlight; however, I am much more comfortable photographing in dull light because generally speaking the film, which of course has a restricted exposure latitude, copes better in less contrasty situations. This is especially evident with slow films. If you follow the advice 'always look to the light', dull lighting need not pose any difficulties.

Consider the two images of the abandoned Chevrolet pick-up on page 15. The first picture was taken in strong sunlight which has cast a strong shadow to the left of the vehicle, which visually creates problem. Firstly, the side of the vehicle seems to merge into the ground without sufficient tonal separations and secondly the strong directional light has picked out an obtrusive plank of wood, which ruins the 'flow' of the picture.

In the second picture the Chevvy was photographed when the sun was masked by the clouds, which is far more conducive to the restricted latitude of the film. The pick-up appears much more

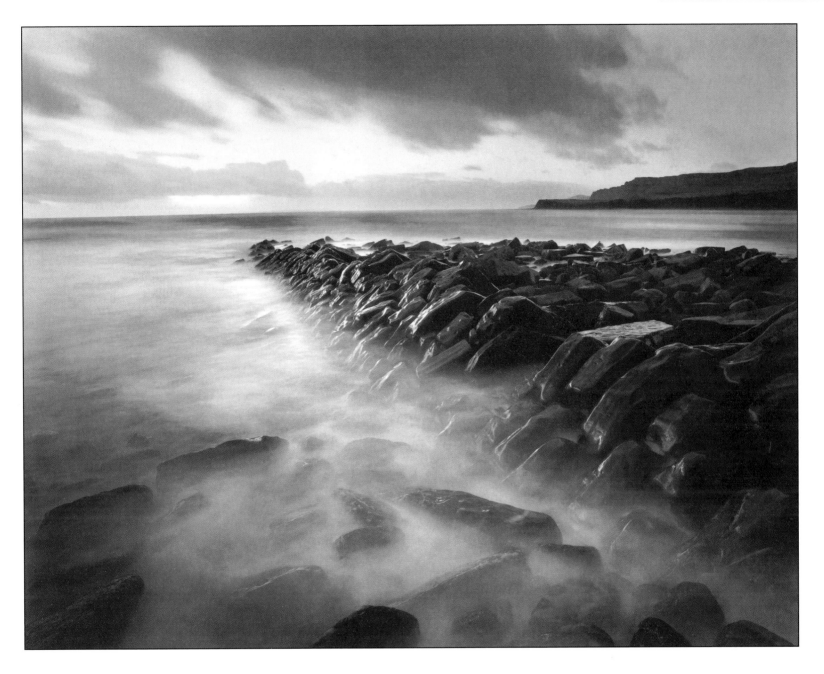

KIMMERIDGE

There are occasions when irrespective of the sophistication of your light meter your reading will be wrong due to reciprocity failure. This shot was taken late in the afternoon as the light was fading. My meter gave a reading of eight seconds, but I have given this an exposure of 35 seconds to overcome the problem of reciprocity

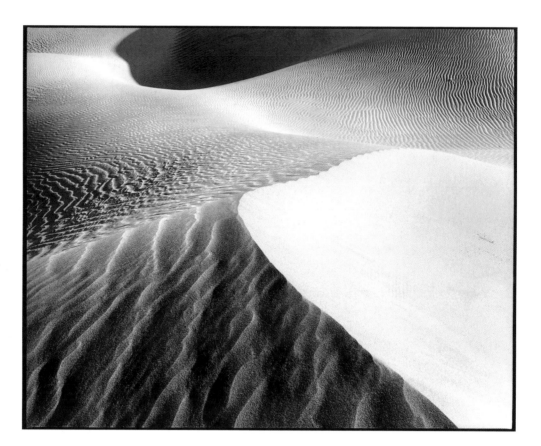

DEATH VALLEY

By way of comparison with page 13 this shot was taken in very contrasty lighting, and yet it was essential that both the shadow and highlight detail were maintained. Chromagenic films such as Ilford's XP2 and Kodak's T Max 400CN are ideal in these situations, not only because they offer speed without obviously increased grain, but also because of the extended latitude these films can offer.

rounded than in the first picture, whilst the tone of the offending plank merges much more comfortably into the background.

Should your negatives come out looking just a little flat, then this can easily be resolved at the printing stage. Alternatively, it is possible to compensate at the processing stage by increasing the development of the film, or using a more energetic developer. This does, however, increase the grain structure, which can negate the value of using a fine film.

Lack of contrast resulting from under- or over-exposure can also be addressed by treating the film with Farmers bleach (to thin the film) or chromium intensifier (to increase the film's density). In the latter case, do not expect miracles; if as a result of under-exposure there is no shadow detail, an intensifier cannot add it later.

TWO-BATH DEVELOPMENT

Whilst negatives displaying low contrast can prove difficult, handling negatives which are too contrasty pose far greater problems. As many of us find ourselves in situations where we are unable to control the contrast, methods of dealing with this are clearly desirable. The standard advice is to decrease the ISO rating of the film (i.e. increase the exposure time) and then to decrease

the development accordingly which generally works well, providing that the normal latitude of the film has not been severely exceeded. And yet there are times when the light meter tells us that what we are about to attempt goes way beyond the capacity of the film, and past experience has taught us that there is little point in bothering. The ideal developer would be one which allows us to develop all the tones up to the point when the highlights are still printable, and then to stop working on them, but continue to build up the shadow detail. I am not aware of any single developer capable of doing this, but recently there has been a reawakened interest in two-bath developers, which can. It was initially pioneered by H. Stoeckler and appeared in the Leica Journal in July/August 1938, although there have been many variants on his basic formula since then. The principle is a simple one; The first bath (Bath A) contains only the developer and the preservative, whilst the second bath (Bath B) contains only the accelerator.

HOW DOES IT WORK?

If a given film ought to be developed in a standard developer for 10 minutes, for example, the idea behind the two bath method is to give the film a five minute development in Bath A, after which the solution is poured out and the solution for Bath B is added for

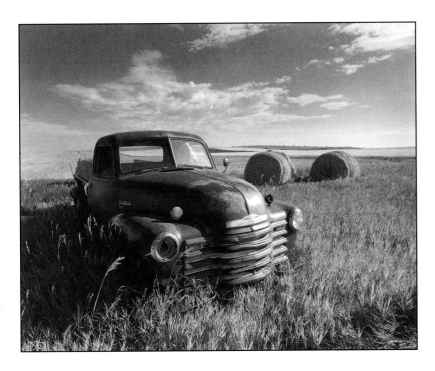

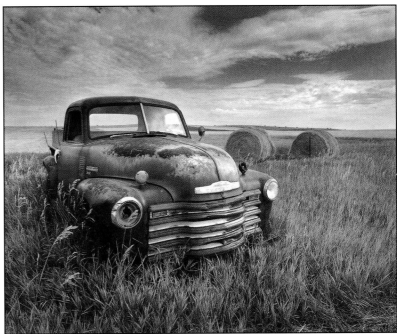

CHEVVY WITH BALES OF HAY

Left: This was taken in strong sunlight which has cast a strong shadow to the left of the vehicle.

Right: By waiting for the sun to disappear behind a cloud, I was rewarded with a more 'rounded' negative which not only made printing easier, but showed the vehicle to its best advantage.

the remaining five minutes of the development time. For the first few minutes of any film development, very little actually occurs as the film is merely absorbing the solution; but, when development does start to take place, it initially works on the highlights. After half the normal development time has elapsed, there is some reduced development on the highlights, but precious little development in the shadow areas. It is at this stage that solution A is poured out, and solution B is added. Providing that you do not wash the film after its immersion in the first solution, the developer (which has been absorbed by the film) carries on working. It is very quickly exhausted in the highlight areas, but continues working in the shadow areas.

The areas of the film which have received least exposure (i.e. the shadow areas) attract maximum development. No doubt many of you have quickly appreciated that if you are anticipating extremely contrasty negs, then it should be possible to reduce the development time in solution A, and thus cut the development time on the highlights even further: in effect, you are using the first bath as your contrast control. It is worth noting, however, that there is little point in extending your development time in solution B, as all the potential development in the shadow areas will have occurred.

THE WATER-BATH TECHNIQUE

This 'compensating effect' can be achieved in other ways, most notably by using the water-bath technique. The advantage of this method is that you can continue to use your standard film developer. The basic procedure is the same as any normal development, except that you agitate the film constantly for a minute and then at the end of each minute the developer is poured off and is replaced by water which remains in the tank for a further 2 minutes, but this time without agitation. This cycle is repeated until the full development is complete. For example, the normal development time for Ilford FP4 in a stock solution of ID11 is $8\frac{1}{2}$ minutes. With an intervening 2 minute water bath at the end of each minute, the total development time is $24\frac{1}{2}$ minutes. Bearing in mind that you will still be required to stop, fix and wash your film, this is a lengthy process, but if the results are printable negatives, it is worthwhile.

A variation of this, which is only really necessary when you are anticipating extremely contrasty negs, is to employ the water-bath technique in conjunction with the two-bath system which undoubtedly works, but you must be extremely organised, and ensure that your bottles A and B are clearly labelled.

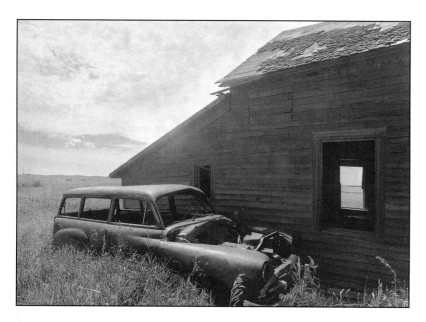
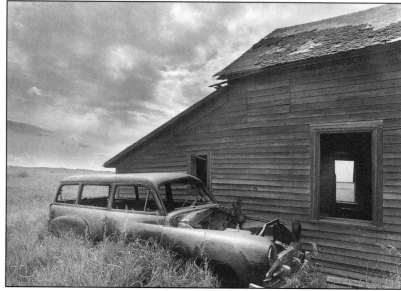

WRECK ALONGSIDE ABANDONED FARM

Above left: This is a typical example of what photographers can confront on any relatively sunny day. I wanted to capture both the sky detail and some from the interior of the building, but the normal latitude of my film (in this instance, T Max 400, developed normally in T Max Developer) could not cope the tonal range. The shadow detail is simply too dark, whilst the sky is too clogged up to offer sufficient contrast.

Above right: This was also shot on T Max 400 about 20 minutes after the first one, but this time the film was processed in Resofine. When the negs came out of the wash, they appeared alarmingly thin, but as they dried, it became obvious that there was detail throughout the negative. Whilst I printed this onto grade 3 paper, the sky only required a 20% increase in exposure.

I must just express my gratitude to Michael Maunder of Speedbrew, who sent me a 10-page document outlining the many formulae available for those who wish to mix their own two-bath developers. Of these, here are the most popular:

THE STOECKLER FORMULA

BATH A	BATH B
Metol 5 g Sodium Sulphite 100 g Water 1 litre	Borax 10 g Water 1 litre

THE ANSEL ADAMS FORMULA
(known as the D23 Formula)

BATH A	BATH B
Metol 7.5 g Sodium Sulphite 100 g Water 1 litre	Sodium Metaborate 10 g Water 1 litre

Those of you who, like me, are chemically challenged will be delighted to know that there are various two-bath developers on the market; Tetenal's Emofin and Speedibrew's Resofine 2B are both excellent products and are generally available. Emofin is available as powder or liquid (the latter costing 50% more). Both products require that you mix one litre each for both baths for storage in dark bottles. They can be used repeatedly without any increase in development time. There is also an American product, Diafine, which I have not yet had the opportunity to use. Using these developers is simplicity itself (unless, of course, you wish to adopt the water-bath process as well), but there are certain pitfalls you need to avoid.

❶ When mixing solution A and solution B, it is essential that there is no contamination, particularly B into A, otherwise you will end up with a normal developer. Even a splash can ruin it.

❷ Label your storage bottles carefully; it is all too easy to put solution B in first.

❸ Avoid the instinct to wash the film, as the film needs to carry over some of the developer into bath B.

❹ Follow the advice on agitation carefully.

❺ Do not panic when you finally pull the film out after the wash. It can look a tad thin (especially the Resofine) and lacking in contrast, but it does improve as it dries.

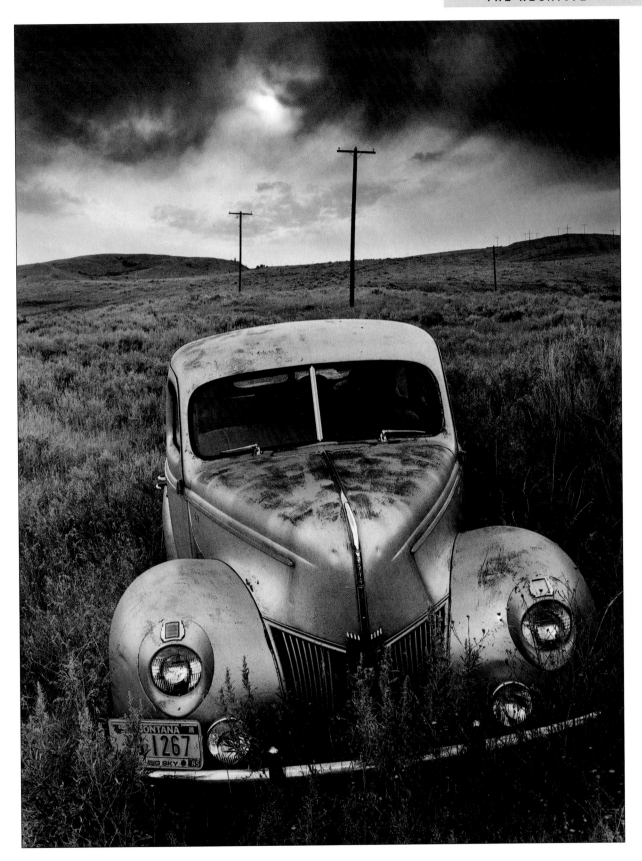

ABANDONED FORD, MONTANA

This is the classic situation where the two-bath development process works best. With the sun in the sky, albeit masked by a thin veil of cloud, the contrast is too great for a normal film-processing technique to cope with. By cutting back on the first development, the highlights did not develop sufficiently to completely clog up the film.

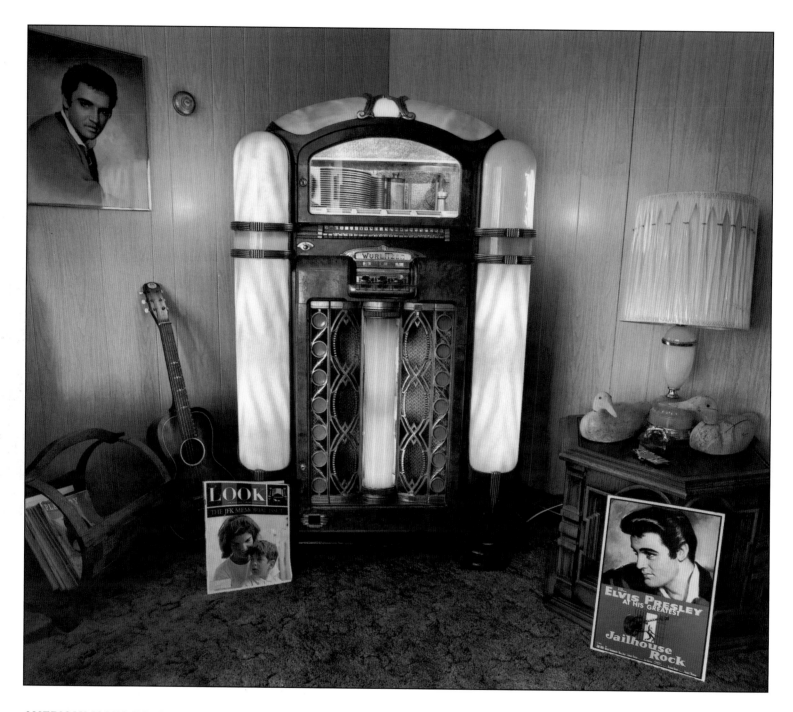

AMERICAN ICONS NO. 1

It is rare for me to get an interior quite as interesting as this one and it was essential that in order to do it justice, I maintained all the shadow and highlight detail. Illuminating the Wurlitzer served to increase the contrast beyond the scope of the film, and so it was important that I was able to control precisely when to stop the highlights developing, whilst allowing the shadow detail to continue to develop. This can only be achieved by using a two-bath developing process.

AMERICAN ICONS NO. 2

At first glance, this must appear to be one of the easiest negatives to print; however, the problem was posed because this garage wall was at right-angles to a large door which was the only source of lighting. The area to the right was in considerably more shadow than the area to the extreme left. Bearing in mind that there are some naturally very light elements on the left-hand side of the composition, once again my light meter suggested that this shot was beyond the normal latitude of the film. Using the two-bath development technique, a more satisfactory outcome has been achieved than otherwise might have been.

The real strength of two-bath developers is that the contrast limit does not affect low or medium contrast negatives, only those displaying high contrast, so it is possible to process a film which has fluctuating levels of contrast and get printable negatives across the whole range. In terms of retaining shadow and highlight details I have not personally come across a better film-developing process.

As with all things photographic, it's horses for courses. The key is to think about what you require from your negatives and, given the lighting conditions at the time of exposure, how best to achieve this. Rather than accepting the usual advice of standardising on a given developer/film combination, it is more helpful to get to know a variety of developers and processing techniques, in combination with different films.

MAKING COPY NEGATIVES FOR ALTERNATIVE PROCESSES

Most of the alternative processes involve the contact printing process. This obviously necessitates the use of a negative the same size as the final print. For those who do not use large format this means that some sort of enlarged copy negative is going to have to be made. This can be achieved in many ways depending upon the original source of the negative, the desired type of final negative and to some extent your budget. For a rare one-off you could leave it to the professionals and go to a good commercial laboratory. This could be produced from either a negative or transparency. However different types of negatives are required for the different alternative processes so both for economy and control it is probably best to produce your own copy negatives.

The characteristics of the emulsions used in alternative historical processes was well suited to the type of negative materials used at the time. Characteristic curves showed a long straight line section indicating equal separations in shadow, intermediate and highlight areas. The films and plates of the era had similar characteristic curves, so were ideally suited for the printing process. Modern films and papers have a longer toe on their curve and this leads to compression of tones when used with most historical processes. For this reason it is usually best to over-expose the copy negative to be used. In this way, the shadow values will be moved to the straight line section of the curve. It is also best to try to produce a negative with a greater density range than would normally do with modern materials. In practice this usually means developing negatives for 20-30% longer than normal (except for the gum bichromate process).

ORTHOCHROMATIC & PANCHROMATIC FILMS

In many cases, the 35mm black-and-white film stock that you are used to using may also be available in 5 x 4 or 10 x 8 sheets (e.g. Kodak Tri-X or T-max films). High acutance, good contrast and a good grain structure is recommended. These can be used to make copy negatives, but generally being panchromatic (sensitive to all colours of light) you will have to expose and process in total darkness. Again process in a fairly vigorous developer to produce the desired negative. More usually, orthochromatic film stock such as Kodak Copy Film 4125 is used because it can be handled using a Kodak Wratten Safelight Filter No. 2.

To produce an enlarged copy negative using any of these materials is a two-stage process. Firstly a positive copy is made by direct contact. This is then used in the enlarger to produce the required size of negative. Develop in Kodak D-76 or Kodak HC-110. Do not use lith developers unless you want total tone elimination. Cleanliness is extremely important, particularly at the contact stage, as tiny specks of dust can be a nuisance. An anti-static brush or gun may come in useful. As this is a two-stage process, inevitable loss of quality may occur at each stage, so exposure and development is critical.

IN CAMERA NEGATIVE

Probably the best way to produce a printable negative in camera is to use a two-bath developer. I use the Ansel Adams D23 Formula. Used undiluted this should process about 80 sheets of 5 in x 4 in.

To process your film use Solution A for 9-14 minutes, depending upon the contrast needed, followed by three minutes' development in Solution B. Agitate every 30 seconds. This is

THE ADAMS D23 FORMULA

SOLUTION A	SOLUTION B
To 750ml of water (50°C) add:	
Metol 7.5g	1 litre of water at 50°C
stir till fully dissolved	Sodium metaborate 10g
Sodium sulphite 100g	
Water to total volume of 1 litre	

especially important in Solution B to prevent mottling of the negative. No washing or stop bath is needed between A and B. This method should yield negatives with full shadow detail and well separated highlights. Also see page 16.

DIRECT DUPLICATING FILM

A one step process to produce an enlarged negative directly from a negative is to use Kodak Professional B/W Direct Duplicating Film SO-132 (formerly SO-339). It is my preferred method of working as the one step process means that you retain as much information from the original negative as possible.

Kodak SO-132 is a direct reversal black-and-white film. It should be used with a Kodak 1A safelight and can be treated as you would do normal printing paper. It is sometimes difficult to determine the emulsion side which is very slightly lighter in tone than the reverse, but an easier way is to find the notch in the film. All large format films are notched in one corner. If you keep this notch in the lower right corner, the emulsion side will be towards you.

When determining exposure, remember that the more exposure you give it the lighter the image will be and vice versa, just as in colour reversal printing. If you use a masking frame, this will mean that the edge of the image will be surrounded by a black border, ideal for creating a clean edged print during printing out processes. When you put your original negative in the enlarger carrier, put it in reversed. The copy negative will therefore be reversed, but when contacted emulsion to emulsion the print will be the correct way round.

Development in dishes is recommended in Kodak Dektol developer, diluted 1:1 at 20°C. for two minutes with continuous agitation. Exposure should be about 40 seconds and you should use the f-stop technique based around this time to prevent any reciprocity problems. This will produce a normal contrast negative. I recommend using a more vigorous developer such as Kodak D19. Both exposure and time of development can be altered to produce the negative of your choice. I use D19 at full strength and develop for 8-9 minutes at 22°C. I have also used Kodak Polymax developer diluted 1:4 with success.

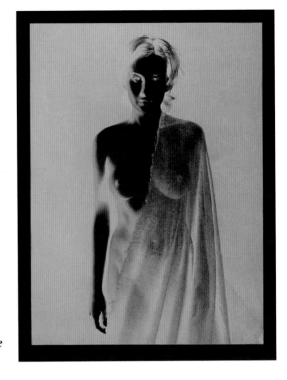

USING A STEP WEDGE

An invaluable accessory which will enable you to understand and predict the effects of exposure and development on the contrast and tonal range of both negative and positive materials is the step wedge. These are made by both Kodak and Agfa though Agfa's is considerably cheaper. They consist of a piece of exposed and processed film which has strips of different densities. The Agfa step wedge has 11 steps from film base to about 2.0. They are small, the area covered about 25 mm x 95 mm. They can be placed on the edge of the image and exposed at the same time. By comparing the processed negative with the original wedge you can determine the tonal and contrast range and adjust it to suit the process. They are also useful at the printing stage when processing changes the appearance of a printed out image, e.g. as in the cyanotype and salt processes.

PAPER NEGATIVES

Some people use a combination process using a paper print for the positive stage. This has the advantage that selective burning and dodging can be done on the print. The method used is to make a conventional print the same size as your required final print. You can use any brand of paper either fibre based or resin coated. The aim should be to produce a high quality print of good contrast but with maximum detail as any detail lost at this stage will be lost forever. The print is then laid emulsion side down on to ortho film and exposed through the enlarger. A guide for exposure using a Durst M670 enlarger for a 10 x 12 print is about 24 secs at f-8. Development is in a fairly vigorous developer (Kodak D19) for four minutes at 20°C. Stop in acetic acid and fix in double strength fixer until the shadows are clear. Wash and dry.

DIRECT PAPER NEGATIVES

An even more intriguing way of making paper negatives, this technique will create an enlarged paper negative in one step. Unfortunately it uses sodium sulphide so a well ventilated darkroom is essential.

1. Place your original negative back to front in the enlarger carrier. Using an RC multicontrast paper such as Kodak Polymax RC, produce a nïormal, but back to front print. Having determined the exposure for a normal well-exposed print now produce another print but expose your negative for three times the normal exposure.

2. Develop as normal. This will obviously produce a very dark, grossly over-exposed image. Don't panic.

A direct paper negative produced on Kodak Polymax RC. Though the reversed image has a brown colouration, it will not affect its use as an enlarged negative for contact printing.

3. Wash.

4. Place the print into a tray of sodium sulphide at normal strength for sepia toning (1:7 or 1:9) for about two minutes. The print will emerge a revolting mucky greenish brown.

5. Wash.

6. Place the print into a tray of potassium ferricyanide bleach (about 10%) for three to four minutes. A reversed image will now appear as the bleach removes the original over-exposed image leaving a sepia brown negative. The white lights can be turned on about half-way through this process.

7. Wash.

8. Fix.

9. Wash and dry.

The paper negative is then used in contact, emulsion to emulsion. Because you printed the image in reverse it will print the correct way round at this stage. Another advantage of this technique is that you can shade or selectively mask the back of the paper negative to enable you to locally control exposure. The contrast of the paper negative will be determined by the way you selected contrast for your original print. You can vary the degree of exposure and this will subtly alter the final negative so you can fine tune your results depending upon the type of negative you need.

CHAPTER TWO

The Fine Black & White Print

I have already stated that a good print can only emerge from a good negative, however even when our negative appears to yield all the information we require, we still have the dilemma of how to 'interpret' it. This is where the skill of printing comes in. In the next section we will specifically look at the opportunities offered by multicontrast papers, but for the moment it is perhaps useful to restrict ourselves to aspects of printing which are common to both multicontrast and single contrast papers.

The choice of paper is an important one, and particularly whether you wish to use fibre-based (FB) or resin-coated (RC) paper. It is not really for me to suggest which is the best, except to say that in the 15 years I have been printing, the quality of all papers seem to have improved considerably. There once was a suspicion that RC papers were more likely to deteriorate with time, but recent tests suggest that a well fixed and washed RC print can last for decades. With respect to ease of use, coupled with the relatively quick washing time, RC paper is both a popular and practical choice. Speaking personally, I do use RC paper quite regularly and enjoy its convenience. However, once I have decided that this is a print I wish to keep, then I will almost exclusively choose to use FB paper, firstly because it is more responsive to archivally permanent toners (which I will discuss later), but also because it appears to possess a 'depth' which is lacking in other papers.

THE TEST-STRIP

One of the most important things to do when making a print is to produce an 'information rich' test-strip. This is absolutely essential if you are to get the very best out of your negative. I have read in various sources recently that one only needs to use a $1/4$ of a sheet of paper to make a satisfactory test-strip. I disagree with this; I prefer to use $1/2$ a sheet because in the long run, miscalculating some of the tones in the final print can prove far more costly, both in terms of time and paper. As I am also eventually likely to tone my work, having a test strip allows me to experiment before committing my print to the toner. At this stage, you may care to cut your test strip in half, giving yourself the opportunity to make various trials. It is also important to position your test-strip so that the full range of the tones available on the negative are covered, either horizontally or vertically, or however the negative dictates. Generally, most experienced printers can make a reasonable guess to the final exposure required and therefore can get away with just three or four incremental strips. The problems arise when the negative displays a rather large dense area which is not consistent with the rest of the neg (typically a sky in a landscape situation); in these cases, it is important to extend your increments, i.e. 10 secs, 15 secs, 20 secs, 30 secs, 1 min, 1 min 30 secs. Try to avoid putting in too many strips, six really ought to be enough, otherwise you will not get the information you require within each strip. On occasions it may be appropriate to make two separate test strips, or even to change grade and start again. Whilst this may seem a nuisance at the beginning of a session, it could prove crucial to the eventual outcome of your printing.

DRY DOWN

The phenomenon known as 'dry-down' catches out most inexperienced printers until they appreciate that their final prints seem darker when dry than they were when they were still floating in the fix. It is estimated that a print will darken by up to 10% as a result of 'dry-down'. Two precautions I recommend are:

❶ When you have made your test-strip, go to the trouble of washing and then thoroughly drying it. Inspect it in normal light and hold it vertically, as you are more likely to make an accurate assessment.

❷ Place a piece of white (unexposed) printing paper, which has been previously washed and fixed, into the fix. You then have an absolute white to gauge your test-strip by.

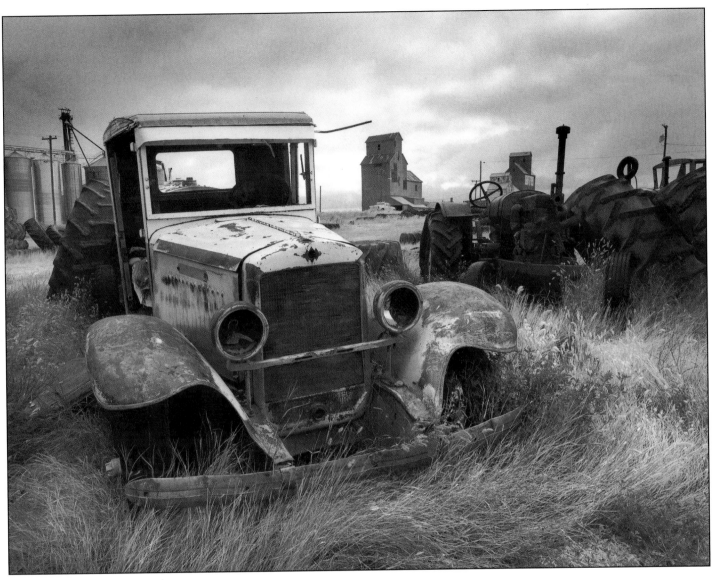

RAILWAY SIDING, MONTANA

This was printed from a very contrasty negative, It was important that both shadow and highlight detail was maintained in order to convey the richness of the scene. I opted to use a grade $^1/_2$ filter for the entire print, not only because of the difficulties presented by the sky, but also because there are a number of highlights scattered throughout the print. In order to add more depth, it has been selenium toned.

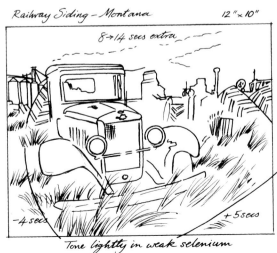

Railway Siding – Montana 12" x 10"

8→14 secs extra

–4 secs + 5 secs

Tone lightly in weak selenium

① 15 secs @ f8 – grade ½, hold back bottom left for 4 secs

② Burn in bottom right corner up to 5 secs

③ Burn in sky left → right by 8 → 14 secs, burn in light area by grain silo 7 secs extra

④ Burn in top of bonnet by 8 secs

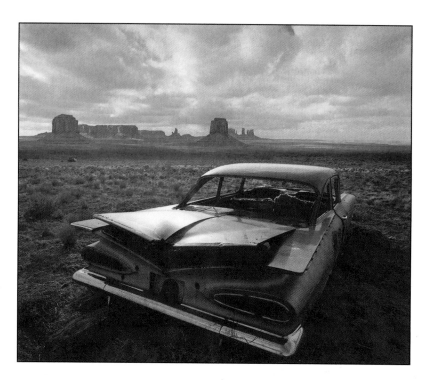

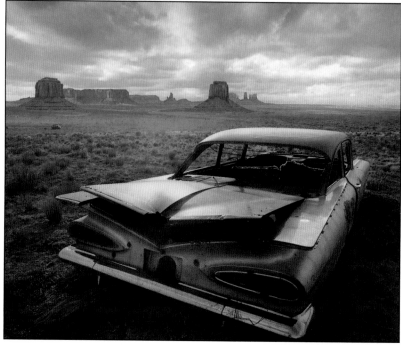

BENCH-MARKING

This is an important principle if you wish to establish some measure of consistency in your work. Before I ever produce a large print, I will always produce one, or even several smaller 'working prints', so that a printing strategy can evolve. I do not want to work this out on larger and more expensive pieces of paper. For me, the ideal negative will always comfortably print onto grade 2 paper, and so initially all my working prints are printed onto this. This gives me the opportunity to assess prints relative to one another. It is usually at this stage that a decision can be made about which grade to use. There has been a trend over recent years for 'softer' printing, and many photographers now welcome the more subtle range of tones available on grades 1, 2 and 3. When experimenting with lower grades of paper, some printers are initially put off by the apparent 'lack of punch' – somehow the blacks don't really look truly black – but it is surprising how those darks change once the print is dry (due to our old friend 'dry-down'). Even if this does not get your blacks quite dark enough, there are one or two toners that will. But when you consider the advantages of printing on softer grades of paper, i.e. good shadow detail, a broader range of mid-tones, delicate highlights, much easier and less obvious dodging and burning in, and simpler printing generally, it is clearly worth experimenting with. 'Printing for the whites' (i.e. ensuring that there is at least some white somewhere in your print) really does apply to this style of print.

ABANDONED CAR NEAR MONUMENT VALLEY

Above left: A straight print. Above right: Knowing that I was going to selenium tone this print, I was able to print it just a little lighter and thus retain more shadow detail.

Another very important reason for producing working prints is that it encourages the printer to experiment: would this image be better 'high-key' or would it be better 'low-key'? Through differential printing, does a particular element look wonderfully dramatic, or just a little too obvious? These questions should be answered before you embark on the full sized print. I view a working print as an artist would view a sketch.

It is helpful, once you have decided what you want from your print, to draft out a printing strategy (see page 23). This is useful, not only to assist you with your larger printing, but it is invaluable should you ever need to reprint. I also make notes concerning any subsequent toning I might have done, as it is amazing how fickle some toning processes can be.

FLASHING

There are occasions when a negative proves particularly difficult to print, because it has strong highlights, or because the highlights are scattered throughout the negative. One solution is to 'flash' your paper prior to printing. A fair amount has been written about this technique, yet talking to photographers it is surprising how

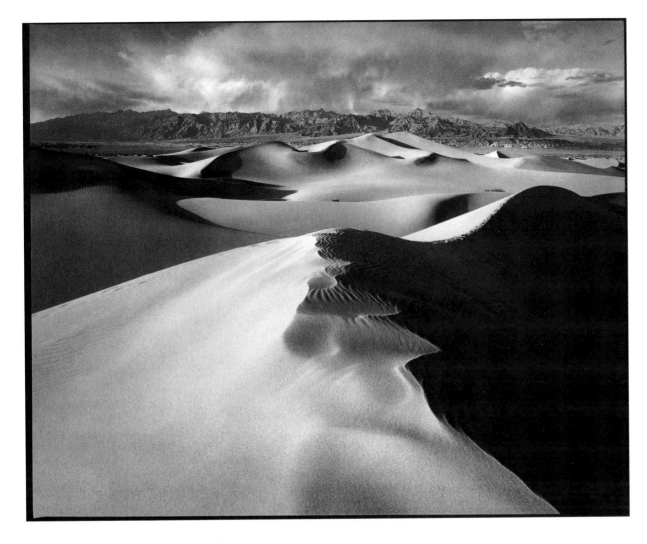

ENCROACHING STORM, DEATH VALLEY

Once again, this was a reasonably contrasty negative, and whilst I welcomed the punch a grade 3 paper would give, I was concerned by the possible loss of highlight detail, especially in the scattered dunes in the middle distance. By 'flashing' the paper beforehand, printing in the highlights become much easier.

many have not really tried it. But it is so simple, and it works! The technique involves exposing a sheet of photographic paper to a controllable source of light (i.e. your enlarger), prior to your normal exposure, with the expressed aim of 'softening up' your paper's resistance to printing in the highlights. You will need to make a test strip; set your enlarger at its maximum height and smallest aperture, then cut a strip of paper and expose it incrementally. You will need to draw out your timed zones on your strip of paper prior to exposure.

Flashing your paper can have quite an effect on your highlights, whilst only having a very minimal effect on the darker areas of the print. The secret is to expose the paper sufficiently so as to make printing in the highlights far easier, but not to over-expose it, and thus fog the highlights.

Once again, it is important that you dry your test-strip before determining your maximum flash point, because 'dry-down' can be

so very deceptive. Flashing your paper is particularly easy to do if you have two enlargers; but even if you just have one, it is still worthwhile, as it can make an 'unprintable' neg printable.

Two points need to be observed:

1 That different papers require separate test strips.

2 That flashing can be localised.

SELECTIVE DEVELOPMENT

When dealing with film development, we emphasised the need to produce negatives with printable highlights. But no matter how careful we are, both with our exposure and with our development, we all produce negatives with difficult highlights which is where 'burning in' and 'flashing' can prove so useful.

Both these techniques occur prior to development, but what can you do when you are watching the print emerge in the developer

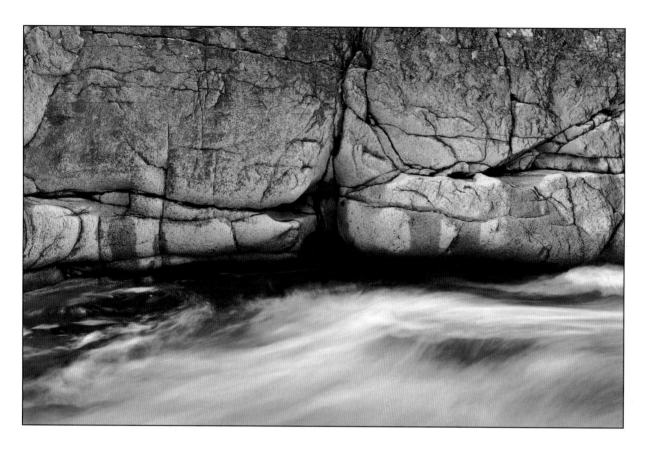

RIVER

In this print it was important to retain subtle highlight detail, especially in the flowing water to the right of the picture, without allowing the shadow areas to become too murky. By using a water-bath technique, it was possible to pull the print at the point when shadow detail was still visible, but then to allow highlight detail to continue to build up in the water-bath.

and it becomes evident that a part of the print is still under exposed? There are various courses of action:

1 Pull the print out and breathe on the area requiring accelerated development. The increase in temperature increases development activity.

2 Rub the area requiring attention with your finger.

3 Pull the print out just a little before its full development and wash it briefly. Apply neat developer to the required area, but then return the print back to the normal developer just to complete the full development cycle. This helps to prevent any 'development lines' occurring.

WATER-BATH TREATMENT

This is a very popular technique for reducing contrast in a print, and works on the same principle as the water-bath film processing technique. The print is 'snatched' from the developer before it has time to develop contrast, and is put into a tray of water (the 'water-bath'). The developer quickly exhausts in the darker areas, thus shadow detail is maintained. The developer carried over in the highlight areas continues to work for far longer, therefore

these areas continue to build up for far longer. It is possible to achieve exquisite highlight detail using this method.

TWO-BATH FIXING

Having gone to a great deal of trouble to produce a fine print, it is especially important that your print is 'archivally' fixed; using a two-bath fixer technique does undoubtedly help. The idea is to put your print through two separate trays of fix, the first will do most of the work, whilst the second serves as a back-up. When you have calculated that your fix has started to tire, (and you need to refer to the manufacturer's notes for that), replace the second tray with the first, and replenish the first tray with fresh fix.

LOCALISED BLEACHING WITH IODINE

Many photographers use 'ferri' in order to clean out highlights, but my own preferred option is iodine. The problem with 'ferri' is that it can sometimes leave a yellow stain which rarely seems to happen with iodine. Iodine can be bought from most high street chemists, although it will more than likely need to be ordered.

It is essential that you dilute your iodine to a thin solution resembling weak tea in colour. Apply the iodine solution with a

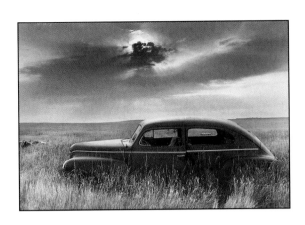

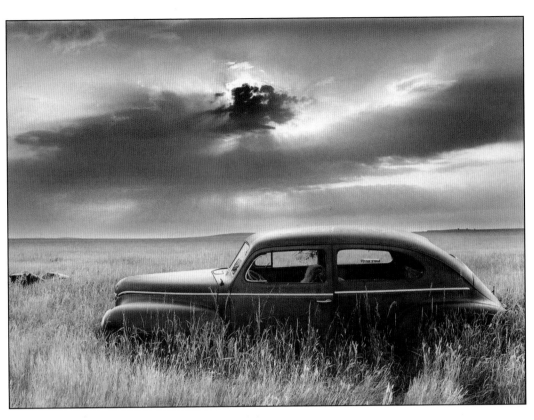

ABANDONED CAR NEAR BELFIELD, NORTH DAKOTA

Above: A straight print.

Right: This print has been strongly toned in selenium, which has not only improved the tones, but has made it more evocative and interesting.

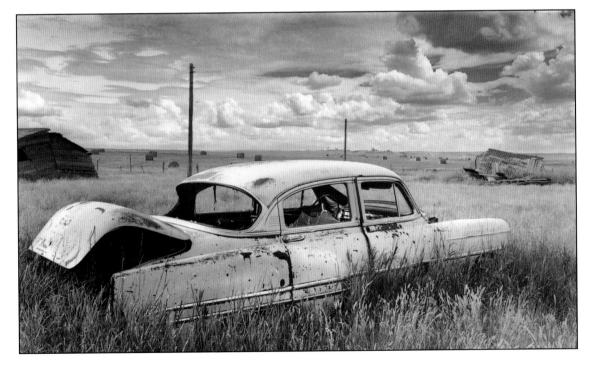

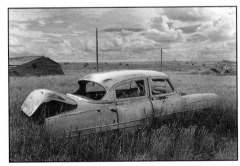

ABANDONED CAR AND HOMESTEAD, NORTH DAKOTA.

Above: A straight print.

Left: This has been positively toned in selenium which seems to have given the print added luminosity.

swab of cotton wool to the areas requiring lightening, but always keep another swab with paper fix on it, in order to stop the bleaching at precisely the right time. Do not over-bleach, as this will remove your highlight detail. Afterwards, it is important that you immerse your print in a weak solution of fix (mixed and prepared specially for the job) and then wash as normal.

One irritating problem that some may have experienced is that areas that have been bleached with iodine can sometimes show up when sepia toned. This can be overcome in two ways:

1 Initially, bleach your print only very lightly, and then tone it. Repeat the process until the desired colour and tone are achieved.

2 After bleaching, toning and washing normally, put the print in a weak solution of selenium (1:20), but do not leave it for too long, otherwise the colour of the print will quickly change.

If you want to lighten the complete print, it is possible to immerse it in a solution of iodine, but make sure that it is extremely weak, otherwise its action can be very quick indeed. You will need to experiment.

SELENIUM AND GOLD TONERS

When any printer thinks of fine art printing, somehow it seems synonymous with these two toners. They are an important means for achieving a fine art print for three reasons:

1 They can be used as the final tonal control; selenium toners are especially useful in this respect as they can quite positively darken a print. My advice, when printing, is to try to use a softer grade paper, but then to rely on the selenium to add extra depth. I generally find this works best before the selenium has had the opportunity of markedly changing the colour of the print, thus maintaining the black-and-white character of the image.

2 They can be used to add aesthetic appeal to your work by subtly or dramatically changing the colour of your print. It greatly depends on the paper you are using, although selenium generally has the capacity to turn your print a rich brown, whilst gold toners can show a bias towards blue. This can prove to be a particularly rich vein to explore, as 'warm toned' chlorobromide papers, such as Ilford's Multigrade FB 'Warmtone', are especially susceptible to toning. This is most evident with gold toners which work particularly well if you also use a warm-toned developer. The effects can be equally dramatic if you over-expose your print, and then slightly under-develop it. The most dramatic results, however,

are achieved with prints which have been lithed, a process we shall consider later.

3 But their primary purpose is to add archival permanence to your print. By toning it in either gold or selenium, you greatly increase the print's potential longevity.

VARIABLE CONTRAST PAPER

In the 15 years I have been printing, the best and the most far-reaching development has been the introduction of variable-contrast (VC) paper, which has revolutionised printing, and has made some hitherto unprintable negatives printable.

Admittedly, in the early days most good printers steered a path well clear of the stuff, and looking back it is easy to understand why. The original VC papers were entirely resin coated, and could never compare to the rich tonality of such classics as Ilford's Gallery or Agfa's Record Rapid. But things change, and it is no coincidence that Agfa has recently announced that this classic, which has been in production since 1933, is to cease because 'professional users' are switching to their recently introduced Multicontrast Classic.

So what are the advantages of VC paper? Well the first one is obvious, i.e. the purpose they were originally designed for and that is to offer the photographer/printer the opportunity to have a range of different contrast papers in one box. Stocking up on all grades of paper is impractical, especially if we have a predilection for one or two favourites. Inevitably there will be wasted boxes, and the obvious reaction is to rationalise and just keep grades 2, 3 and 4; but in those circumstances, what happens when you produce that negative that can only be printed on grade 1? Having a full range of grades available in one box encourages precise and sensitive printing.

Secondly, the real value of this paper only emerges when you begin to appreciate its absolute flexibility; not only have you the choice of grades and $^1/_2$ grades, but you can also use them in conjunction with each other. It is a situation similar to an artist who wishes to produce a fine drawing. He may wish to create a gritty drawing and will opt for an 8B pencil, or he may wish to convey a more tonally delicate subject and choose to use a 2H or even a 4H. Most artists, however, will opt to use various grades, as a fuller range of tones become available to them.

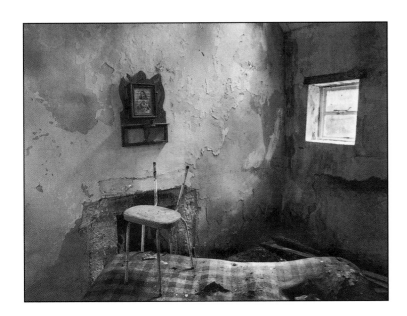

IRISH INTERIOR WITH IMAGE OF THE SACRED HEART

Left: An interesting black-and-white print, however the wall to the right-hand side requires clearer tonal definition.

Below: By split-toning this print, first in selenium and then in gold, the mid tones have become much more defined, and aesthetically infinitely more appealing.

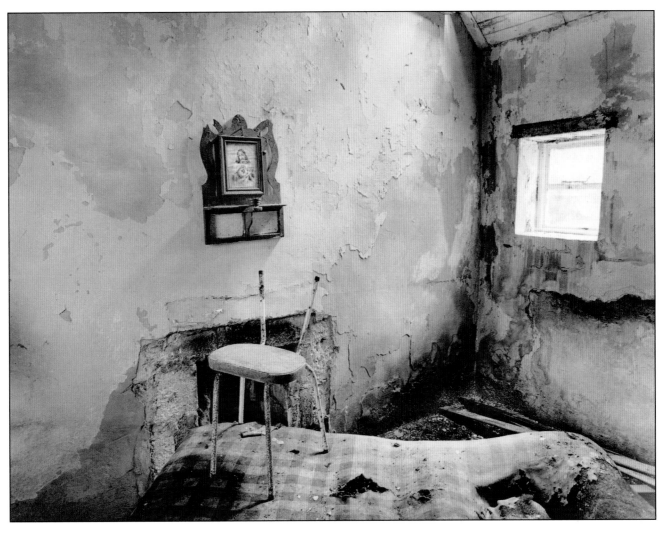

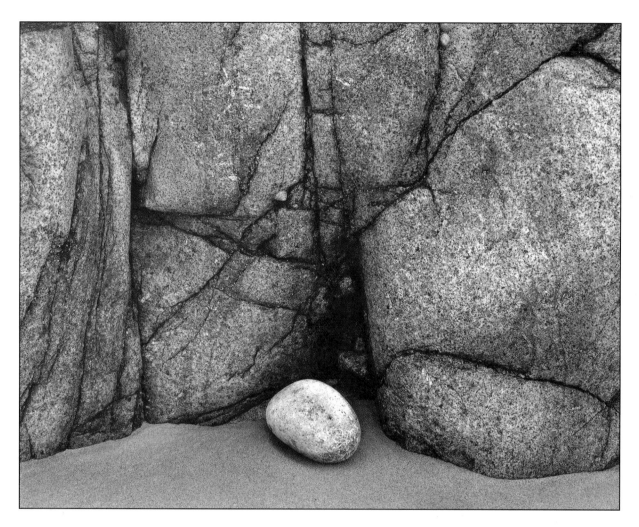

COT VALLEY

Split-grading need not always be a big deal. In this print I was struck by the way the light smoothness of the rounded sandstone boulder contrasted against the gritty darkness of the granite.
I had initially intended toning and tinting this image, but then realised the contrast could equally as well be suggested by split-grading.
The print had an overall exposure on grade $3^1/_2$, whilst the lighter stone was burned-in using grade 1.

SPLIT-GRADING

In order to gain the full potential of this technique, it is important to understand what all the grades can do. How often have you used grades 1, $^1/_2$ or 0? Generally speaking, most printers use grades 2, 3 or 4, and grade 5 will also be a relatively unused option. But the range of tones available between these grades is quite extraordinary, and if used fully they are capable of overcoming most printing problems.

Hard-grade papers (grades 3, 4, and 5) are capable of delivering prints with great visual punch. They are characterised by strong blacks and dramatic highlights, but they are reluctant to record delicate highlight detail. Soft-grade papers (grades 2, 1, and 0), on the other hand can be remarkably subtle, rendering exquisite shadow and highlight detail, but they are notoriously poor when strong shadow or highlight separation is required. The beauty of split-grading is that the printer can harness the advantages of both.

DIVIDING THE EXPOSURE INTO TWO

Producing proof (or working prints) is an essential exercise here, because in the first instance it is important to try and establish which grade comes nearest to your anticipated goal. 'Benchmarking' your proofs helps enormously as it encourages the photographer to make meaningful comparisons. I generally do all my proofs on grade 2. The real skill comes at this stage, because you have to ask yourself: "How can I improve this print?" It may well be that certain highlights lack sufficient subtlety, whilst there is still inadequate separation in your shadow detail. This is where you need to split-grade. Split-grading works by dividing your exposure into two parts. For example, you could give 50% of the exposure at grade 3 and a further 50% at grade 1. You may wish to extend your tones further, and choose to use grades 4 and 0. By split-grading with certain negatives you should notice better shadow separation and more delicacy in the highlights.

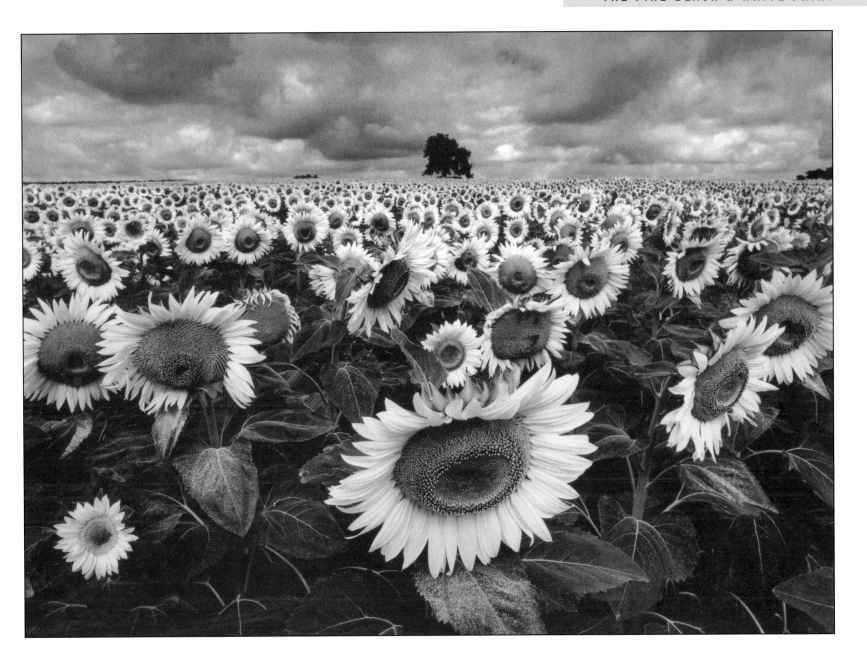

FIELD OF SUNFLOWERS

This is a classic example where split-grading can help to resolve a difficult printing situation. Whilst this shot was taken on a moderately overcast day, in order to get the drama I required from the sky I needed to use an orange filter. This served to darken the leaves, whilst lightening the sunflowers. When printed on grade 4, the leaves and sky worked well, but it was very difficult to get any detail into the sunflowers. Burning in was difficult, because the sunflowers were scattered throughout the composition. The answer was a simple split between grade 4 and grade 1. As I was anxious to retain the 'drama' evident in the grade 4 proofs, I balanced my split-grading 60:40 in favour of 4.

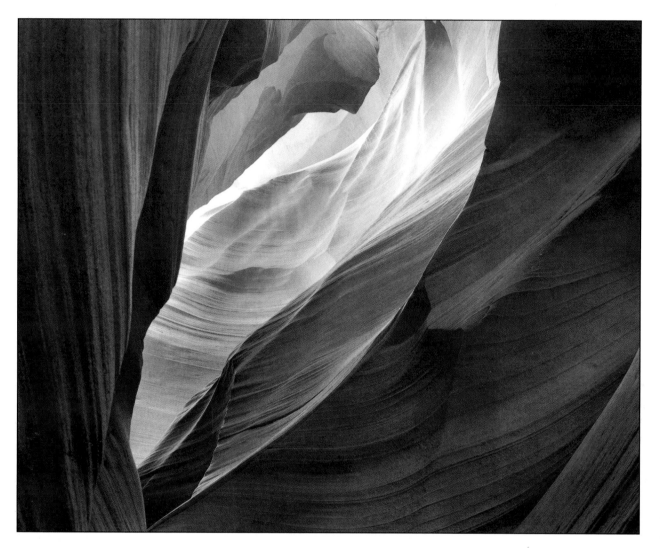

ANTELOPE CANYON — THE TULIP

Many a photographer has come to grief in this notoriously contrasty slot-canyon. One of the solutions is to reduce the contrast at the film-processing stage (see the chapter on two-bath development), and the other is to split-grade. I gave an over-all exposure using grade 3 in order to bring out the texture of the rock; I then gave the lighter area of rock a 60% increased exposure using a grade 0 filter, and thus avoided printing 'hot-spots'.

As you become more practised with this technique, and more experienced at analysing your proof prints, you will quickly appreciate that the split exposures need not necessarily be equal. It may well be that a bias towards more subtle highlights is required therefore, the softer grade will dominate the exposure. Conversely, you may feel that better shadow detail should prevail, and place a little more emphasis with the harder grade filter. The real key is to produce various test-strips. Find out what grade 1 has to offer your negative, and then change to grade 4, or 5 and see if there are any advantages to be gained. It is important always to remember that when you are using filters 4 and above, you will need to double the exposure required. Also, split-grading cannot be the panacea to all your printing problems, nor is it required with many of your negs. Like any technique, it should be used judiciously.

DEALING WITH SHADOW DETAIL

Once you have appreciated the flexibility of split-grading, you will quickly understand that this process can be used in a localised way. For example, you may well decide that the entire exposure should be made using a grade 3 filter, therefore a normal split-grading procedure is not needed. But in order to add a little more drama to the foreground, you have decided to print this area in, using a grade $4^{1}/_{2}$ filter. It is quite easy; all you need to do is dodge the area during the normal grade 3 exposure, and then burn in with the grade $4^{1}/_{2}$ afterwards. The secret is to keep your dodger and burner moving during both exposures.

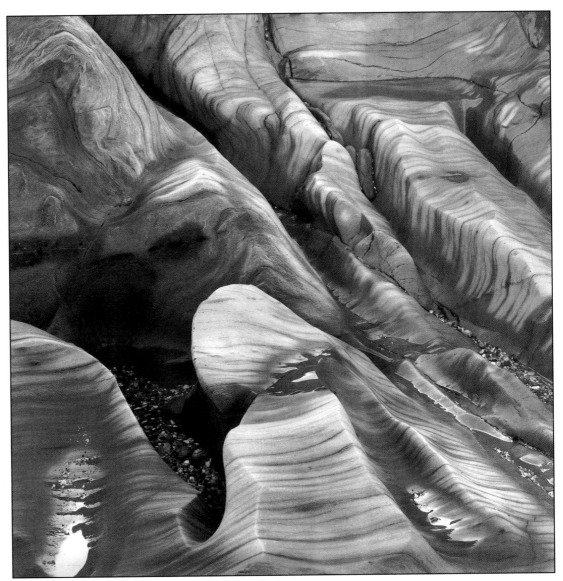

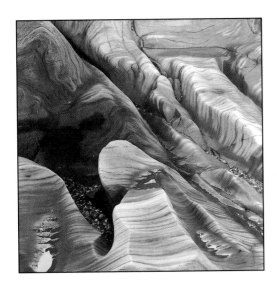

MORTHOE NO. 2

I was particularly anxious to photograph this when the sky was overcast for fear of unacceptable lack of shadow detail. The negative proved to be reasonably printable, but despite my care with the lighting, the area to the bottom and left was still too light. The problem was exacerbated because bright pools of water were also located in the lightest area. In normal circumstances this should not have been a difficult negative to print as most of it printed quite comfortably onto grade 2. The answer was to print the entire image onto grade 2, and then to burn in the difficult lighter areas using grade 0.

DEALING WITH HIGHLIGHT DETAIL

This is the commonest use of split-grading and the one that most photographers have been using since the development of VC papers. Quite simply, if you have decided that you wish to give your print a general exposure on grade 3, you may also feel that the lighter areas of the print require burning in using a much softer grade (grade 1 for example). This has various advantages:

1 It is likely to be quicker, because you need less exposure before some detail begins to appear.

2 The 'hot-spots' which so characterise clumsy burning-in are far less evident.

3 Burning in highlights, especially when using grades 3, 4, and 5, can greatly exaggerate the film grain. This is particularly noticeable if you are using 35mm, but not if you burn in using a lower grade filter.

4 Finally, the contrast between the subtle highlight areas achieved by using a softer grade and the punch evident in other areas of the print can add a depth which cannot be achieved on any single grade paper. It is this 'interpretative' potential of VC paper which I find so very useful.

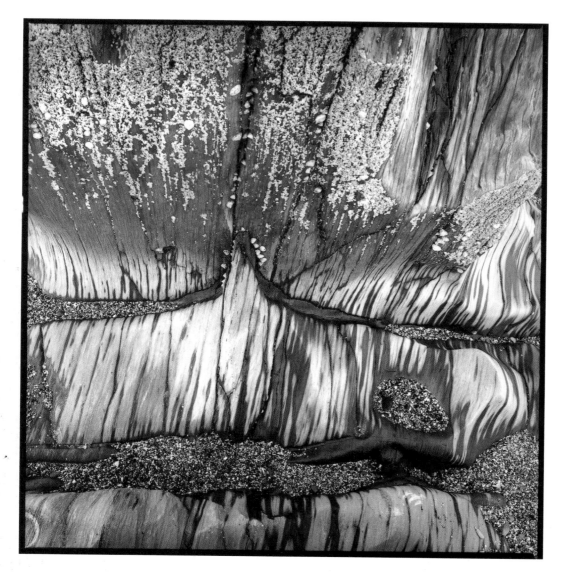

**MORTHOE NO. 7 –
THE WHALE'S TAIL**

In this little abstract the printing needed to be 'sharp' yet subtle. I tried printing this on grade 3, and whilst the results were acceptable some of the tracery in the highlights was lost; printing at a lower grade meant losing the strong delineating lines which hold the composition together. The solution was to split-grade between 1 and 5, but in this instance, the bias was towards grade 1.

THE INTERPRETATIVE QUALITY OF VARIABLE CONTRAST PAPER

It is at this point that the printer can begin to use VC paper creatively. One of the big problems we have as photographers is how to effectively translate the three-dimensional world we are photographing onto a two-dimensional piece of paper. Sometimes, particularly with landscape, the results can be very disappointing. A feeling of recession is a particularly important visual element in many landscape situations, yet this seems to be difficult to achieve with single grade papers. If we use a harder grade of paper the foreground can look powerful, giving the impression that it is very close; unfortunately, it has the same effect on the distant areas, as any sense of aerial perspective disappears. Conversely, whilst soft grade papers convey aerial perspective extremely well, the foreground can often appear unacceptably flat. But once you have an appreciation of where you want your 'punch' and where you want delicate tones to be, printing becomes a completely new ball-game. For example, if the sky above the horizon is softly printed, whilst those clouds directly above you at the time the photograph was taken are printed more strongly, the sense of depth can be greatly increased. This does not just apply to landscape work; you may wish to print-in a portrait very delicately, whilst the remainder of the print remains strong. The opportunities are endless and it can apply to virtually any subject. Those photographers who regularly split-grade find this method of printing to be wonderfully expressive.

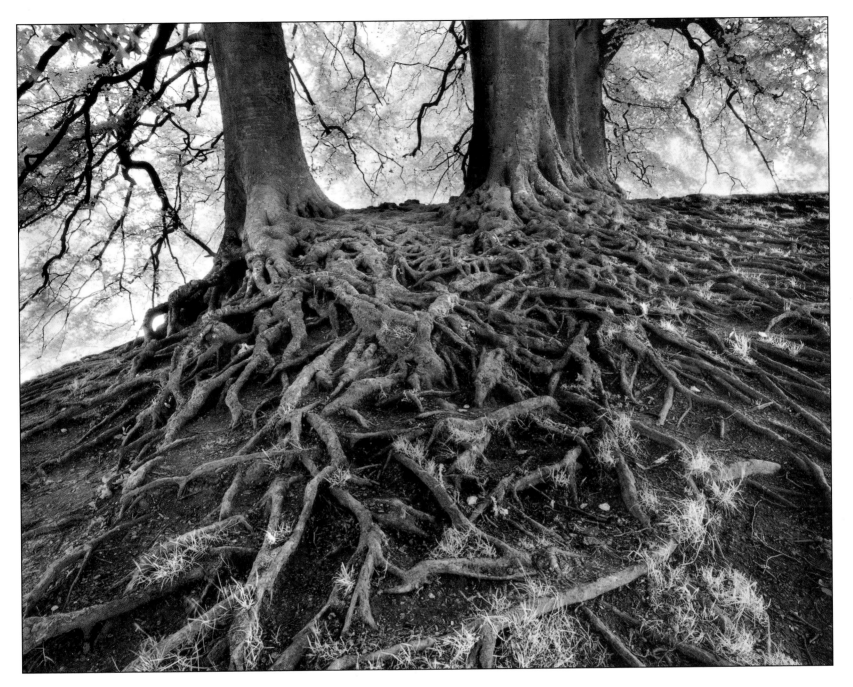

ROOTS

This shot was taken using infrared film, in order to guarantee some tonal differentiation between the roots and the branches. Given the contrast of the situation, I chose to take a light reading off the ground, which resulted in a very dense sky. The solution was to burn in these areas using a grade $^1/_2$ filter.

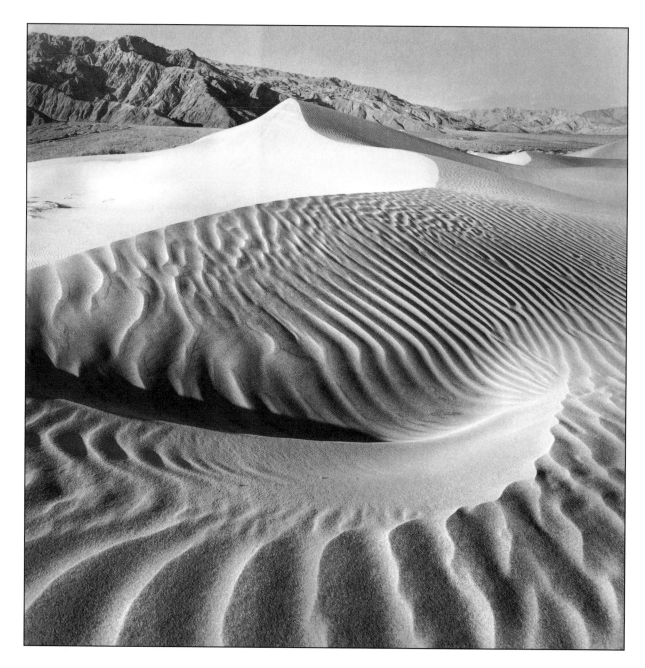

Hold back and burn in for 52 secs grade 4 @ f11

Burn in using grade 1/2 24 secs ← 10 secs

22 secs grade 2 1/2 @ f11

Darken corners slightly

DEATH VALLEY

I needed three separate grades to get this one right, and it is useful to draw a plan to help with these situations (as above). My test-strips showed that the ripples in the sand were best printed onto 2¹/₂. However the strong highlight in the dune required careful burning-in, whilst the distant mountains needed to be printed just a little more aggressively. I decided to divide the exposure into three parts; I gave an overall exposure of grade 2¹/₂ although I masked the top half of the print with a moving piece of card. I then printed the top half with grade 4, comfortable in the knowledge that it was unlikely to affect the highlights in the dunes. I then burned-in the dunes using grade ¹/₂.

In order to split-grade successfully, it is helpful to observe the following guidelines:

❶ Look at proof-prints, analyse them and decide how they can be improved.

❷ Produce a variety of test-strips, using various grades of paper, in order to discover the best printing strategy.

❸ Produce a 'working-print' as a guide for you to follow in subsequent prints.

❹ Produce a detailed printing plan. This may take the form of itemised notes, or an explanatory drawing.

❺ It doesn't matter which way you split-grade. You can print hard grade first, followed by the soft grade; conversely, you can start with the soft grade, and finish with the hard.

❻ Do not compromise your design simply because you have got difficult areas to print; most areas of most negatives are printable, and split-grading will help.

CHAPTER THREE

Liquid Photographic Emulsions

The range and quality of modern photographic papers enables us to produce predictable, fine prints. However, the mechanical process which is designed to give a high quality uniform result can also be restrictive to many artists. The ability to coat emulsions by hand directly onto a variety of surfaces leads to the production of a unique piece of work, liberating the artist from the restrictions imposed by manufactured products. The artist is freed from the flat plane and can make use of three-dimensional objects and mixed media. It is pointless trying to produce perfect photographic quality using liquid emulsions – for that you might as well use the manufacturers' paper. The beauty of the hand process lies within its imperfections and flaws. The work of photographic artists such as Peter Kennard, Melanie Manchot and David Scheinman, are prime examples of the creative way the medium can be used.

EMULSION TYPES

You can make your own emulsions, but for most of us commercially manufactured emulsions are more convenient. There are a variety of products on the market, among which the most easily available are the SE brands. The SE emulsions are blue-sensitive and therefore can be coated and exposed in normal safelight conditions, but it is best to store the emulsion in a refrigerator (an essential part of any darkroom – if only to keep the beer cool!).

SE1 Emulsion Most brands of liquid emulsion are identical to this. It is normal contrast bromide emulsion with a high silver content giving a neutral to slightly warm image.

BASE SELECTION

This is where the real reason for using liquid emulsions becomes apparent. Paper is probably still most widely used, but surfaces such as glass, stone, marble, ceramics, wood, fabrics and canvas are possible choices. I've even seen some wonderful pinhole images on the inner surfaces of egg shells. In selecting the surface you must be aware of its characteristics. These will obviously affect both the appearance and longevity of your image. Surfaces may be porous and textured like some hand-made papers or wood. These will accept emulsion well, but it will be absorbed into the surface, and as importantly, so will the processing chemicals. They are then hard or almost impossible to remove adequately. Remember also that without some surface preparation, the original colour and texture will show through, affecting (transforming) the final image.

With smooth and non-porous surfaces like glass, the problem is to get the emulsion to adhere and stay put during processing. This will inevitably mean surface preparation, e.g. etching the glass or spraying with artists' varnish, or painting the surface with a primer.

Surfaces may actually contain chemicals which will react with the emulsion, e.g. metals, certain hardboards, MDF and chipboards. In this case some form of barrier between the wood and the emulsion must be employed; a white primer paint or artists' varnish will do. The amount of preparation a surface needs will vary.

PAPERS

Most good papers (Fabriano, Buxton, Arches Platine) will need no preparation, however sizing and the addition of a wetting agent may improve adhesion on certain brands if they prove to be very absorbent. PVA, gelatin (about 36 grams to a litre of water) and starch can all be used as sizing agents. When considering papers, think about the effect that weight, colour and texture will add to your final image. It's probably best to start with a heavier hot-pressed paper about 300 gsm which will coat well and stand up to the rigours of wet processing. As you become more experienced you may be able to justify working on more expensive hand-made papers in which the paper quality and surface plays an integral part of the image. Good examples of this can be seen in the work of Jane Reese.

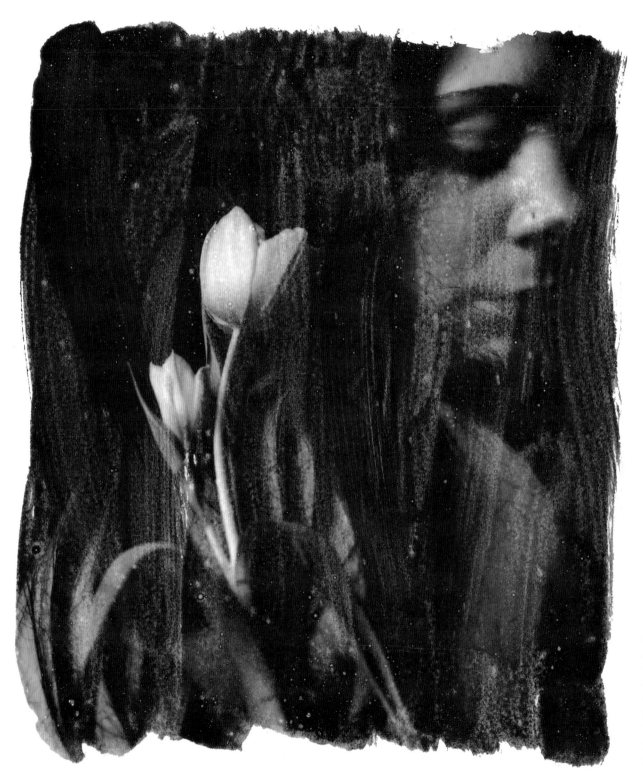

SUE WITH TULIPS

This is a single exposure against a black background. Though I liked the idea of the piece of work, printing onto normal photographic paper produced an inevitable lack of detail in the shadows which was killing the picture. Using liquid emulsion with subsequent selenium toning changed it dramatically. The brush marks added interest to the background and seemed to link the face with the flowers.

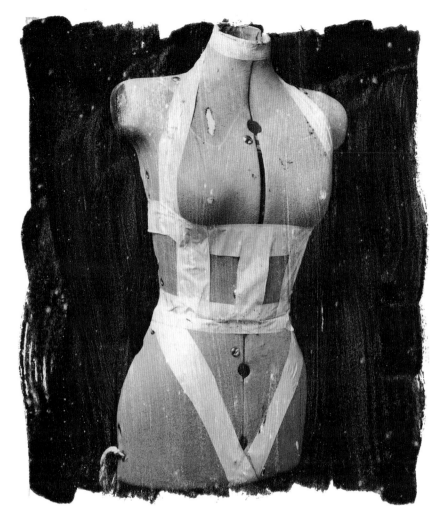

MANNEQUIN

I became interested in photographing mannequins about 20 years ago when I came across some laughing shop window dummies in Athens. Since then I became acquainted with amongst others, the work of Eugene Atget and his rather surrealistic images of shop window displays. This tailor's model had reached the end of its life and was 'dressed' in masking tape when I found it. I found the trussing up of this inorganic body quite surreal so felt that using liquid emulsion would help to convey my feelings.

FABRICS

Linen, cotton, muslin, silk and canvas are commonly used with success. They tend to absorb emulsion quite rapidly, so a primer (oil based) may be required.

GLASS

Though it is more difficult to use, the translucency of glass can be very effective especially when experimenting with back-light. As glass is very smooth, emulsions do not adhere very readily. To coat the glass you will have to clean and degrease it well with either a household detergent or caustic soda, then dry well and use a subbing layer of either artists' varnish or hardened gelatin solution before coating the emulsion. An alternative would be to have the glass etched, though this would change the nature of the surface, of course.

COATING THE SURFACE

The emulsion can be applied under normal safelight conditions, but when you remove it from the refrigerator it will be a hard gelatinous white mass. The emulsion must therefore be melted to a liquid form first. I use a small measuring cylinder covered in silver foil (lightproofing so that I can switch lights on later). The emulsion is spooned in this and then placed into a water bath at about 50°C. For larger pieces of work I use an old film processing tank with a lightproof lid. For the water bath I use a large measuring cylinder or washing up bowl. As the emulsion is melting I use a wooden chopstick to ensure all the lumps have disappeared. If you buy your emulsion in small quantities, then the whole bottle can be placed in the water bath and poured out as required.

Print from original negative.

This shows how toning can affect the final image. The colder image (left) is toned briefly in Kodak rapid selenium toner, whereas the warmer image (right) has subsequently been toned in thiourea to provide warmth. Which is the best interpretation is up to you but I feel that the bleaching and subsequent thiourea toning has opened up the image and increased its luminosity.

Brushes are most commonly used to coat the emulsion and by experimenting with fine and coarse brushes you can achieve predictable marks upon the surface. I tend to use a single coat with undiluted emulsion, but for a more refined finish you can use several coats, drying between each coat and applying the emulsion in alternate horizontal and vertical strokes. Be careful of any puddling of the emulsion. This will produce areas of thickened emulsion which will absorb and release processing chemistry at different rates, leading to uneven exposures and staining as chemistry is hard to wash out. Bubbles and missed areas can also occur if you are too hasty. It is a matter of taste, but I particularly like this happening.

On smooth surfaces such as glass you can pour the emulsion on and spread with your fingers (use a rubber glove and ensure that the glass is warmed first).

Three-dimensional objects or very absorbent fabrics can be coated by spraying with a rechargeable aerosol. To produce a good coating which dries evenly it is recommended that the emulsion is mixed with alcohol or clear methylated spirit (1 litre of emulsion to 500 ml of alcohol plus 5 ml of 10% formaldehyde as a hardener). On large fabric surfaces such as bedsheets, a sponge decorating roller is quite effective. After coating the emulsion which can be done in normal safelight conditions, it is usually air dried in the dark. For small pieces of work, I use a cupboard in my darkroom which contains a series of wire letter trays. You can also use boxes, but be careful if you are using empty paper boxes. As the paper dries it may curl or buckle and the tacky surface may come into contact with the upper surface of the box. Alternatively, you can use a warm air hairdryer if you are in hurry. Make sure that the emulsion and base is thoroughly dry or else staining can occur.

PRINTING AND PROCESSING

As this process uses the same photosensitive chemistry as normal printing paper it is suitable for enlargements and not restricted to contact printing like many alternative processes. When coating a surface you must also prepare an identically prepared test-strip to determine exposure. Process as you would for normal papers, ensuring that during fixing the emulsion clears properly. Do not leave materials in the chemicals any longer than you have to as they may be difficult to wash out in some cases. Use of Kodak Hypo Clearing agent is probably a wise step. Remember that the surface of the emulsion is highly prone to damage when wet and may lift if washed for too long or at too high a temperature.

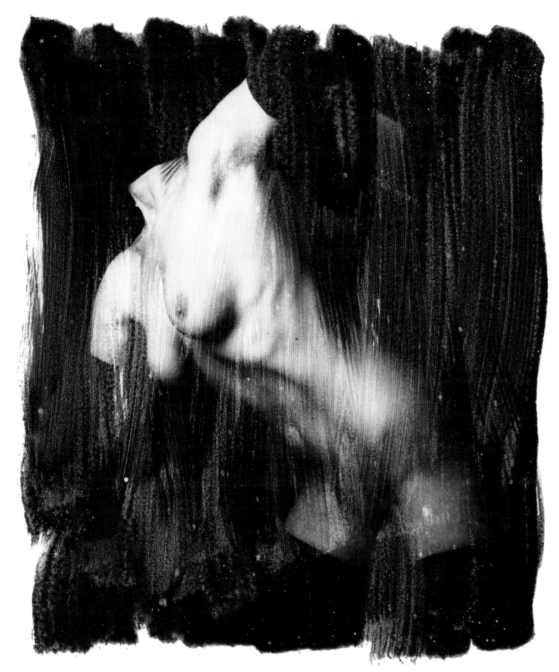

TORSO

The model was photographed against a black background and her head and limbs were concealed by black cloths. I particularly found the pose to be dynamic and the body full of life. Minor details like the creases in the neck just add to the tension of the figure. The use of liquid emulsion has added interest and depth to both the background and the figure.

AFTER TREATMENT

Most after-treatment techniques such as toning, tinting and hand colouring can be used with liquid emulsions as you would expect. The effects are usually quite rapid and I have found it best to use fairly dilute solutions to gain a measure of control – particularly with ferricyanide bleaches. However, new areas also open themselves up, particularly at the pre-coating stage. Oil paint for colour can be used in selective areas which will show through the lighter areas of the image. Texture can be incorporated onto the paper by using sand, grit etc. Collage can also be used – objects such as feathers, petals and leaves can be glued or pressed into the surface of the paper.

Using liquid emulsions is in essence a simple process. Many things affect the end result, however, and this is what I find so fascinating. Though you may work to a defined end point, the process and its 'mistakes' can throw up unexpected avenues for exploration.

CHAPTER FOUR

Toning and Split-Toning

The very word 'monochrome' seems immediately to suggest black and white, but printers are increasingly employing a range of toning techniques which can colour and further enhance the photograph. It is, however, very important that we understand what various toners do, and in what way can they improve the print.

Essentially toners divide into two categories; those that warm up the tones (e.g. sepia, copper and red), and those that cool down the tones such as blue and green. I do not propose to discuss selenium and gold as separate toners, as we have already covered them in an earlier chapter, although I do intend to examine what each of these two toners can do in conjunction with others. It is also worth noting, that all toning can occur in normal daylight, and there is no need to use a darkroom at this stage.

When toning, you have a reasonable degree of control over the eventual density of the colour and it is no bad thing to experiment and find out what precisely the various toners can do. Sometimes it is necessary to start with a darker print, whilst with other toners, your print should be lighter than normal. Similarly, it is not always necessary to tone to completion; in fact it is often far better if you do not. Personally, I prefer to maintain something of the original monochrome quality of the print, which means making a conscious effort to avoid getting carried away with the process. In those processes which require a separate bleach, I aim to remove only a small element of the silver from the print in order to retain its inherent richness.

WHAT YOU NEED TO UNDERSTAND ABOUT TONING

Virtually all toning processes involve converting the black silver in the print to another metallic compound. If done correctly, it should be chemically stable, although in the long term some compounds are more stable than others.

All prints must be thoroughly fixed and washed, otherwise marks will appear at the toning stage; if in doubt, fix and wash again.

Tone by eye, and not by time; when to 'pull' a print varies, depending on the strength of the toner, its freshness and its temperature. It is always a good idea to have a water bath available, so that you can stop the process at precisely the right time. There should be no need to fix your print after toning.

Toning only works on papers with a silver-based emulsion, although each paper has its own inherent characteristics.

Whilst RC papers are far more convenient to use than FB papers because of the shorter washing time, they do need to tone for longer. FB papers absorb the toner better, producing richer hues.

The grade of paper can have an effect on the toning outcome: i.e. the higher the grade, the stronger the tone. VC papers tone well, although because of the complex structure of the emulsion, they require a slightly longer processing time. The quality of the toning is dependent on the silver content the paper; the higher the content, the richer the tone will become.

Handle prints with care as they mark very easily when wet. Always use clean tongs. Always agitate the toner evenly and continuously for even toning.

Avoid contamination of chemicals. Keep your graduates clean, don't mix your tongs and wash thoroughly between processes.

Pre-soak your print for at least a minute in order to encourage even bleaching and toning. To retain subtle highlight detail, especially when sepia toning, soak your print in luke-warm water.

SEPIA TONING

This is possibly the most popular of all toners because it is easy to do, it is generally available in most photographic shops, it does not greatly alter the initial monochromatic character of the print, and

HOTROD

This image works well as a simple monochrome image, but the image needs warming up a little.

The print above has been lightly bleached, and then toned in a very weak sepia toner so that hardly any of the silver has been affected.

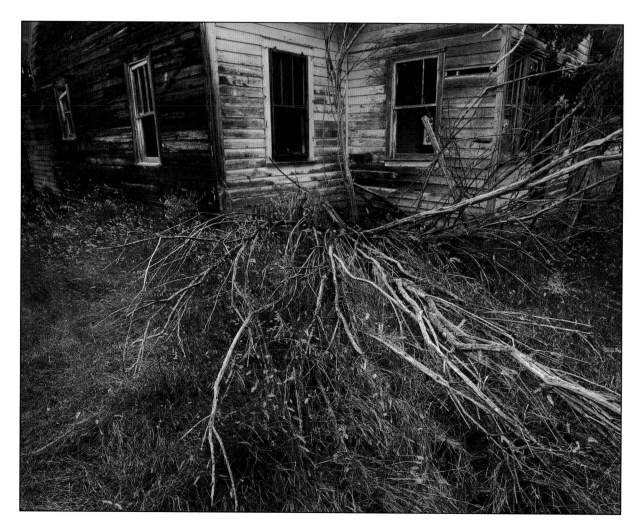

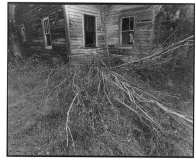

ABANDONED FARM AND DEAD TREE

Above: Tonally, this works well as a straight monochrome image, however it does lack emotion.

Left: It is important always to consider whether toning a print necessarily helps. In this instance, I think it does. This was a dry and arid area which the sepia helps to suggest.

it increases the archival permanence of the print. All sepia toners require a bleach bath; this works by initially bleaching away the lighter tones (and, if you allow it to happen, it will finally bleach away all the darker tones as well). What you will be left with is a very light biscuit-coloured 'ghost' of your print. After a thorough washing, the bleached image is then transferred to the toner, which quickly re-establishes the image, but this time in tones of brown. If you complete the full process you will have bleached out all the blacks and your print will be much lighter. This may well be your intended aim, but do remember that you can bleach as little or as much as you like; an important control with this process. Often photographers using this process for the first time, start (not unnaturally) with fresh chemicals, and are surprised how quickly things happen; this is your other control. Dilute your bleach, to half, or even a quarter of the recommended strength, as you are then able to judge when your print has been sufficiently bleached.

DILUTING YOUR TONER

The technique of using weakened solutions can also be applied to toners (and most notably to sepia toners). The main advantage of weakening sepia toners is that it lightens the eventual colour of the print. I find the easiest way for adding flexibility to my toning is to pre-mix a number of toning solutions of varying dilutions (such as half or a quarter of the recommended strength) and store them in clearly labelled bottles. It should be noted, however, that the weaker the solution, the quicker it tires.

VARIABLE SEPIA TONER

Rather than weaken your toner, you may care to use a variable sepia toner instead. Fotospeed has developed a variable toner called ST20 Vario Sepia Toner; it comprises three parts, the bleach, the toner, and the toner additive which varies the colour of the

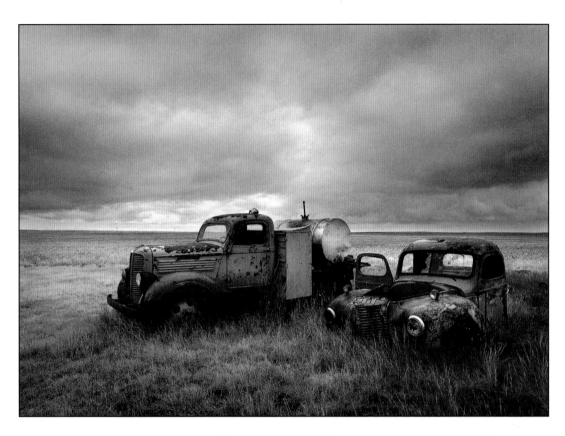

TWO ABANDONED VEHICLES

Left: toned in a variable contrast toner, with 15ml of additive mixed with the prepared toner.

Below: toned in a variable contrast toner, with 50ml of additive mixed with the prepared toner.

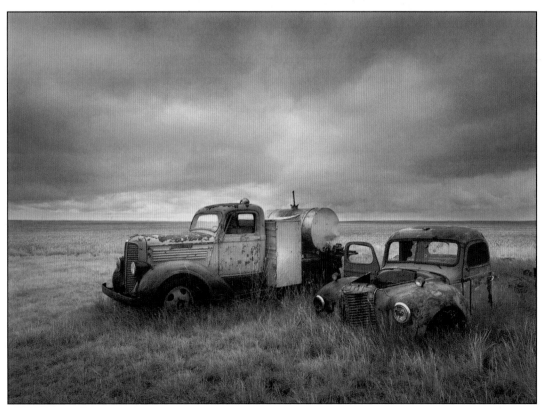

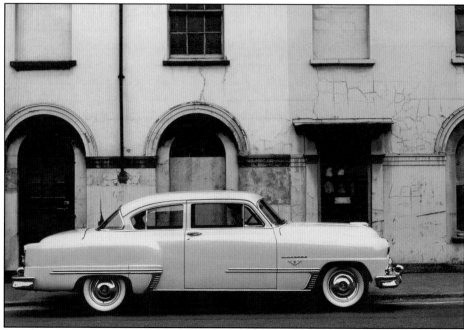

DE SOTO

Above: Monochrome print.

Above right: Bleached and sepia toned.

Right: Bleached and toned in a solution of toner and paper developer.

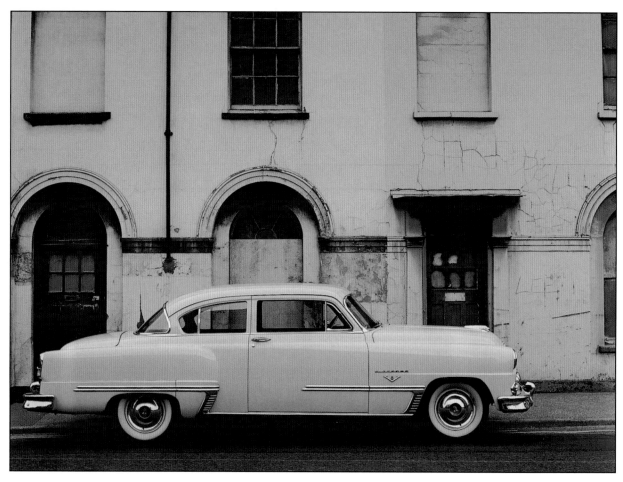

DAVE

It is important to be sensitive about the toner you choose to use with any given subject. In this case, the rich coppery tones serve to compliment the figure.

toner. The principle is virtually the same as any other sepia toner kit, i.e. you bleach your print. However, you are also required to mix the sepia toner and the additive prior to toning. You must have some additive present in the toner for it to work.

HOW TO CONTROL THE COLOUR

YELLOW BROWN	– add 5 ml additive to 1 litre prepared toner
SEPIA	– add 15 ml additive to 1 litre prepared toner
MID-BROWN	– add 30 ml additive to 1 litre prepared toner
DARK BROWN	– add 100 ml additive to 1 litre prepared toner

It is important that the bleach and toners are stored in airtight containers. The toners can be reused, so labelling a toner's 'strength' makes sense. If you find that subtle highlight detail disappears, it could be that your toner is too cold.

Finally, interesting things can happen if you add a small amount of paper developer to the sepia toner (5 ml developer to 500 ml toner), as this can greatly intensify the mid tones.

COPPER TONING

This generally comes in a two part concentrate, which when mixed makes a single working solution. It works with both RC paper and FB but the intensity of colour seems far greater with the latter. The shade of red is determined largely by how long the print remains in the toner. You should follow the manufacturer's guidance notes on dilution, but these do not have to be precisely followed. This toner has a built-in bleach, therefore expect your print to go lighter. To compensate, print about 15% darker.

It has been suggested by some authors that once mixed, copper toners rapidly go off. My experiences are that they store quite well and improve with age. By comparison to a sepia toner, copper toning is a relatively slow process, and you may need to leave your print in the toner for up to 10 minutes, even with a relatively fresh batch. Interesting results can be achieved by leaving your print in a copper toner for an hour or two which is well in excess of its normal working time. Not only does the intensity of the reddish/brown colour greatly increase, but slowly all the blacks begin to disappear and eventually all the whites as well. A print which shows no obvious blacks or whites is anathema to many

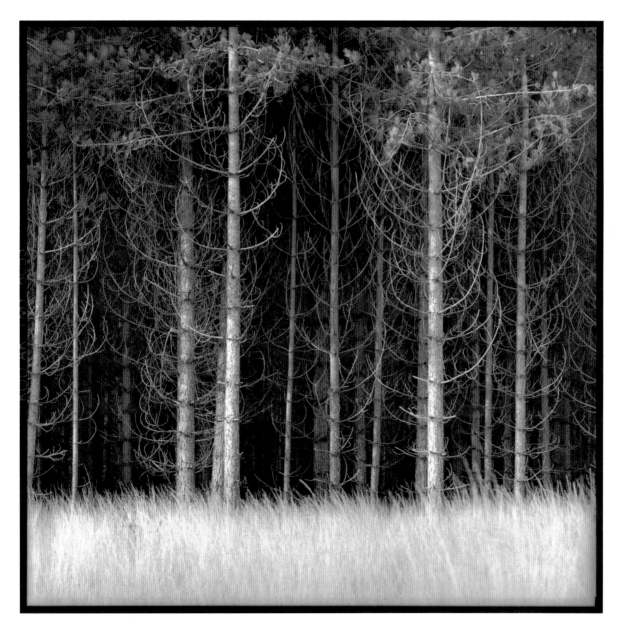

FOREST EDGE

Above: it is important to ensure that you print is 15% darker than normal, as copper-toning lightens the print.

Left: it is important to understand what effect toners will have on your print. Without stating the obvious, we know that the print will turn a coppery red, but the toner also warms up the print, which contrasts with the usual notion of trees; i.e. trees are green, therefore they are cool. These trees have been defoliated, possibly as a consequence of acid rain and in this case suits this unusual choice of colour.

monochrome workers, however from an aesthetic standpoint it is amazing how tolerant we become once the print assumes a distinctive colour. Prints with a strong colour bias but lacking any obvious blacks and whites can often appear gentle yet moody. This may not be to everybody's taste, but it is still an avenue that is worth exploring. From a practical standpoint, toning in copper is a useful way of reducing contrast in a print, in the same way as some printers use sepia or selenium to increase contrast. Because copper toners can be relied upon to work slowly, it really is a useful way to control the reduction of the contrast of your print.

COPPER TONER FORMULA

By comparison to some toners, this is an easy one to mix up for yourself. It is not especially expensive to buy ready mixed, however if you are considering doing a lot of copper toning, it may well be worth your while mixing your own.

SOLUTION A	SOLUTION B
Copper sulphate 25 g	Potassium ferricyanide 20 g
Potassium citrate 100 g	Potassium citrate 110 g
Water 1 litre	Water 1 litre

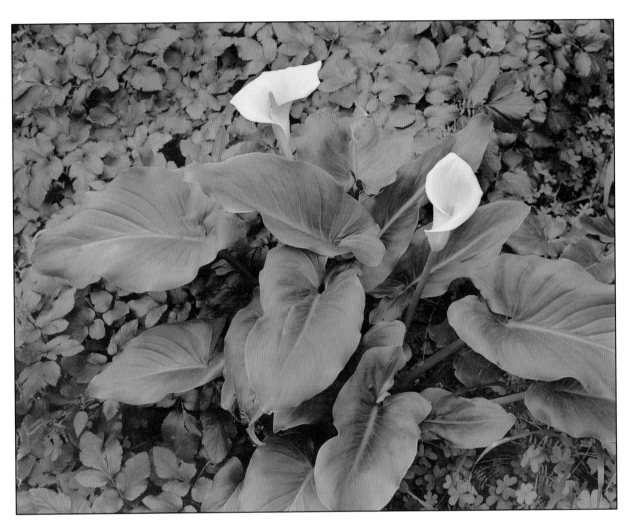

TWO WHITE LILIES

Above: printed as a 'straight' monochrome.

Right: green toning works particularly well with low key subjects; it is important that there are one or two significant highlights, otherwise the toning can become rather overwhelming. You need to judge your black-and-white prints well for this particular technique, as they need to be darker than normal, but the highlights need subtle yet definite detail. Images of this kind are especially suitable for hand-tinting.

INTENSIFYING COPPER TONER

Generally, the longer you tone in copper, the richer the colour becomes, but at a price, because your tones are reducing in contrast. One way of resolving this is to alternately put your print into a copper toner then paper developer, although one needs to be cautious as you can get a rather unwelcome 'solarised effect'.

GREEN TONING

Really this is a 'hybrid' toner. It comes in three parts: Part A is a bleach; Part B is a yellow toner; and Part C is a blue toner. The shade of green is determined by the mix of B and C. The length of time you tone the print, and the extent you bleach it, also has an effect on the final outcome. With this toner it is advisable to start with a darker than normal print, possibly up to 20% darker. Furthermore, it should be remembered that the more you bleach out, the more you reduce the contrast. This is a toner that you definitely need to plan for, as once mixed, it has a very short shelf-life. It also tires very quickly, so do not plan to put too many prints

OLIVE TREE NO. 2

Above: a straight black-and-white print.

Green toners can prove to be rather insipid unless it has been 'intensified'. A small addition of potassium bromide can work wonders.

through. Most toners work better on FB paper, although this is especially evident with green; RC papers do not seem to absorb the colour quite as well. The toner is red in colour, which is confusing as it is difficult to see any changes occurring. It is particularly important to pull the print out slightly, to check on its progress.

If you wish to intensify the colour of your green, add potassium bromide to your toner. This is a useful solution to make up, because it is capable of intensifying all toners.

INTENSIFIER – POTASSIUM BROMIDE

To make stock solution, add 100g of Potassium Bromide to 1 litre of water.

To intensify your toner, add 25ml of 'stock' to ¹/₂ litre of toner.

Some printers experience problems with green toners; whilst the whites look clean immediately after toning, they appear rather yellowish after washing. This can be caused by traces of iron in the water. The answer is to soak your print in a weak solution of citric acid, (a spoonful per ¹/₂ litre of water should do the trick).

Another way to achieve a green tone is to split-tone your print sepia and blue, which is a technique we will consider later.

ICE

Above: Print your image about 15% lighter than normal as blue toning darkens your print.

Right: The blues that can be achieved with this toner vary enormously depending on how fresh it is, and how long you leave it in the toner. The solution was very 'fresh' when this print was put in, and quickly built up to this vibrant blue.

BLUE TONING

The standard advice when blue-toning is to begin with a photograph which is 10-15% lighter than normal, as all blue-toners serve to darken the tones. There lies your first problem, as it is very difficult to assess when a print has reached its optimum tonality until you see it. I much prefer to dip the print in a very weak solution of a sepia bleach, prior to toning, but only for a very few seconds, as you run the risk of your final print coming out a greeny-blue. By briefly bleaching your image, the finally blue-toned image should remain tonally the same as the non-toned version. I find this helps enormously. I have also been accused of being a 'homeopathic' printer as I seem always to want to greatly dilute the chemicals I use. I would particularly recommend diluting blue-toners to between 25-50% of the suggested strength as they are notoriously fast-acting. It is very easy to over-tone, achieving what I consider a hideous acrid blue; it is important to pull your print

early, really at that point when you detect blueness in the print. If you have pulled your print too early, it is easy enough to give it a few seconds more in the toner. Blue toners can be reused (and, in fact, are much better when older), but there can be a problems.

There is the possibility of a sludge accumulating in your storage bottle, which, if it rests on your print during toning, can cause stains. It is no bad idea to filter your toner solution from time to time. It can prove discouraging when you first remove your print from the toner bath, as it appears darker than you expected, and the whites appear to have been stained yellow. You do need to wash your print thoroughly (a hand-spray is perfect) and in a very short time, the harshness and yellow staining disappear. One final piece of advice: it is possible to over-wash your print, thus turning the blue to a dull grey. If you do this, simply re-tone it.

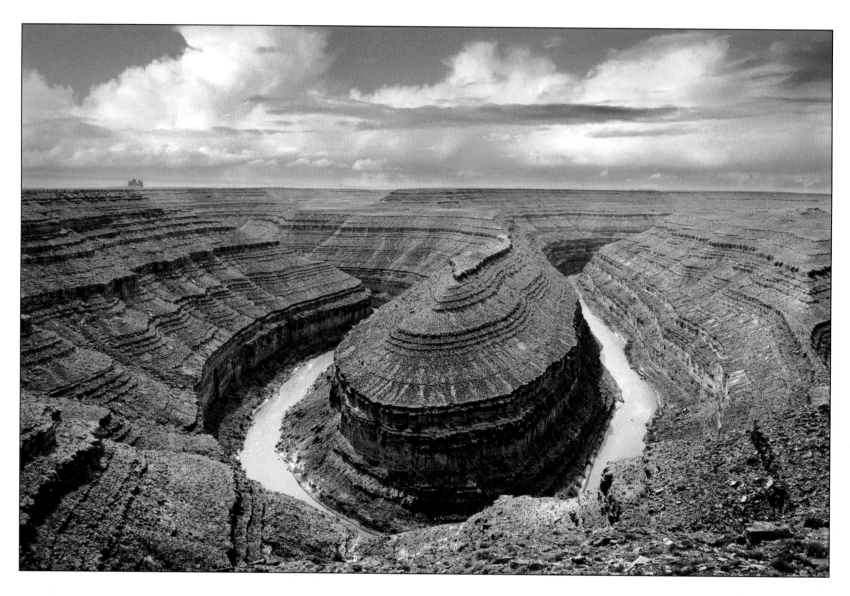

One note of caution is that blue toners are particularly unforgiving concerning finger marks. If you are aware that you plan to blue-tone your print, try not to touch your paper, even at the exposure stage; use latex gloves to handle the paper otherwise you will experience intensified areas of blue where you have.

If you wish to intensify your blue, this can be achieved by firstly redeveloping your toned print in normal print developer, (which will return your print to its original black-and-white tones), and then re-tone it in the blue tones. It is essential that you wash your print between each stage. As you repeat this process, the blue intensifies. Alternatively, you could also add potassium bromide to your toner (see notes on green toning).

GOOSENECKS

Sometimes there are technical reasons for toning a print, and on other occasions there are emotional reasons for doing so. In this instance, the grandeur of the scene is enhanced by blue-toning.

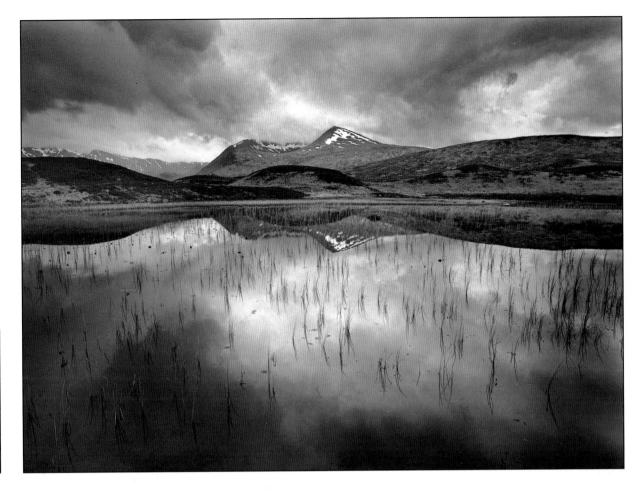

REFLECTION; RANNOCH MOOR

Landscapes often work well blue-toned, although it is important that you print your sky lighter than normal.

Blue-toning can be relied upon to darken your print by up to 15%; this can sometimes be used to your advantage. This photo was taken at the end of May, and I would have expected to see all the snow had disappeared. But clearly it had not. I particularly wanted to give emphasis to the scattering of snow on the peak, and the subsequent reflection. By toning this print blue, all the tones have become darker, with the exception of the peaks, whilst vitally important shadow detail has been retained.

If, on the other hand you wish to reduce the blueness of your print, try soaking it in a very weak solution of fix (1:50). Do not leave it in too long, otherwise all the blue will disappear. Wash carefully once this process is complete. The process of washing is in itself another method of reducing the intensity of the blue, but it can take a little while and the effects can prove rather irregular.

Finally, it is also possible to achieve a purple by blue-toning (and for this piece of information I am indebted to John Herlinger of Fotospeed). Try to achieve an intense blue by putting your print into alternate baths of blue toner and paper developer (but, of course, washing your print in between). Once your print has reached a truly intense blue, put it into a very weak solution of selenium (1:29). Be prepared to remove it very quickly, as the selenium can change the colour rapidly.

BLUE TONER FORMULA

Blue toners are reasonably cheap to buy and accessible from most photographic stores, but if you do wish to make up your own solution this is one you might like to try.

SOLUTION A	SOLUTION B
Potassium ferricyanide 2 g	Ammonium ferric citrate 2 g
Sulphuric acid 10% 10 ml	Sulphuric acid 10% 10 ml
Water 1 litre	Water 1 litre

The two solutions should be stored separately, but mixed in equal parts to make up a working solution. The working solution can be reused, but has a short shelf-life.

CRETAN MEADOW

Left: in this picture I chose to use a dark green filter, which has given the foliage an ethereal, 'infrared' feel. As a straight black-and-white print, it was just a little too delicate and some of the tracery was lost. Blue-toning has strengthened some of the lighter tones without losing the required delicacy of the subject. In order to restrict the natural aggression of this toner, the print was briefly given a sepia bleach bath before being toned. This has introduced very subtle light brown tones, and is a simple example of 'split-toning'.

BEECH FENCE IN SNOW

Right: in order to heighten the sense of drama I chose to intensify the blue by adding a small amount of potassium bromide to the toner.

SEPIA AND BLUE (SPLIT TONING)

Split-toning is a particularly rich vein to follow as it can open up all sorts of interesting opportunities. The principle is a simple one in-so-far as you use two toners, one which is only allowed to partially convert the silver, leaving the rest to be changed by the second toner. There are quite a number of variations, although a popular combination is sepia and blue.

The sepia toner affects the lighter tones, whilst the blue toner affects the darker tones. Consequently the light and dark tones are split between sepia and blue. I personally favour sepia and blue in a landscape situation because the terrestrial colours that can be achieved closely mirror the colours found in landscape.

It can be especially effective with skies, where the darker areas translate as blue, whilst the lighter areas come out as a nice biscuity colour. The real difficulty lies in getting the balance right; if the sepia predominates it can serve to degrade the blue, whilst

too much blue toning and the sepia is lost. This is especially difficult with images that have a restricted tonal range. The ideal solution is to print for the technique by ensuring that you have a wide tonal range; this might require using a harder grade of paper. This tonal split can also be induced chemically, by adding just a few drops of paper developer to the blue toner. When split-toning sepia and blue, it is preferable to start with the sepia; bleach your print in the normal way, but remember, the more you bleach, the more the sepia is likely to dominate your print. I try to bleach very sparingly, taking out only the very lightest of tones. When the print has been sepia-toned, it should look as if it has only been very slightly done. Washing thoroughly between all stages cannot be overstated. When you immerse your print in the blue, it is essential that you keep a careful visual check; as soon as you detect any sign of blueness, remove it from the bath and wash it thoroughly. If it is still not blue enough, return it to the blue toner.

SEPIA THEN BLUE

OLIVE TREE

Left: as a black and white print.

Right: whilst toning maintains a strictly monochromatic character, split-toning moves the print a little closer to colour. In this print the combination of sepia and blue has partially created the natural olivey colour of this tree. Similarly, the lighter areas have come out as an attractive biscuity colour consistent with areas bathed in sunlight, that one would expect to see in a colour photograph.

COPPER AND BLUE

In many respects, this is very similar to sepia and blue, except the mid-tones come out looking a little more mauve; but there are other subtle differences. In addition to changes in the mid-tones, the quality of the blue is also different, appearing slightly warmer.

Like sepia and blue, you will need to tone your print in the copper solution first. But unlike sepia, over-toning with copper does not have an adverse effect on the blue which makes it an excellent combination for many split-toning situations. You do need to be careful with the blue, as it can easily overwhelm the copper.

Most split-toning methods increase contrast, but this is especially evident in this case. The copper toner will appear to affect the mid tones first, and as a consequence will lighten them whilst the blue toner will affect the darker tones by darkening them even further. You will find that this is a very tolerant split-toning process which can produce some very pleasing results.

SEPIA AND SELENIUM

This is a classic combination yielding interesting browns and purples. It is usually used to add archival permanence although it does work extremely well to split tones. In the chapter *The Fine Black-and-White Print,* I urged printers to use the advantages offered by the softer grades, but the penalty can sometimes be a rather tonally flat print. The ideal way to resolve this is to split-tone in sepia and selenium. Whilst the sepia affects the lighter and mid-tones, the selenium works on the darker tones first. The results can vary on a number of issues;

1 How contrasty your original print was in the first place.

2 Whether you sepia or selenium tone first.

3 The extent to which you use the sepia bleach.

4 The extent to which you tone your print in each of the toners.

5 The relative 'warmth' of your paper and paper developer.

6 Whether you are using RC or FB paper. Whilst these toners work on both sorts of paper, the effects of the selenium are not so obvious on RC papers.

The results are variable, but relatively easy to predict, which makes this split-toning combination an invaluable tool in fine printing.

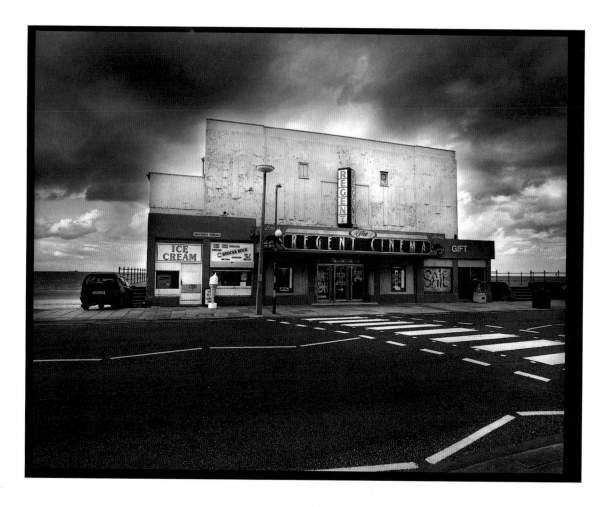

SEPIA THEN BLUE

THE REGENT CINEMA, REDCAR

Above: printed a little dull and dark.

Left: the split-toning has not just added a feeling of colour, but has split the tones as well. It was important that the cinema facade remained sepia, therefore a careful eye was needed at the blue-toning stage to ensure that it remained unaffected.

THE STRAY CAFÉ, REDCAR

Above: Though technically sound, this lacks strong visual interest.

Right: Taken one December, the low winter sunshine has picked out the 'scar tissue' in the road surface that would otherwise be lost at any other time of the year. The split-toning has helped increase the textural qualities of this image.

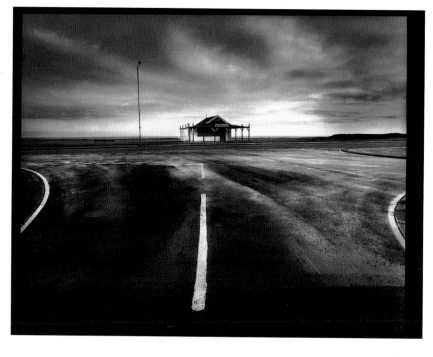

SEPIA THEN BLUE

CLACTON PIER

Above: by split-toning, the quality of backlighting on the wet boards is greatly increased.

Left: this version lacks the drama and the atmosphere of the toned example.

COPPER THEN BLUE

THE REX CINEMA, WAREHAM

Left: this was taken in my local cinema and was taken almost entirely in gaslight; it required an exposure of seven minutes.

Above: the copper has very clearly affected the lighter tones, whilst the blue has worked on the darker ones. It is important to allow the copper to convert only these lighter tones, otherwise the blue will have nothing to work on.

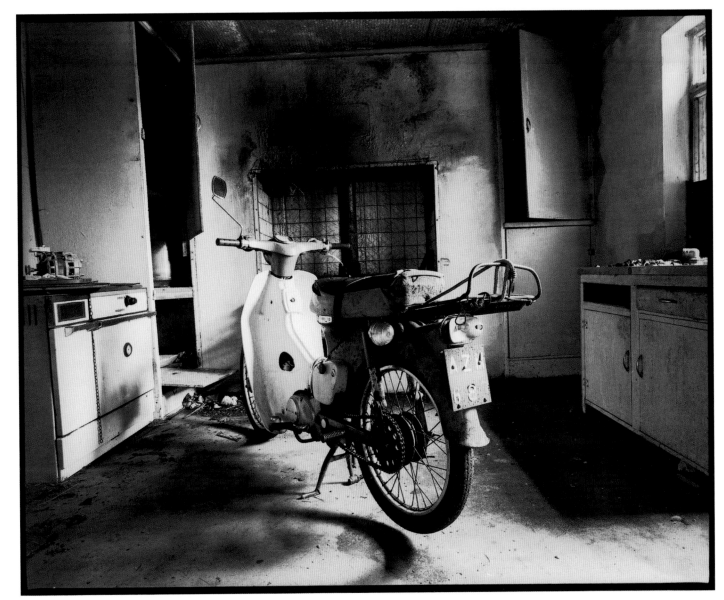

COPPER THEN BLUE

HONDA 50 IN IRISH COTTAGE

Split-toning seems to have exaggerated the difference between the darker and lighter tones, thus increasing the strong sense of light within this interior.

COPPER THEN BLUE

URINALS

Split-toning with copper and blue seems to work particularly well with very low-key prints.

On the face of it, this seems an unpromising choice of subject, but what caught my eye were the tones; splitting these between red and blue has greatly added interest.

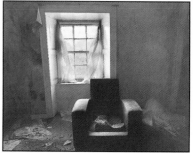

SEPIA THEN SELENIUM

CHAIR IN IRISH COTTAGE

Above: initially, I thought this was one of those negatives that was not worth bothering with; whilst there were interesting highlights on the chair, generally the print was too murky.

Left: the value of split-toning should be obvious in this print; firstly, because I knew I was going to selenium tone the print, I was able to print just a tad lighter, thus maintaining vital shadow detail; secondly the sepia has served to separate the mid-tones from the dark, thus removing the sense of murkiness.

SELENIUM AND GOLD

This is another classic split-toning combination which can be relied upon to greatly enhance the archival quality of your print; in this instance you will see a rich brown in the shadows whilst the highlights and mid-tones show the characteristic blueness of the gold toner. It is important to tone the print in selenium first, but it is vital that you wash it thoroughly before progressing to the gold, because even a small trace of the selenium will rapidly diminish the effectiveness of the gold. Bearing in mind how expensive gold toner is, this is a precaution no printer should choose to ignore. It is recommended that you wash your print for at least 30 minutes after toning in selenium. The effects of this process are far more obvious when the print has been lithed (see chapter fifteen on lith printing).

SELENIUM AND BLUE

The results of split-toning in selenium and blue are very similar to those achieved with selenium and gold, although, of course, it is a very much cheaper alternative. It is also very important that you tone your print in the selenium first; if you tone in the blue first, the selenium simply overwhelms the blue, resulting in an unsatisfactory grey. It is also important to start with a print showing a wide range of tones, otherwise it is difficult to establish a satisfactory split. Your choice of paper and developer can have a significant bearing on the final outcome of your print; if you are using a cold paper and developer, the areas affected by the selenium will come out looking rather purple in colour. By way of contrast, a combination of a warm developer and paper can significantly alter the browns in the shadow areas, which will

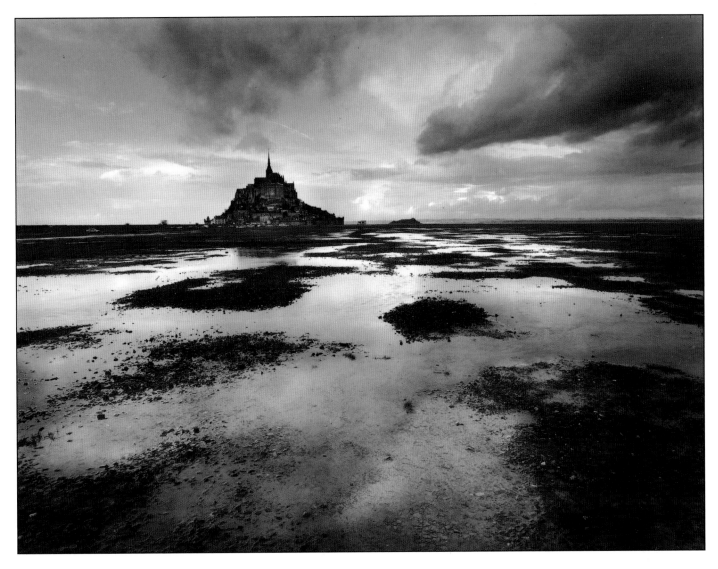

appear much more gingery. For many toning processes I have recommended that you dilute your toners weaker than that suggested by the manufacturers; with this process, whilst I would advise you to dilute your blue toner, I would also increase the strength of your selenium toner, possibly up to 1:4. You do need to be very positive at the selenium-toning stage, and keep a keen eye on those areas which are being affected. The selenium will appear to tone the darker areas first, but once you have reached the balance you require, you should remove the print and wash it thoroughly. One also needs to exercise caution at the blue-toning stage; if you allow the blue to become too dominant, it can result in a 'solarised effect' which can entirely change the character of your print. It is important to 'pull' the print at precisely the right time. It is also helpful to have a saline bath close to hand to halt any further blue-toning.

SEPIA THEN SELENIUM

MONT ST. MICHEL

Right: This was printed from a very contrasty negative requiring a low grade paper to ensure both shadow and highlight detail; as a consequence, the print lacks punch.

Above: By split-toning, first in sepia and then in selenium, the sepia has lightened the highlights, whilst the selenium has enriched the shadow areas.

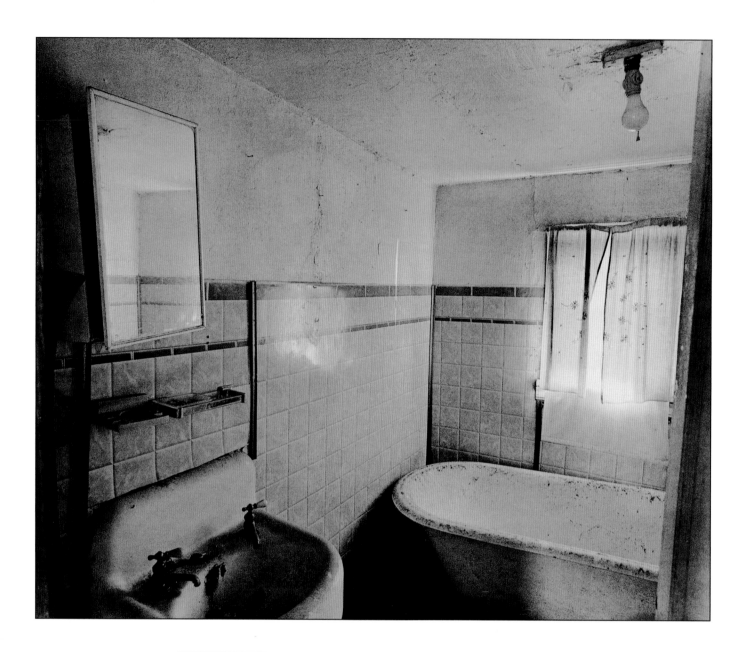

SELENIUM THEN GOLD

NEGLECTED BATHROOM

Left: whilst some of the mood is still apparent in this version, much of the rich texture evident at the taking stage seems to be lost.

Above: by split-toning this first in selenium and then in gold toner, the strong brown/blue separation has greatly enhanced the textures.

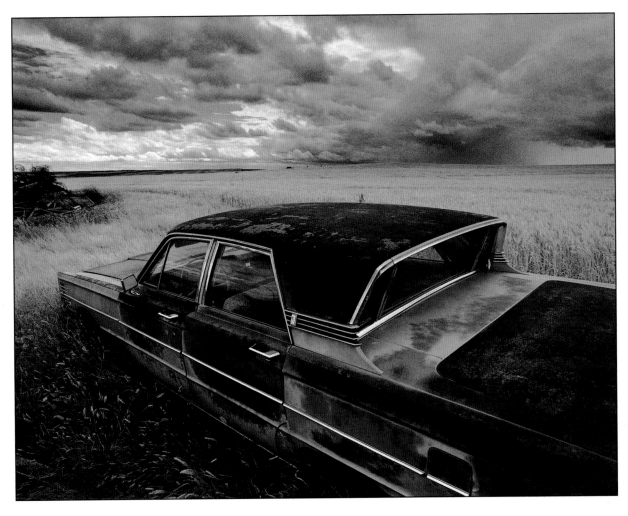

SELENIUM THEN BLUE

ABANDONED CAR
NEAR HAVRE

Above: having used a cold paper/developer combination, the areas affected by the selenium have translated into a cool purple, which suits the mood of this photo.

Left: it is important to start with a print with a good tonal range.

Right: whilst this has been successfully sepia toned, it fails to convey the bleakness of this scenario.

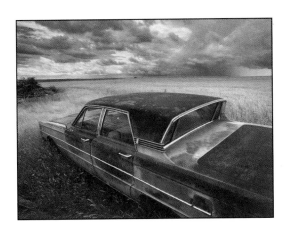

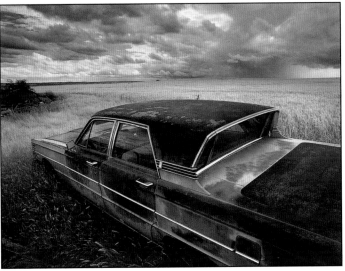

SELENIUM THEN BLUE

ABANDONED SCHOOL, RHODES

*Split-toning
is not a precise science, and whilst
I would have liked the interior to
have remained brown and the
exterior blue, the split is a result of
the tonal balance of the picture.
It is, however, possible to exercise
some control, by keeping a very
careful visual check at the selenium-
toning stage, and removing the
print at the optimum moment.*

SEPIA AND COPPER

This is a particularly beautiful, if subtle combination. On first inspection, the results are very similar to sepia and selenium, but the shadows are much more likely to assume a strong purple. It has been suggested that if you wish to increase the contrast of your print, try sepia and selenium – sepia and copper have the reverse affect; the copper in particular removes some of the kick in the blacks and can sometimes reveal shadow detail which was otherwise lost. Whilst the colour is attractive, you may be tempted to use this technique as a means of producing a 'fine print'.

SELENIUM AND COPPER

This is an interesting split-toning technique which is highly dependent both on the warmth of the paper and the paper developer used. As you tone in the selenium first, much depends on how it reacts with the paper. On a moderately cold paper, the darker areas (which are affected by the selenium) come out looking rather cool, whilst the lighter areas, which are affected by the copper, assume a warm pinky colour. If you wish to suggest both warmth and coolness in your print, this is an excellent process to use. By way of contrast, a much warmer overall result can be achieved by using a warm paper in the first place. Whilst the darker areas affected by the selenium come out looking rather gingery, the lighter areas assume a warm peachy colour. If you find this "warmth" too overwhelming, you can choose to remove your print before the copper has had an opportunity of converting all the remaining areas, which will introduce a rather interesting grey in certain parts. It is worth experimenting with this combination.

With split-toning you will need to experiment and accept that the process is open to so many variables that it is difficult to repeat. But that is part of its charm. Generally, the highlights will take the colour of the first toner, whilst the shadows will take on the colour of the last toner and the mid-tones are a cross-over of both.

WAITING ROOM, HOMESTEAD, MONTANA

Above: print from original negative.

Right: Selenium then copper. This has been printed on a moderately cool paper and therefore the selenium has had the effect of cooling down the darker tones, whilst the copper has warmed up the mid and lighter tonal areas.

SEPIA AND COPPER

ORGANIC DECAY

Not only does this combination aesthetically improve the print, but it is a valuable means of controlling contrast.

SELENIUM AND COPPER

STILL LIFE WITH CRUSTACEANS

As this was a relatively dark print to start with, the selenium has very quickly converted the silver in the shadowed areas, and some of the mid-tones, leaving only the lighter areas to be toned by the copper. Whilst there is a uniformity about the colour introduced into prints as a result of split-toning, it does open up wonderful opportunities for further work, especially with hand-tinting.

CHAPTER FIVE

Alternative Printing Processes

A nsel Adams made the analogy of the negative as a musical score and the print as a performance. A composer may write music for a specific instrument but would certainly also utilise the full range of musical instruments available. Photography, in its relatively short history, has generated an enormous range of processes for producing the final image. Each process has its own unique character and adds to the rich diversity of image making that we have at our disposal. In general, it maybe only be time or laziness which prevents many from experimenting with some of these techniques, but a little effort can result in new impetus and excitement in our image-making. Some processes are the result of modern technological developments, such as digital manipulation, new materials and printing techniques; and some, such as the cyanotype, rely on chemical discoveries which date back to the early 19th century. When we consider alternative printing techniques we think of those other than gelatin silver prints. Technology marches on however and no doubt silver printing itself will become an 'alternative process', particularly in the light of modern developments in digital imaging and printing. The point is, we should never consider one process to be the only option. Make use of the enormous range of materials and processes available.

Many of the alternative printing processes require similar equipment and because of the resurgence in these processes it is now relatively easy to buy the equipment new. But some of the fun comes from improvising or searching out old apparatus from car boot sales, auctions, or old attics.

MEASURING CHEMICALS

SCALES One of the attractions of returning to archaic or alternative processes is the ability to control every element of production using relatively simple components. You do not need a degree in chemistry to cope with making up the sensitisers used, in fact if you can follow a recipe which only has two or three

Weighing chemicals on a simple balance.

ingredients and no cooking then you can easily make up your own materials. Most chemicals will be bought in their dry or solid state. Accurate weighing according to the formula needed will usually require a set of scales accurate to 1 g or less. Electronic scales are available but I still prefer using a balance. Whatever you use some form of inert material will be needed to contain the chemicals. Small weighing boats are useful or folded filter papers can be used. They should be discarded after use.

MEASURING CYLINDERS Pyrex cylinders are best as these are easily washed, but plastic or polypropylene can also be used. A range including 100 ml, 250 ml and 1 litre cylinders will suffice most needs. A mixing beaker of about a litre in size and a thermometer is also useful. When mixing chemicals a glass stirring rod is essential. In most cases it is best to add raw chemicals a little at a time and mix until dissolved before adding any more. This is especially important when adding two or more chemicals to a solution. In some cases the order of adding the chemicals is important to enable them to dissolve easily. Most solutions you are using are aqueous and you should use distilled water rather than tap water which may contain contaminating ions. Always work at a clean surface that can be easily wiped if there are spillages and ensure that you do not inhale any dry chemicals. Always read the relevant instructions on their safe use and ensure that you are prepared for accidents. Never add water to strong acids or alkalis. Always add acids drop by drop to water. Many chemicals dissolve

more easily if the water is warmer, around 40-50°C. The wearing of rubber gloves when handling chemicals is advisable, as is a face mask when dealing with fine powders.

SYRINGES Syringes without needles are invaluable for measuring small quantities of liquids, especially when measuring sensitiser for each sheet to be coated. The 1ml and 5ml syringes are most useful and again it is advisable to reserve syringes for specific processes. They are cheap and can be easily labelled with a fine waterproof marker pen.

STORAGE All containers should be clearly labelled and dated and kept away from children. Brown glass storage bottles are cheap and most useful, though polypropylene can be used. Never store chemicals in old drinks bottles. They may be too much of a temptation if children do find them. Most chemicals keep best in a cool, dark place. A lockable steel filing cabinet in a cool garage or similar will do.

Variety of brushes used to coat surfaces.

COATING SURFACES Brushes have been used traditionally and in many cases are a good cheap way to coat papers and other surfaces. Care has to be taken with the possibility of chemical reactions occurring between metal ferrules and the sensitising solutions, however. For this reason Jiaban or Hake brushes are a good investment. They are relatively cheap and the hair of the brush is glued and sewn to a wooden handle and no metal is used. They normally come in 2in and 3in widths which is adequate for most uses. It is advisable to reserve a different brush for each different process. When using a brush it is easiest to pour the required amount of sensitiser into the middle of the paper and work out towards the edges using even brush strokes. By angling the paper towards the safe light you should be able to see relatively easily if any areas have been missed. Papers are normally dried in the air in a dark cupboard or box, but hairdryers on gentle heat can also be used. If so, it is best to allow the sensitiser to dry a little first.

Brushing sensitiser onto paper using a Hake brush.

GLASS ROD COATING

A technique which has been borrowed from the science laboratory is that of using glass rods for coating sensitisers. This is particularly useful when using expensive chemicals as in the platinum process. It requires less sensitiser and the glass rod can be easily cleaned preventing cross contamination. Glass rods can be purchased ready made or, with simple laboratory skills, made from lengths of capillary tubing or glass rod. The rod resembles a pair of handlebars bent at an angle of 90° at each end to form hand grips. The straight section of the rod is usually equivalent to the width of the print you wish to make, i.e. for a 5in x 4in print, the straight section would be 4in long.

Using a 1ml syringe to measure the sensitiser.

To coat a piece of paper:

❶ Tape your paper to a clean piece of glass on a level surface. It is worthwhile using a small spirit level to ensure that the surface is level, otherwise you may find your sensitiser running to one edge. Mark the area to be coated. This can be done by using the negative as a template (or a reject negative of the same size). Make a pencil mark at each corner of the negative, ensuring that there is sufficient space around the edge of the area to allow for over matting.

❷ Use a syringe to take a measured amount of sensitiser. For a 5in x 4in print about 0.4ml will be sufficient. A 10in x 8in print will require about 1.6ml. Carefully expel the sensitiser in a line between the two upper marks.

Taping the paper to a level surface to prevent it moving during sensitisation.

Marking, in pencil, the limit of the area to be coated.

Using a 1ml syringe to measure the sensitiser.

Making a line of sensitiser on the paper.

Drawing a glass rod through the sensitiser to coat the surface of the paper.

Drawing a glass rod through the sensitiser to coat the surface of the paper.

Drawing a glass rod through the sensitiser to coat the surface of the paper

Blotting the excess sensitiser.

❸ Take a clean glass rod and place it down above the line of sensitiser. Carefully pull the rod downwards until it just touches the sensitiser. Pause a few seconds to allow the sensitiser to distribute itself evenly along the rod and then draw the rod down to the lower pencil marks. The sensitiser will spread evenly behind the rod.

❹ Lift the rod over the remaining sensitiser and push back up the paper. Repeat this so that you have spread the sensitiser about five times. Lift off the rod and leave to dry. Blot any excess sensitiser remaining.Wash the rod to prevent sensitiser drying and crystallising on it.

LIGHT SOURCES

Most of the alternative processes are contact printing techniques using UV as a light source. The cheapest and most pleasing to use is, of course, the sun. However, the vagaries of weather, time of year and time of day may make this a little inconvenient. Many people resort to using an artificial source such as a UV light-box. These can be purchased ready made, new or second hand, or they can be quite easily made from raw materials. Use only UVA tubes not UVB, which is carcinogenic, and try to avoid lamps which emit infrared or else you will melt your negatives.

THE SUN is cheap but variable. Be careful of direct sunlight which can have rather too much heating effect. Diffused sunlight, though slower, is less likely to damage your negatives.

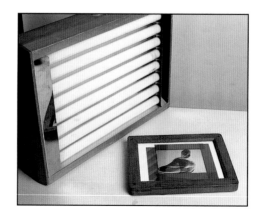

UVA light source with hinged-back printing frame.

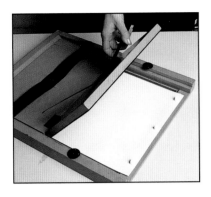

Placing sensitised paper in the back of a register hinged-back printing out frame.

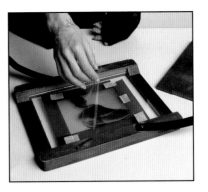

LIGHT-BOXES can be purchased cheaply at car boot sales or bought new at a cost. A simple bed can be made by using Phillips TLADK 30W/05 UV tubes. Four such tubes should be sufficient. Always have electrical equipment checked by a competent electrician before using.

PRINTING FRAMES

A contact printing frame is necessary for holding the negative in contact with the paper during exposure. A simple glass sheet and backing board can be used, but a hinged-back frame is much more useful. Again these can be bought new but old examples are still to be found for a few pounds and are well worth searching out. I use an old Kodak register frame bought at a car boot sale.

The hinged back allows inspection of the print during exposure without upsetting the registration. By mastering the inspection technique you will not need to do any test-strips.

To prevent the possibility of damage to your negative, a thin sheet of polyester film can be placed between the negative and the sensitised surface. Mylar film of not more than 20 microns is normally used, particularly if your process requires some form of humidification as in the platinum palladium process.

Ruby lith masking film is also sometimes used at the printing stage to mask the edges of the print and create a sharp, well-defined edge. Some people prefer to leave the edges rough to show 'hand made' quality of the print. It is up to personal choice.

With a minimal outlay and a bit of imagination it is now possible for you to embark on a wide variety of processes which will enhance both your technical and hopefully your creative potential.

Above: placing a thin Mylar sheet over the negative to protect it from the sensitised surface.

Top right: checking the progress of the print out process.

Bottom: Ruby lith masking film taped to the edges of the negatives to produce a clean-edged print.

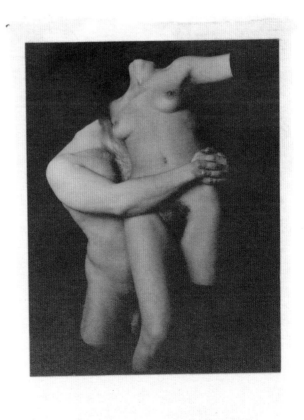

An image produced by a print out process. You can see the original pencil marks to delineate the area to be covered by sensitiser and the excess around the edge of the image which can be overmatted later.

73

CHAPTER SIX

Salt Prints

As a an ex-biologist, I can vividly remember the realisation that the more I learnt about the natural world, how little I really knew. Nevertheless there was always a great excitement at making new discoveries. As a photographer of 25 years standing I feel the same excitement when I discover new ideas or techniques, even if they have been in existence for over 150 years. Everyone knows about the role of William Henry Fox Talbot in the history of photography, but how many of us have tried to emulate his early processes? A good starting point is Fox Talbot's salt process. My own experiments and research have revealed many variations on what is essentially a very simple technique.

As far back as 1725, Johan Schulze had demonstrated the photosensitivity of silver nitrate and his experiments were continued by Carl Wilhelm Scheele, who discovered the light-sensitive nature of silver chloride. At the beginning of the 19th century, Humphrey Davy and Thomas Wedgewood experimented and published their findings concerning the sensitivity of silver nitrate and silver chloride to light. They produced photograms by the contact process, but were unable to 'fix' the image. Exposure to light caused the darkening and inevitable disappearance of the image. Fox Talbot, surprisingly, was unaware of this work, though he no doubt knew of the discoveries of Johan Schulze and Carl Wilhelm Scheele. He started his own experiments in capturing images from nature in the early parts of the 1830s, and by 1834 had produced a photographic negative of the outline of the buildings of Lacock Abbey. The earliest surviving negative of the window was made in 1835.

Fox Talbot was rushed into revealing his process in 1839 on hearing of the news of Daguerre's invention. Daguerreotypes astounded everyone by their wealth of detail and to many, Talbot's paper process could only produce relatively crude results. However, the ability to produce a negative from which could be made limitless positive prints was the main reason that Talbot's

LUCINDA

Originally taken on 35 mm Kodak infrared film, this image was then copied onto Kodak SO-132 direct duplicating film. The print was gold-toned before fixing which produces a slight colour shift to produce a cooler image.

MULTIPLE EXPOSURE

This was an image that was produced by multiple exposure in camera.

The model was photographed against a black background in the studio on Kodak 35 mm infrared film. The film was then rewound and images of water and rivers were then superimposed on the figure.

process was maintained and developed long after the demise of Daguerreotypes. The loss of detail which was inevitable from using paper negatives allied to paper prints was not seen as a disadvantage to everyone, and very soon the 'artistic' qualities of the process became a positive feature. Though advances in the production of more sensitive negative materials, and the discovery of the latent image which could be developed, saw rapid changes at the taking stage, the salt print remained popular for a considerable period of time. Now, along with other processes, the beauty of the salt print is once again being appreciated.

WHAT IS A SALT PRINT?

Salted papers are basically produced by floating or immersing good quality paper in a salt solution, drying, and sensitising with silver nitrate. The paper is then exposed to daylight or UV light in contact with a negative. It is a printing out process requiring only a wash and fixation.

Fox Talbot's original process involved soaking good quality writing paper in a saturated salt solution and sensitising by brushing on silver nitrate. Fixation was achieved by washing and soaking in a strong salt solution. Talbot had first tried potassium iodide to fix the image which had led to a pale yellow tint in the highlights. Salt as a fix leads to a pale lilac tint which varies depending upon the paper and the quality of the silver nitrate. In 1839 Herschel advised

Talbot to use Sodium Thiosulphate (Hypo) as a better alternative to salt for fixation and this was used from then on.

PRODUCING A NEGATIVE FOR A SALT PRINT

As with most processes, it is important to consider the end result before you begin. It is never really satisfactory to try to use a negative which has been taken for normal gelatin silver printing. Greater success will be achieved if you produce a negative with the salt process in mind. Salt prints are characteristically quite flat, though there are ways of improving the contrast. Remember you are not trying to produce a punchy black-and-white print so just learn to accept the quality and tonal range that salt prints give. As this is a contact process it can be used for photograms, and/or with large negatives. Copy film can be used to produce an enlarged negative from 35 mm or 6 x 6, but I prefer to work from an original negative, even if it is small. I use mainly 5 x 4, working on a very old MPP field camera with only one lens. This enables me to concentrate on image-making rather than equipment. The small print produced has a very intimate feel and invites close scrutiny.

Negatives should have a long density range and have good separation in the shadow areas. You will find that during the printing out process, the build up of density in the print will have a self-masking effect. As exposure is increased, the tonal separation and therefore contrast in the shadow areas will decrease. This

BODY BUILDERS

A rather unusual subject for a salt print. I enjoy using contemporary imagery with historic processes. You would certainly not have seen this type of woman in Fox Talbot's day.

masking effect is not so great in the highlight areas. The result is that one can achieve very delicate tonalities in highlights, but shadow areas can tend to block up.

SALTING THE PAPER

There are various formulae and methods recommended for salting the paper. Apart from a source of chloride ions which can come from sodium chloride (salt) or ammonium chloride, a source of organic material is also needed. This may be present in the paper, but is usually added at the salting stage by including gelatin. This acts as a size and prevents the image from penetrating too far into the paper fibres.

Start off by soaking the gelatin in warm water for about 20 minutes (250 ml of water for 1 litre of solution). Then dissolve the other chemicals (depending upon which formula you use) in hot water. Mix and make up to the required amount with cold water. Let it cool and it is ready to use.

These solutions will keep for several weeks before the gelatin starts to decompose. The addition of the Sodium Citrate increase the brightness of the print and makes it slightly reddish.

After having chosen your paper, cut it into appropriate sizes. I use about 8 in x 6 in for a 5 in x 4 in print. This enables space for over

FORMULA 1
Sodium chloride 20 g
Gelatin 2 g
Water to make 1 litre

FORMULA 2
Sodium Chloride 20 g
Sodium citrate 20 g
Gelatin 2 g
Water to make 1 litre

FORMULA 3
Ammonium chloride 12 g
Sodium citrate 12 g
Gelatin 5 g
Water to make 600 ml

matting, but does not produce too much waste paper which can absorb expensive gold toner. Take care not to mark or touch the surface of the paper more than necessary. The paper is then coated either by floating on the surface of a tray of the salt solution or by immersion. The method depends upon the quality and porosity of the paper and there has been much written on methods of floating. It is the recommended method to prevent unevenness of coating which can cause uneven density resulting in blotchy prints. From personal experience I have found that with a good quality paper such as Fabriano or Cranes Parchment, immersion for about 30 seconds with consistent agitation to prevent air bubbles sticking on the surface works for me. Be careful of touching the

surfaces as this can lead to marks on your final print. I usually write the letter S on the reverse side of the paper so that I know that it has been salted. The paper can then be stored until required. This whole process can, of course, be done in daylight.

SENSITISING

The area to be sensitised is indicated by placing the negative on the paper and marking the four corners in pencil. The sensitising solution is silver nitrate.

SENSITISING SOLUTION	
Silver nitrate	4 g
Distilled water	30 ml

RHUBARB

A timeless still life, more in keeping with the process. The jar of medicinal powder is an extract from the rhubarb leaf which also appears in the picture. This is from a 5 in x 4 in negative taken at a workshop at Peter Goldfield's Duckspool residence and was one of the first salt prints I ever produced.

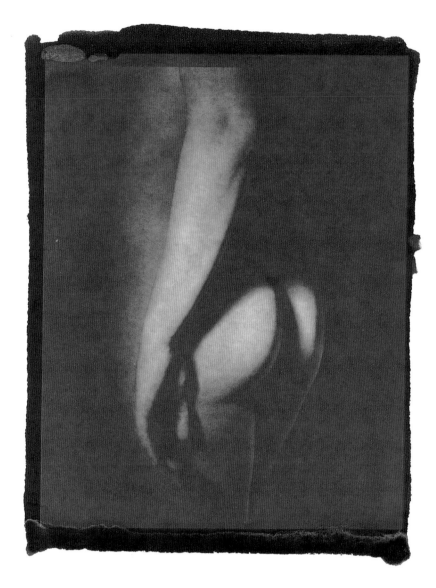

HAND

A carefully lit 5 in x 4 in negative of a seemingly androgynous though sensual figure. The salt process has combined with the paper surface to produce a soft effect. Printed onto normal photographic paper this image would be far too contrasty.

Sensitising can take place in subdued tungsten light. Tape the salted paper to a piece of board or glass so that it will not move during coating. A brush can be used to coat the salted paper, but the glass rod method is far more efficient and leads to a smoother coat. About 0.3-0.4 ml of silver nitrate solution is sufficient to coat an area for a 5 in x 4 in contact print. Using a 1 ml syringe, a line of silver nitrate is syringed along the top of the paper, and the clean glass rod is gently brought down into the solution. This is then drawn down the paper, spreading the solution. The rod is then passed back up and back down once more. Reasonable pressure must be applied, but not too great as this could damage the fibres of the paper. The sensitised paper is then dried, either air dried in subdued light or with gentle heat from a hairdryer. The paper can then be stored in a black bag or used immediately. Wash the glass rod and clean with soft tissue. Try to keep the silver nitrate off your fingers – it will leave indelible black stains. Any impurities in the silver nitrate solution, even dust particles, can lead to small black specks of silver deposit. Avoid shaking the bottle and coating these on to your paper. If necessary they can be filtered out.

EXPOSURE AND PROCESSING

Lay your negative in contact with the sensitised paper and place in a printing frame. These have a hinged back so that the progress of the printing out process can be monitored without disturbing the registration of the negative. Traditionally the exposure is to sunlight, but a light-box with UVA tubes is more convenient if consistent results are required. The paper will darken quite rapidly

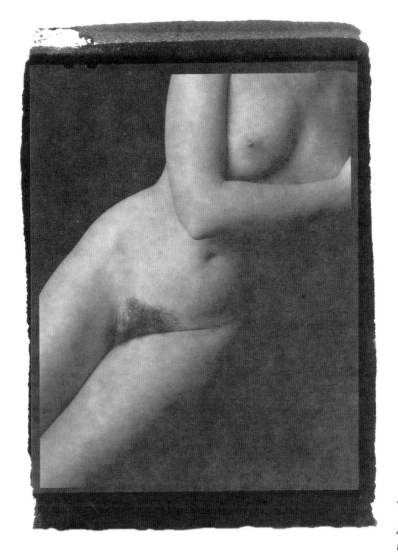

TORSO

An original 5 in x 4 in negative relying on diagonals and triangles as elements of composition.

and progress can be checked by carefully peeling back the paper from the negative in subdued light. To achieve a correctly exposed print you should allow the highlights to go darker than you require in the finished print. You will find that the image will lighten during fixation.

The type of light that you use for the exposure will have an effect on the final appearance of the print. Bright sunshine and UV lamps generally produce a lower contrast result. Higher contrast can be achieved by using overcast conditions or facing the printing frame towards indirect Northerly light.

As this is a printing out process, no development is required. The exposed print should be washed in gently running water or transferred through several baths of water to remove excess silver nitrate. A milky appearance will be seen over the print, especially in the shadow areas. This must be removed completely and may take four or five minutes. Excess washing may weaken the print, however, so don't get too carried away. Fix in plain hypo (2-5%) for five minutes and wash and air dry as for normal fibre-based prints.

TONING

Untoned salt prints are attractive in their own right, varying from brown to reddish brown in colour. Toners can be used to alter the final colour and also increase archival permanence. Normally toning would occur between the wash and fix stage. If you want to tone after fixing make sure that the print has been washed for about ten minutes before toning.

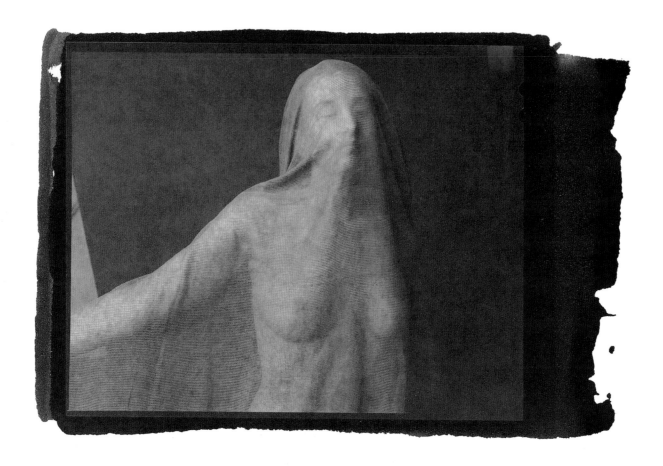

GOLD TONING

This is my favoured method of toning. Though it is expensive it increases the permanence of the print and shifts the colour to a slightly colder plum brown. I use Fotospeed gold toner, though you can make your own. The final colour produced will depend on the pH of the toner used. Gold toning can be used after fixing, but I usually tone before. I find that if you do this the fixer is less likely to bleach your print and makes determining the exposure easier.

Acid toners (such as borax toner) give a colour shift towards red whilst alkaline toners (thiocyanate toner) shift more towards blue.

Toning time depends on the required effect, but may take anything from one to ten minutes. As these toners are expensive, it makes sense to use as little waste paper around the borders as possible.

Working with salt printing is not only an aesthetic pleasure, but I also get great satisfaction from linking up with the beginnings of photography and getting 'back to basics'. Visiting Lacock Abbey or the Royal Photographic Society archives after using the salt process makes one understand and appreciate the pioneers of photography even more.

BORAX TONER
Borax 3 g
Gold chloride (1%) 6 ml
Water 400 ml

THIOCYANATE TONER
Ammonium thiocyanate 2.5 g
Tartaric acid 1 g
Sodium chloride 2.5 g
Gold chloride (1%) 10 ml
Water 500 ml

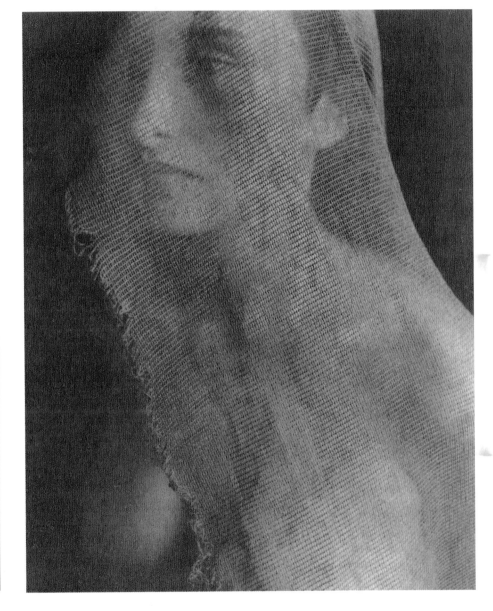

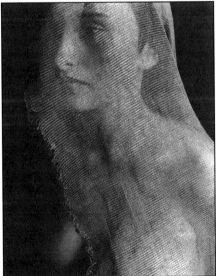

VEIL

Opposite page and above: the salt process has produced a soft, but detailed image which still retains a delicate balance within the mid-tones. The colour difference between the two images is due to gold toner being used which cools some of the brown in an untoned image.

CHAPTER SEVEN

The Cyanotype Process

The cyanotype or blueprint process was invented by the astronomer and scientist, Sir John Herschel in 1842. He was an astounding man whose contribution to photography was significant. He put the words photography, negative and positive into common usage. He pointed out the ability of sodium thiosulphate (Hypo) to fix a silver image and his work on salts of iron led to his own process – the cyanotype – for recording the likenesses of natural objects. The process was quickly seized upon by Anna Atkins, who in 1843 used it to produce botanical studies, some of which can still be seen in London's Victoria and Albert Museum. They are a testimony to the archival nature of the process. Atkins went on to produce the first photographically illustrated book, *British Algae: Cyanotype Impressions,* in 1843.

The cyanotype has had both its advocates and its critics. Anna Atkins described it as Sir John Herschel's beautiful process. It was used by Henri Le Secq and Alvin Langdon Coburn, though Peter Henry Emerson in his book *Naturalistic Photography* said that, "no one but a vandal would print a landscape in red, or cyanotype".

It is with a certain irony that we literally have painted the landscape with cyanotype. Prussian blue (ferric ferrocyanide) was used on the mountains of North Wales to absorb the radioactive fallout from the Chernobyl disaster to prevent radioactivity entering the food chain.

As with many 'alternative processes', the cyanotype is seeing a revival. It has been used by many contemporary workers such as the late Helen Chadwick, Bea Nettles, Betty Hahn, Sarah Van Keuren, John Metoyer and Bobbi Carrey. One of the attractions is that it is a relatively simple, inexpensive process that can be used with a wide variety of surfaces (paper, wood, cloth, leather) and mixed with other media (watercolour, gum bichromate, oils).

WHAT IS THE CYANOTYPE PROCESS?

Basically it is a negative/positive contact printing process using paper coated in iron salts to produce a blue image. The traditional method of coating the paper is to prepare two solutions:

SOLUTION A	SOLUTION B
Ferric ammonium citrate (green) 20g Water 100ml	Potassium ferricyanide 8g Water 100ml

These solutions can be prepared in normal room lighting and stored almost indefinitely (though the Ferric Ammonium Citrate may grow mould if left too long).

To use, equal parts of A and B are mixed together under subdued light – weak tungsten, not fluorescent or daylight.

Mixing the two solutions produces Ferric ferrocyanide or Prussian blue. On exposure to UV light the ferric salts are reduced to ferrous salts which are insoluble and form the image. Processing is a simple matter of washing in water to remove the unexposed ferric salts.

WHAT TYPE OF NEGATIVE?

When deciding on what type of negative to use, do not limit yourself, there are too many rules restricting the imagination as it is. However, in purely photographic terms, for a print with full tonal range, a negative with full density range of at least 1.8 is recommended. This can be produced by over-developing your negative by 70-80%. In practice what you can use as a negative depends on the final result you want to achieve. Virtually anything can be used as a negative. Photograms are produced by using objects in contact with the paper – flowers, leaves, feathers etc.

You could use photocopied acetates to introduce high contrast or text into your images. Rubbings on greaseproof or tracing papers

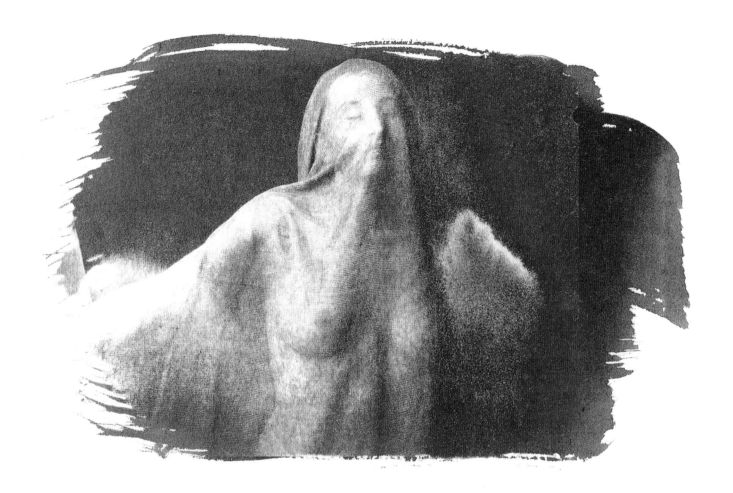

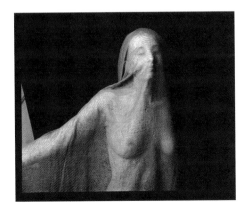

VEIL

This is a cyanotype print on Fabriano paper. I particularly like the rough edges in cyanotype prints which suggest that this is only a part of the whole and that there could be more outside the frame, adding a slight sense of the unknown. This, of course, is also reflected in the subject matter where the figure is veiled, leaving a sense of ambiguity and hidden mystery.

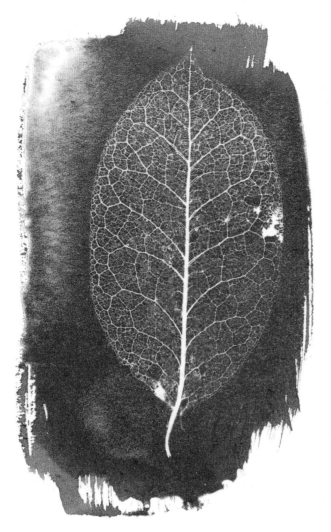

MICROSCOPIC FORMS

As an ex-biologist I had inherited some old glass lantern slides of biological specimens. I thought that producing some cyanotype prints of these marine diatoms would provide a link to the original cyanotypes of seaweeds made by Anna Atkins.

LEAF SKELETON

The cyanotype is ideal for capturing the fine tracery of the leaf skeleton left behind by the inevitable process of decay.

can transfer natural textures to your work. You could work directly on the paper like contemporary photographic artist Lisa Durk who uses water resist oils and lotions on her body. She then lays on the surface of the paper to form a water resist imprint. Consequent sensitisation of the paper with the water-based cyanotype solution leaves an impression of her body. The paper is then exposed to daylight, in conjunction with feathers or rubbings of fossils to produce large scale pieces of work which are half human / half animal. This technique is sometimes referred to as photo-batik.

PRINTING SURFACES

Paper is the normal surface used. Any paper can be used, but many contain chemicals that can affect the colour and archival quality of the final image. I often use Fabriano 5 but quality papers such as Arches Platine, Atlantis Silversafe and Whatman watercolour papers are ideal. Beware of alkaline buffered papers though as they

will affect the image. Papers which have been sized will prevent the sensitiser from sinking deep into the fibres and thus will be easier to wash out during processing. You can size your own papers by immersing them in gelatin solution or using spray starch. Also chemical impurities can cause changes in the sensitiser over time. If your sensitised paper starts to turn blue before exposure then you should consider using a different paper. If you are not concerned with archival quality or maybe are interested in an image that changes with time, try cheap papers, even newsprint – interesting juxtapositions can be formed by combining your cyanotype image with existing images and text in newspapers.

The cyanotype is also ideal for use on other surfaces, particularly organic ones such as textiles and leather. Try fabrics such as cotton or silk; use the qualities of their surfaces, their ability to wrap around structures, to move in the wind. It is an ideal medium for installation work in a three-dimensional space.

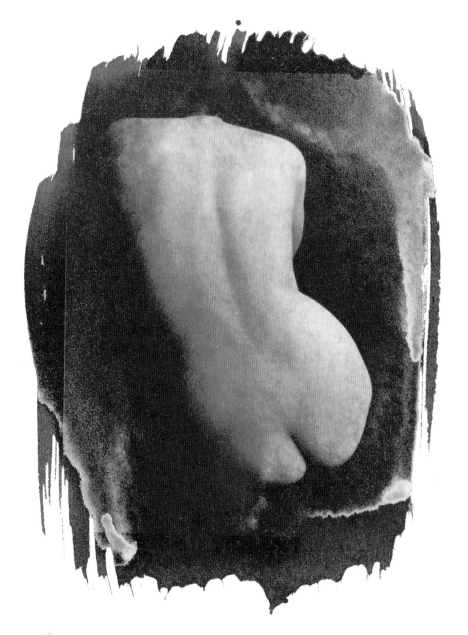

BACK

I find that the cyanotype works particularly well with simple shapes and forms. The colour is also sympathetic to this classic back view of a woman. The use of a hair dryer has caused interesting marks in the background.

COATING THE SURFACE

You can apply the sensitiser in a number of ways. The technique you use depends on the surface and the end result you want. The glass rod method is good for producing an even layer of sensitiser on smooth surfaces. It is economical with sensitiser – about 1.6ml is enough to coat a 10in x 8in. Immersion in the sensitiser is ideal for fabrics. I use brushes (a variety of types, but generally either foam or Jiaban goat's hair brushes), and find the coating to be an important part of the creative process. 'Mistakes' can occur such as uneven coating, puddling etc. When used with controlled drying techniques they can produce interesting effects. For large scale projects such as sensitising king-sized bed sheets, a foam roller

works well. As with all things, experimentation is the key to understanding and controlling such effects. Keeping a workbook with accurate notes is invaluable. Fortunately, cyanotype is a relatively cheap process and therefore is ideal for experiments and the occasional failure.

Drying should occur in subdued light if using a source of heat (a normal hairdryer is fine), or left in the dark if air-drying. Your coated paper/fabric will keep quite easily for a week if stored in the dark. The sensitiser will also last if kept cool and dark – I use a graduated cylinder covered in silver foil. The neck of a 1200ml cylinder is wide enough to allow easy access for my brushes. Alternatively an old film processing tank (with lid) can be used.

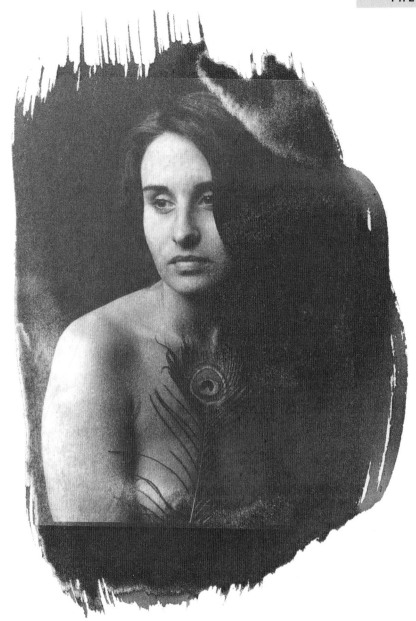

This was a very contrasty 5in x 4in original. The cyanotype process has been able to keep detail in both highlight and shadow areas. In a normal monochrome print the shadow areas seem too heavy.

EXPOSURE AND PROCESSING

You need a source of UVA light. The sun is the obvious answer and can be used effectively (though Herschel complained that the poor weather in 1841 had an adverse effect on his experiments). It is free, though unfortunately not always readily available. UVA light sources such as sunlamps or UVA tubes are more reliable.

Exposure times obviously depend upon the strength of the UV source and the type of negative you are using. Remember that this is a contact process so you will need to use large negatives (a good excuse to buy that 5 in x 4 in or 10 in x 8 in camera you always wanted), or copy negatives. I usually find about ten minutes right for my negatives, but you can determine your exposure either by tests or by inspection.

To use the inspection method you need a printing frame with a split back. This will allow you to look at the print without disturbing the positioning of the negative. Determining the correct exposure is a matter of experience, but you will see the green colour of the dry sensitiser change to a blue-grey. Check the highlight areas – they should look one or two stops over-exposed and shadow areas may even reverse in tone. When you process, the image will lose density and the highlights will clear. With experience you can judge how much density a print will lose.

This was from a series in which I double-exposed the model with a suitable sky. Originally a 35mm negative taken on Kodak infrared film, the print was made from a 5in x 4in copy negative made on Kodak direct duplicating film and printed using the new cyanotype process.

PROCESSING THE IMAGE

One of the advantages of this process is that it only needs water to process the image. You can take washing too far, however, and start losing the image. About five minutes in running water is sufficient. This, of course, depends upon the surface you have coated and the temperature of the water. As you wash you will see at first a blue colour washing out, followed by a yellow solution. When this has all gone and the water runs clear you must take your print out of the wash. Some people use a ruby masking film to produce clean edges to their image. If you do, this should produce an unexposed area for you to observe as the water washes the unexposed iron salts out.

A fond memory I have is being involved in a workshop with students on Harlech Beach in North Wales. On the previous evening we sensitised squares of cotton fabric with cyanotype liquid. We took these in lightproof bags to the beach. Here we collected objects such as shells, crab claws, feathers, seaweeds etc. which were used to make photograms on the cotton squares. They were washed (processed) by immersing them in the sea and hung up to dry on a wire fence while we enjoyed the sunshine – yes they do get sun in Wales. The resulting squares were then sewn together into a banner, incorporating some of the original objects.

CHANGING THE IMAGE COLOUR

When wet the colour of the image is a medium blue. This quickly darkens and intensifies on drying. Within 24 hours its probably as dark as its going to get. If you are in a hurry to see a dark blue image you can add a few drops of hydrochloric acid to the final rinse (about five drops per litre) which will cause darkening. Beware of keeping acids near sensitisers or ferricyanide though – it can form deadly cyanide gas if in the wrong combination. The hazard identification for potassium ferricyanide says that the cyanide is bound and is relatively safe but I like to err on the side of caution.

A brownish purple colour can be produced by immersing the processed cyanotype in a 5% solution of ammonium hydroxide. The blue colour will disappear. Now wash and place the print in a weak solution of tannic or gallic acid (1 g tannic acid to 100 ml water). Finally wash and dry.

An ultramarine colour can be produced by toning a print in a 5% solution of lead acetate at 30°C or higher. A weak solution of sulphuric acid will produce a greenish tone.

Red-brown tones can be produced by immersing the print for five minutes in a solution of tannic acid (6 g in 180 ml of water),

A 5in x 4in copy negative on Kodak Direct Duplicating film, from a 6cm x 7cm original. I particularly like the strong confident pose of Josephine who confronts the viewer straight on.

followed by immersion in a solution of sodium carbonate (6 g to 180 ml). Of course, hand-tinting is also possible.

AN ALTERNATIVE CYANOTYPE PROCESS

After more than 150 years, an updated version of the cyanotype has been produced by the guru of photographic processes, Dr Mike Ware. The new process is a single part sensitiser which uses ammonium iron oxalate instead of citrate. The process has certain advantages over the traditional process, mainly less likelihood of the image disappearing during wet processing. You will need

> Ammonium iron oxalate 30 g
> Potassium ferricyanide 10 g
> Ammonium dichromate (25%) 0.5 ml
> Distilled water to make 100 ml

The potassium ferricyanide must be ground to a fine powder (wear a face mask for safety – dry powders, especially in fine form are easily inhaled and are poisonous).

Dissolve the ammonium iron oxalate in 30 ml of water at 50°C.

Add the ammonium dichromate solution and mix thoroughly. Whilst still hot, add the finely powdered potassium ferricyanide a little at a time with constant stirring. Allow the solution to cool and crystallise overnight. Green crystals should appear.

Filter the liquid from the green crystals (potassium iron oxalate). Make up the liquid with distilled water to a final volume of 100 ml. Filter and store sensitiser in a brown bottle. Kept in a cool dark place it should keep for about a year. If all that seems too much bother, Fotospeed is now selling the sensitiser ready made.

PROCESSING

Processing can still be a simple matter of washing in running water, but an initial treatment in a bath of 4% Citric Acid solution (40 g per litre of water) for five minutes will produce better tonal gradation and stronger shadow areas. A litre of citric acid should be sufficient to process about ten 10 in x 8 in prints. Wash for about 20 minutes. Check after washing that all the yellow staining has disappeared. If not, a second citric acid bath can be used.

The main advantages of the alternative cyanotype process are:

1. Increased sensitivity.

2. The solution penetrates the paper more easily.

3. There is little loss of image density at processing.

As an introduction to alternative printing processes, the cyanotype is ideal. It is also a great way to get young people involved in photography. I also feel that it is a rather neglected process that offers great creative possibilities to contemporary workers.

TORSO

A classic view of the nude. I find the blue cyanotype process sympathetic to simple figure work.

CHAPTER EIGHT

The Kallitype Process

Literally translated, kallitype means 'beautiful print'. What more can I say? The Kallitype process has enjoyed a chequered history in the past 100 years. First patented by Birmingham chemistry lecturer W.W.J. Nichol in 1889, the process involves the use of light-sensitive iron salts to reduce silver nitrate to a metallic silver image. The platinum process was the favoured means of producing fine prints and kallitypes have been rather overlooked until the recent interest in alternative processing techniques. As an alternative to platinum/palladium printing it certainly has the advantage of lower costs and in the right hands can achieve very similar results. By changing sensitising, developing and toning formulae a range of tones, from blue-blacks to warm browns, and varying degrees of contrast, can be achieved. Kallitypes have had the reputation of being less than permanent. This is probably due to the original patent using ammonia as a fixer, but by using conventional thiosulphate it should be as permanent as any other silver print, and as it generally lacks the gelatin emulsion it is less prone to attack by micro-organisms.

As with many other early processes, the kallitype is a contact process involving the use of large format or enlarged negatives. The type of negative required can vary depending upon the sensitiser and developer being used, but generally would be slightly over-exposed and over-developed with a density range of about 1.2-1.3. Exposure is to UV light, either sunlight or artificial usually in a split back printing frame so that you can determine the correct exposure.

Nichol patented a number of different kallitype processes and other workers have since modified and produced their own working methods. Equally you will find dispute amongst workers as to which is the 'best' method to use. The only answer is to try and decide for yourself, which may mean a little bit of experimentation. You can keep the technique very simple using 'off the shelf' products or you can go the whole purist hog and prepare your raw materials yourself. I suggest you start at the beginning and keep things simple before you get swamped by the vast variety of alternatives available.

WHAT IS A KALLITYPE?

A kallitype print is produced by coating paper with a sensitiser containing an iron (ferric) salt. Exposure to UV light through a negative reduces this ferric state to the ferrous state. The ferrous ions then reduce any silver ions they come into contact with to metallic silver which produces the final image. The silver salts can be included either as part of the sensitiser, or in the developing solution, depending upon which method is chosen. The permanence of the final print then depends on removing all the remaining iron salts along with unused silver and fix. Toning with gold is then often used to confer archival permanence.

The traditional sensitiser in kallitype processes, and some would still say the best, is ferric oxalate. This can be purchased from specialist chemical suppliers, or if you are a devoted kallitypist you can make your own. If you have trouble obtaining or making your own ferric oxalate then try this first alternative.

THE VANDYKE OR BROWN PRINT KALLITYPE

This is a kallitype process producing a distinctive brown image. It does not require ferric oxalate and can be used as a printing out process without a developer. Originating from Herschel's early experiments, the Vandyke brown print has been used on and off for both the production of photographic prints and as a process for producing copies of architectural and engineering drawings in a similar manner to the blueprint. Again there are several versions of this process, but basically they involve using ammonium ferric citrate sensitiser mixed with a silver nitrate solution. Water is then used as a developer and to remove unused sensitiser.

VEIL

An air of mystery is invoked by heavy exposure to produce a low key image.

SENSITISER

A working sensitiser can be made from stock solutions as follows:

SOLUTION A	SOLUTION B
Ammonium ferric citrate 6g	Tartaric acid 1.0g
Distilled water 22ml	Distilled water 22ml

SOLUTION C
Silver nitrate 2.5g
Distilled water 22ml

Make the tartaric acid up fresh, but the other solutions can be prepared in advance and kept in small brown bottles out of direct light. Add equal quantities of A to B. Then add C drop by drop whilst stirring with a glass rod to prevent any precipitate forming. A 5ml syringe can be used for this, dropping the solutions into a small liqueur glass or small glass beaker.

COATING THE PAPER

Paper for coating should be clean, sized paper. I use Cranes Parchment but you can experiment with others. You can coat the paper using a Jaiban brush or a foam brush. Place the sensitiser in the middle of the paper, having previously marked the area to be covered. Work out from the centre using smooth strokes to cover the whole area. Coating with a glass rod is probably a better technique. The paper can be coated in safelight or subdued tungsten light, and dried with a warm hairdryer. Remember that you are using silver nitrate which stains skin, clothes etc black so be careful.

EXPOSING THE PAPER

A split back contact printing frame is ideal but any arrangement of glass and board can be used as long as it is possible to check the effect of exposure without affecting the register of the negative. As your negative will be in direct contact with the sensitised surface of the paper, make sure that the paper is dry and to be extra careful you can use a very thin sheet of Mylar film, available from most art shops, to prevent any damage to the negative.

Contact your print in sunlight or with a UV lamp and check for the appearance of an image. The exposure is complete when the shadow areas are almost as dark as you would wish. As with most processes this is a matter of experience.

FISH FOSSILS

The ability of kallitype to render fine detail is shown by this still life of two fish skeletons on a limestone cliff.

PROCESSING THE PRINT

The exposed print is then developed in a tray of running water. You should see the appearance of a milky residue as the excess silver nitrate washes out and combines with the chlorides in the water. After about two minutes the print will be fully washed and will have become darker and be a yellow-brown colour.

After washing, place the print in a weak hypo solution, about 12 g plain thiosulphate per litre of water should suffice. The hypo will act as a fixer on any remaining silver nitrate (though there probably won't be any after a good wash) and it changes the colour of the image to a darker chocolate brown. Beware that too strong a fixer or excessive fixing time can lead to bleaching of the print. About five to ten minutes should be sufficient.

Now wash the print as you would any fibre-based print, about 20-40 minutes in running water, or you can use Kodak Hypo

Clearing agent to reduce washing. Prints can then be toned (e.g. gold or selenium toner). When prints are dried they do tend to darken slightly so this is a factor to take into consideration when determining your original exposure.

USE OF FERRIC OXALATE

Ferric oxalate has traditionally been used as the sensitiser in kallitype printing and certainly the following method and derivatives of it can produce a wide range of results which can be fine tuned for colour, density and contrast.

SENSITIER	
Ferric oxalate	8 g
Oxalic acid	0.5 g
Silver nitrate	3 g
Distilled water	50 ml

Dissolve the ferric oxalate and oxalic acid in the distilled water at 38°C first, then add the silver nitrate. Stir with a glass rod and if a precipitate forms this can be removed by filtering. The solution can be stored in a brown bottle.

HAIR

This was a promotional shot taken for a hairdresser. Original shot on 35mm Kodak infrared film, the negative was enlarged onto Kodak SO-132 direct duplicating film for contact printing as a kallitype.

Sensitising and exposure is as before for the brown print, but a developer is now used. By varying the formula of sensitiser and developer a variety of tones and contrasts can be produced.

DEVELOPER FOR BLACK TONES
Sodium tetraborate (Borax) 50 g
Sodium potassium tartrate 35 g
Water (38°C) 500 ml

Dissolve the borax before adding the sodium potassium tartrate and develop in warm developer for five minutes

DEVELOPER FOR BROWN TONES
Sodium tetraborate (borax) 25 g
Sodium potassium tartrate 50 g
Water (38°C) 500 ml

Warmer tones are produced by reducing the borax and increasing the sodium potassium tartrate content of the developer.

DEVELOPER FOR SEPIA TONES
Sodium potassium tartrate 25 g
Water 500 ml

After development the print must be cleared, fixed and washed.

CLEARING BATH
Potassium oxalate 60 g
Water 500 ml

Clear the print for about 5 minutes.

FIX
Sodium thiosulphate 25 g
Ammonia (10%) 6 ml
Water 500 ml

Fix for five minutes and change fixer as it becomes exhausted. Wash and/or hypo clear as normal.

CONTROLLING CONTRAST

Contrast of kallitype prints can be altered by the use of potassium dichromate added to the developer. The more dichromate you add the more contrast will be achieved (up to a point). Try using between five and 20 drops of 10% potassium dichromate solution to the developer. You will see a cleaning up of the whites and apparent contrast increase. This is an effective means of matching your negative to the type of print you require as you would when selecting conventional graded paper or using multigrade filtration on modern gelatin silver papers.

Kallitypes are often seen as a poor man's platinum print, but with care and experimentation the kallitype can actually produce the 'beautiful print'.

CHAPTER NINE

The Argyrotype Process

During the course of photographic history the number of new processes or variants of the old has been overwhelming. Some remain, but many exist only as interesting curiosities. Modern variations of old processes are fewer but one man has been in the forefront of redefining old processes and using modern chemicals to try to make these processes either better or more user friendly. That man is Dr. Mike Ware. Having redefined the cyanotype process, he has also looked at the kallitype with fresh eyes. His new technique which he developed in 1991 is the argyrotype process. Like many of the other techniques I have discussed, it is a print out process which is an iron-based silver process. The end product is similar to the kallitype with colours ranging from a black/brown to a purple/grey. The vital ingredient in the argyrotype is silver sulphamate. This is manufactured when the sensitiser is made up.

SENSITISER

As with many other alternative processes this can be made in subdued tungsten light. To make a litre of sensitiser you will need:

SENSITISER
Sulphamic acid 76g
Silver oxide 76g
Ammonium ferric citrate (green) 231g
Tween 20 8ml
Distilled water to make 1 litre

1 Dissolve the sulphamic acid in about 700ml of distilled water at room temperature.

2 Add the silver oxide gradually while stirring. As with all powdered chemicals, beware of breathing it in. The silver oxide should dissolve in about 20 minutes.

3 Add the ammonium ferric citrate gradually with constant stirring until dissolved. This will produce a murky green coloured solution.

4 Add the Tween 20. This is a so called surfactant and will help the spreading of the solution on the paper at the coating stage.

5 Make up to 1 litre with distilled water.

6 Some residue may be found from stage 2. This can be filtered out now and the solution kept in a brown bottle. This should keep well at room temperatures but will last longer if kept in the fridge.

Of course, if you do not want to make your own sensitiser it is now available commercially from Fotospeed.

Coating paper is the same as for kallitypes, using either the brush or glass rod method. The coating can be done in subdued tungsten light. To gain a uniform coating, the glass rod is best, but by using brushes and even multiple coating some interesting variations in tone can be produced. Whatever technique of coating you choose, leave the paper to air dry for a few minutes to allow the sensitiser to soak in. You can then dry with warm air from a hairdryer. The paper will keep for a short time (a week or so in dry conditions), but it is best to use it within a couple of hours.

CHOOSING PAPER

The type of paper you use can have a significant effect on the end product. The type of surface, its rate of absorption, the use of sizing or whitening agents all have an impact. Heavier papers with a weight of 120-300gsm are the easiest to handle when wet and generally dry flat if dried at normal temperatures. The following give good results: Atlantis Silversafe, Whatman watercolour, Rives BFK and Cranes Parchment.

It is best to avoid papers which have a mixed content or are gelatin sized. These can lead to blotchy results or staining of the print. You can also use other materials such as cotton or linen. These can be sized before use with arrowroot starch.

JOSEPHINE

The type of paper chosen for argyrotype printing is quite crucial. This is a Fabriano paper which seems to take up the sensitiser unevenly and does not give a very predictable print. However, I have used it because of its faults; I like the way it has varied the tone giving an aged appearance.

This was an image that was produced by multiple exposure in camera. The model was photographed against a black background in the studio on Kodak 35mm infrared film. The film was then rewound and images of water and rivers were then superimposed on the figure.

TYPE OF NEGATIVE

The argyrotype is inherently fairly soft so your negatives will need to have a long density range. Normal film may need over-development by anywhere between 75-100%. Using Kodak Direct Duplicating Film SO-132 allows you to adjust contrast more easily and means that you can produce inter negatives of any size up to 10 in x 8 in. I use Kodak D19 developer, stock solution developed for about eight minutes at 22°C. By making a copy negative, your original negative will not be damaged by any contact with the sensitiser, which I have found can attach itself to your negative if the paper is still slightly damp or if the sunlight gets too hot. This is a possibility if you humidify to change the contrast. A thin sheet of Mylar film can also be interspersed between the negative and the sensitised paper. Use the thinnest possible, about 20 microns to prevent too much softening of the image.

The correct exposure is determined by inspection. Fortunately, this is a self-masking process and you keep exposing until you have adequate detail in highlights. If you cannot see detail in highlights at this stage they will not appear during processing. An orange-brown image will be formed against a yellow background. During processing the image will darken slightly and there is a dry down effect, so again a little experience helps.

EXPOSURE

A split back frame is best, but a piece of glass and board can suffice. Contact print either in daylight or by using UVA tubes. About 1-2 minutes in sunlight or 5-10 minutes with UV lamps is recommended but with my negatives I have found this to be dependent upon the time of year. Working recently in the April weather I have found a great variation in exposure times ranging from 15 to 50 minutes depending upon the intensity of the sun , whereas the summer sunshine gave me exposures of 3-5 minutes. This is where the split back printing frame comes in so useful. As you follow the production of the image you may see patches almost reversing in tone and subsequent processing gives some interesting, if uncontrollable, effects. I find that plain dark areas of the image are particularly enlivened by this process, adding variety of tone and colour.

PROCESSING

Processing is simply a matter of washing and fixing.

1 Wash gently in running water for about five minutes until no more yellow colour appears. The alternative technique that I prefer is to use several changes of water in a tray with agitation

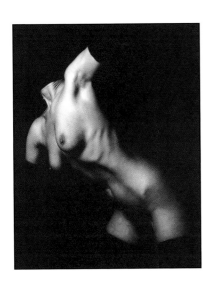

Print from original negative.

TORSO

Sensitiser was brushed on to Cranes Parchment paper in a deliberate fashion to follow the movement of the figure. Such rough brush coating will lead to an unevenness which can add interest to large areas of shadow.

at each stage. If you have chosen the wrong type of paper it is possible that some of the silver image will wash out. This is shown by the appearance of a reddish brown stain washing out of the denser areas.

❷ Fix in a bath of 5% sodium thiosulphate for about three minutes. You will see the image darken to a rich brown. A litre of fixer is sufficient for about ten 10x8 prints. If you have an over-exposed print, prolonged fixation will bleach back slightly.

❸ Wash the resulting print in running water for about 30 minutes. Over washing can cause a slight bleaching of the print.

❹ Dry. It is best to air dry on nylon mesh or hanging from a line. You will see the effect of dry down which can be equivalent to almost a whole zone in some cases, so a preliminary test with the paper you are using is advisable.

ADJUSTING THE IMAGE COLOUR

There are several ways of altering the image colour. Firstly, heat drying using a hot plate dryer or even an iron will result in a more neutral blackish-brown colour. Humidification of the paper before exposure causes a shift to a purplish grey colour. This is achieved by leaving the paper over a tray of water for about half an hour before exposing it. Be careful to use an interleaving Mylar sheet to prevent sticking the emulsion to the negative. Humidifying will also help to improve the tonal gradation, particularly in the highlights.

Of course, being a silver based image it is also suitable for more traditional toners such as selenium, gold, sepia, copper/red and blue. If using selenium be careful not to overdo it as it does bleach the image. As with the kallitype process, the argyrotype can also be used in conjunction with other processes such as cyanotype and is particularly suitable for hand colouring with watercolour pigments.

I have found the argyrotype somewhat easier to use than the kallitype and buying a ready-made solution is an advantage to those who go weak at the knees at the thought of a chemical equation. It is capable of great subtlety and variation of colour and is a welcome addition to the range of alternative processes.

CHAPTER TEN

Platinum / Palladium Printing

The platinum print holds a unique, almost revered status in some photographic circles. Whether this is to do with the rareness and expense of the materials, the unique quality of the print, its archival nature or its seeming difficulty in printing I'm not sure. What I do know from my experience is that like most processes, if you are willing to work methodically and not take short cuts, printing in both platinum and palladium is no more difficult than most other processes. With modern methods is not outlandishly expensive either.

Once again we have Sir John Herschel to thank for drawing attention to the fact that platinum salts could be used to make photographic images. This was in 1832, but it was not until 1873 that William Willis took out the first patent for the 'Platinotype' process and formed the Platinotype Company in 1879. Coated paper was originally sold under licence and though formulae became available for hand coating, most workers used commercially prepared paper until it became almost impossible to obtain due initially to the Russian Revolution and then to the Second World War. This led to many well known platinum printers, most famously Frederick H. Evans, giving up photography altogether. More recently as materials have once again become available and interest has resumed, many workers are using platinum for its unique quality and beauty. Irving Penn returned to hand-coating paper for his beautiful platinum prints of still life objects and portraits, and Jan Groover's table top still life prints of everyday objects reveal great subtlety in the process.

Platinum/palladium printing is based upon the photosensitivity of iron salts which are used to reduce salts of platinum and palladium to their metallic state.

An image formed by the platinum process consists of very fine particles of platinum as opposed to the silver of a normal photographic print. Platinum and palladium are chemically more inert than silver and therefore less likely to be changed over time

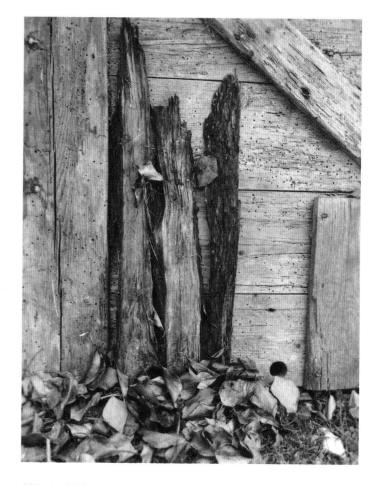

STILL LIFE

This is from a 5 in x 4 in negative taken at a workshop at Peter Goldfield's Duckspool residence and was one of the first platinum prints I ever produced. Platinum print on Fabriano paper.

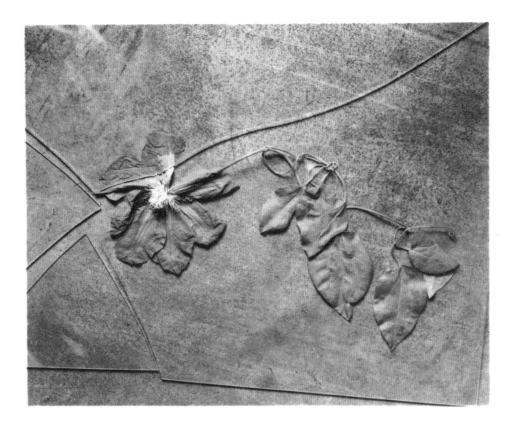

CLEMATIS

I grow plants for pleasure, food and photography. This clematis had provided both an aesthetic and practical function by growing over and disguising a rather ugly down pipe on my house. Its reward was to be plucked in its prime and sandwiched between some broken glass and a rusty metal plate. The print is on Cranes Parchment and is Pd/Pt 3:1.

by atmospheric pollution. Therefore, archivally it is probably the best process to use. The image is also formed directly on the paper, with no gelatin binder or use of whitening agents. This provides a matt image which depends very much on the type of paper chosen for its final effect. The final colour of the image can also be varied from cool greys to warm browns by changes in the sensitiser and processing.

Though the full contrast range of modern silver gelatin papers may be hard to achieve, the subtlety of platinum/palladium, especially in separating mid-tones, is a major attraction of the process.

WHAT TYPE OF NEGATIVE?

As this is a contact process a large negative either formed in camera or produced under the enlarger is necessary. The platinum process is capable of separating an immense gradation of tones and for this reason it is best to use a negative which has a greater contrast range. A normal negative has a range from about 0.05 to 1.40 (base plus fog), but for platinum printing a range from 0.15 to 2.10 or higher is advisable. This can be achieved by over-developing your negative between 30-50%. Halving the ISO rating to give twice normal exposure will increase the density and should

be used in conjunction with increased development. Remember though that you are trying to achieve a long tonal scale and not a totally dense negative, so don't overdo it.

Probably the best way to produce a printable negative in camera is to use a two bath developer. I would use the Ansell Adams D23 formula with Kodak T max 100 pro film. (See production of copy negatives). Ideally a large negative will be produced directly in camera for subsequent printing. In reality many people will make a copy negative from a smaller format. Good contrast and an extended tonal range are produced by over-exposing and over-developing as described earlier. Kodak Direct Duplicating film SO-132 is ideal for the purpose, but with the advent of more affordable digital production techniques, the ability to make a large negative direct from 35mm original (colour or monochrome) is worth thinking about. The advantage of such systems is the fine tuning of selective burning and dodging and contrast control. Using an Epson Stylus Photo EX ink jet printer on ink jet film I have been amazed at how easy it is to produce the exact type of negative I need for the process I am going to use.

In fact, apart from a very thin negative the platinum process is capable of producing good results with a wide variety of negatives

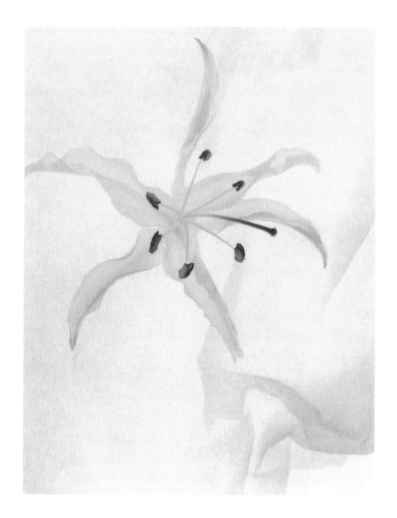

LILY

The lily was placed on some hand-made paper which I slightly folded. This was laid on a light-box and simply photographed from above using an MPP 5x4 camera. The resulting print was produced by coating Cranes Parchment with a 3:1 Palladium / Platinum sensitiser.

if you match the processing technique with the negative. Contrast control in your final print can be achieved at the sensitising or development stage so that even 'normal' negatives can achieve satisfactory prints.

PAPERS

The nature of the platinum process is such that the particles of platinum are embedded in the fibres of the paper on which it is coated. This means that the surface quality and colour of the paper become an integral part of the image. Apart from gelatin-sized papers, there are many quality products to choose from. Usually these papers are made for watercolour painters or printmakers, but the following are particularly recommended: Arches Platine, Atlantis Silversafe, Whatman watercolour and Buxton.

You will find that these differ in surface quality and absorption of sensitiser, but it is worth while getting to know a few papers to increase your creative control. Generally speaking, a hard pressed HP paper, about 200 gsm, with a high cotton (alpha cellulose) content is best. Gelatin-sized papers can be used with the palladium process, but will produce weak images with platinum. Also avoid paper which has been buffered with chalk (calcium carbonate) which will react with the sensitiser. To produce a platinum print you will need to prepare several solutions.

SENSITISER

This is prepared in three separate solutions. Be meticulous about the cleanliness of containers and measuring cylinders, ensuring they are not contaminated with any silver from normal photographic processes. Use glass rods or non-metallic stirrers (disposable plastic cocktail stirrers work well) to mix the solutions. Preparation and coating of the sensitiser can be done in normal tungsten lighting.

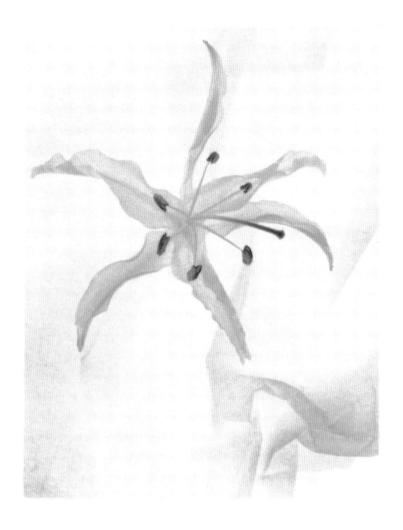

This is a print on Arches Platine. It is slightly warmer than the print opposite and I feel that the tonal quality is more pleasing.

(Ammonium tetrachloroplatinate can be used instead of potassium tetrachloroplatinate. It is easier to obtain but does not keep as well in solution, so don't buy more than you are going to use within about six months.)

With Solution C check that at room temperature there is no precipitation of platinate. If this does occur, just warm the solution up slightly until it redissolves.

SOLUTION A
Distilled water (50°C) 55 ml
Oxalic acid 1 g
Ferric oxalate 15 g

SOLUTION B
Distilled water (50°C) 55 ml
Oxalic acid 1 g
Potassium chlorate 0.3 g

SOLUTION C
Distilled water (37°C) 5.5 ml
Potassium tetrachloroplatinate 1 g

The quality of ferric oxalate is important. If your prints begin to look dull with fogged highlights, the ferric oxalate is probably going off. Fresh supplies of ferric oxalate may be difficult to obtain and those who are serious about platinum printing would probably be advised to make it themselves. There are several ways to make ferric oxalate and for an in depth discussion look at Dick Stevens' *Making Kallitypes* published by Focal Press.

The solutions should be stored in dark bottles and preferably kept in the dark when not in use. Try to obtain bottles with medicine droppers in the lids, as measurement of solutions can be easily calculated using numbers of drops. Alternatively, buy separate 1 ml syringes for measuring small quantities of solution.

To coat paper with the sensitiser it is most economical to use the glass rod method and depending upon on the absorbency of the paper, about 0.4 ml will be sufficient for a 5 in x 4 in print (about ten

drops using a medicine dropper). A small glass vessel such as a liqueur glass can be used for mixing the sensitiser solution and I would make enough sensitiser to coat three or four pieces of paper at a time.

By varying the composition of the sensitiser, a degree of control can be made over contrast. The following is a guide measured in ml of solution, and can be easily measured using a 1 ml syringe.

AMOUNT OF SOLUTION (ml)

	Soft	Slightly soft	Normal	Moderate contrast	Contrasty
Solution A	0.92	0.8	0.58	0.42	0.0
Solution B	0.0	0.17	0.33	0.5	0.92
Solution C	1.0	1.0	1.0	1.0	1.0

After coating, dry the paper in subdued tungsten light. Allow the surface to lose its initial wet sheen and then dry gently with a warm hairdryer. You will need to produce a test-strip, so this must be coated and dried in the same way as your final sensitised paper. It is best to use the paper fresh, but it can be stored in a dark bag in dry conditions. Inclusion of a bag of silica gel is a good idea to prevent moisture retention.

Expose your negative to the test-strip using a source of UVA, ensuring that your test-strip covers both highlight and shadow areas of the negative. You will probably see some printing out of the image as a pale brown image against a yellow background. The use of a step wedge here is very useful to accurately gauge exposure.

Depending upon the sensitiser combination you have chosen, the speed of the paper will vary – as the contrast increases the speed decreases.

CONTRAST CONTROL USING HYDROGEN PEROXIDE

Instead of using potassium chlorate (Solution B), hydrogen peroxide can be used to control contrast. Use equal quantities of the sodium tetrachloroplatinate and ferric oxide solutions. A 3% solution of hydrogen peroxide added to the sensitiser solution will increase contrast. About one drop to 1 ml of sensitiser will increase the contrast by about 1 grade. It can also be added to the developer. Add about 5 ml of 1% hydrogen peroxide to 500 ml of developer for a similar result. Make sure it is well mixed before use. As hydrogen peroxide is unstable it will not last too long in the developer. About 12 hours is about the limit. OK for a single session, but not to keep over to another.

EXPOSURE AND PROCESSING

Using a split back frame the sensitised paper is exposed in contact with the negative to a source of UV. Either sunlight or UV tubes can be used. Contrast will be affected by the type of UV light source you are using to expose your paper. If you are using UVA tubes, a weaker source at a greater distance will give more contrast, as will an overcast day as opposed to bright sunshine. Ruby masking film can be used to define the edges of the print and give a clean presentation which tends to suit the platinum print. If using original negatives, a thin sheet (about 20 microns) of polyester film is recommended to prevent damage from the sensitiser. (This will become more important when using pre-humidified paper, see contemporary process later.) A test-strip, prepared in the same way as your final print, must be produced first. A faint image may be seen, but the full image will only show during development. You will have to learn by experience what is going to be the correct time, but it is usually six to ten minutes under my UV tubes.

DEVELOPMENT

It is at this stage that the ferrous iron formed by exposure to light reduces the platinum salt to metallic platinum. This occurs in the presence of oxalate and in an aqueous solution. The normal developer then is a saturated solution of potassium oxalate. This is simply made by dissolving about 100 g of potassium oxalate in about 350 ml of warm water. Using some litmus paper test that the solution is neutral or just slightly acid. A small amount of oxalic acid can be added if necessary.

To develop, tip the tray away from you, slide the exposed paper quickly and evenly under the developer and allow it to flow back over the paper. An image will be seen almost immediately and development is complete after four minutes. Agitation is not necessary during development. The developer lasts almost indefinitely but may need to be decanted or filtered occasionally to remove any precipitates of platinum or iron salts. Development is usually at room temperatures, but by raising the temperature up to as much as 50°C, contrast can be further reduced. This will also tend to make your images warmer, i.e. browner. Remember though that to ensure consistent results you should always treat your test-strip and final print in the same way.

CLEARING

After development any remaining ferric iron salts must be removed and for this purpose a succession of clearing baths are used. The traditional method is to use a 0.5% bath of hydrochloric acid . The print is passed through a succession of three such baths for about

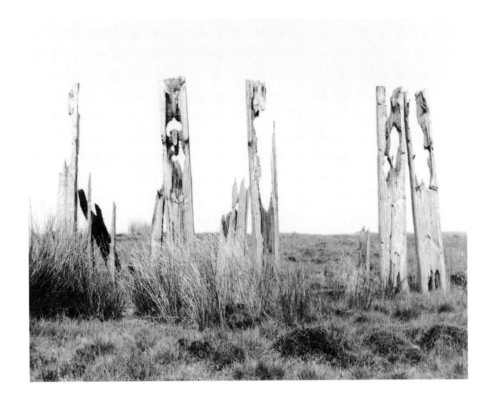

SNOW BARRIERS

On a recent foray to the north of England to run an RPS workshop my friend and colleague Leigh Preston took me to see the remains of some barriers which had been erected to keep drifting snow off of a railway line. They were made of railway sleepers that had been embedded into the ground and stretched for hundreds of yards. 50 years of wind, rain and snow had weathered them into these remarkable natural sculptures. Palladium print on Cranes Parchment.

five minutes in each, agitating every minute or so. These are rotated and replaced after two or three prints have been through the first bath. Replace the exhausted first bath with fresh clearing agent and use it as the third bath, moving the original second and third bath to first and second respectively. Remember that when you make up an acid solution from concentrated acids, always add the acid to the water and never the water to the acid.

If you don't like the thought of using hydrochloric acid, and some say that it can actually damage and etch the print, particularly a palladium print, then a modern safer alternative is to use either di-sodium or tetra-sodium EDTA (Ethylene Diamine Tetraacetic Acid). Tetra-sodium EDTA is cheaper and seems to work as well. However, if you shop around laboratory suppliers you will find di-sodium EDTA at a quarter of the price of some photographic suppliers. A 5% w/v (weight per volume) solution is used in exactly the same way as above. EDTA is also longer lasting and a litre of solution should clear about 20 10 in x 8 in prints or the equivalent before it needs replacing. Be very careful when using dry powders. They are easily dispersed and should not be inhaled. The last batch of EDTA I made reinforced the point. I had a tiny cut on my finger and though I took great care, the powder somehow caused a terrible

irritation. I'll use a plaster beforehand next time. After clearing, simply wash and dry as normal.

A CONTEMPORARY PROCESS

To some the traditional process outlined above will always be the only way to work, but I feel that any advances or modern developments should be considered on their merits. Certainly contemporary exponents of platinum printing have made use of recent technological developments to increase both the ease and control of the printing process. Firstly the process itself has been redefined by Mike Ware and his developments are in common use. Secondly, and maybe more unexpectedly, the use of digital imaging and the incorporation of digitally produced negatives is adding an exciting new dimension to the fine tuning of image production.

The use of ferric (iron 111) oxalate is key to the traditional platinum print. The trouble with ferric oxalate has been one of supply and purity. Though the answer to this is to make it from raw materials, many people do not want to be bothered. However an alternative can be found. In the contemporary process, ammonium iron (111) oxalate is used. This is fairly easy to buy in a pure form.

Making test-strips and developing out the image has been replaced in the contemporary process by using a printing out process which is dependent upon a pre-humidification process. There is also a self-masking effect which means that a wide range of negative density can be used.

By combining platinum and palladium salts in various ratios, a fair degree of contrast control can be achieved. In reality, I rarely use platinum by itself, preferring to combine platinum and palladium solutions, or at times use palladium solely. This is partly for reasons of cost, but I find that palladium is more forgiving with the type of papers that can be used. I can also use palladium immediately without waiting an hour for the mixture to mature.

PREPARING THE SENSITISER

Preparation of the sensitiser, coating and processing can all occur under subdued tungsten light. The sensitiser is composed of an equal volume of iron solution with an equal volume of either platinum, palladium or mixed solution.

SOLUTION A

The iron solution.

The iron solution contains ammonium iron (111) oxalate and can be made up in one of two ways:

(i) The easy way

> Ammonium iron (111)
> oxalate trihydrate 30g
> Distilled water to make 50ml

Dissolve the crystals in about 30ml distilled water at about 50°C and make up to 50ml with the rest of the distilled water.

(ii) Alternative process

> Iron (111) nitrate
> nonahydrate 30g
> Ammonium oxalate
> monohydrate 30g
> Distilled water to make 50ml

Warm the iron (111) nitrate crystals in a small glass container. This is best achieved by warming in a bath of hot water. The crystals will melt to form a clear red liquid. Grind the ammonium oxalate to a fine powder and add gradually to the melted iron nitrate with constant stirring. Keep the mixture warm over the water bath (about 50°C). Eventually you should finish up with a clear green solution which can be made up to 50ml with distilled water. As water is present in the original chemicals (being in a hydrated form) this will probably only require 12-15ml of water.

SOLUTION B

The platinum solution.

> Ammonium
> tetrachloroplatinate 5g
> Distilled water to make 20ml

Dissolve the crystals in about 15ml of distilled water at room temperature. The crystals will come pre-weighed in a glass vial, so it makes sense to rinse out with the rest of the distilled water to make up the 20ml. This solution should be kept in the dark and allowed to stand for 24 hours before use.

SOLUTION C

The palladium solution.

> Ammonium
> tetrachloropalladate (11) 5g
> Distilled water to make 25ml

To make a platinum print: mix an equal volume of A and B. Allow the mixture to mature for one hour before use.

To make a palladium print: mix equal volumes of A and C. This can be used immediately.

To make a platinum / palladium print: B and C are combined in any ratio and the combined volume mixed with an equal volume of A. Again allow to mature before use. A good starting point is to use a 1:3 ratio between platinum and palladium.

COATING

The rod method is most economical and recommended. Allow the paper to air dry for the first few minutes until the surface sheen has disappeared and then use a warm hairdryer to complete the job. When drying the surface of the paper beware of any crystal formation which can be seen by holding the paper at an angle. Crystals can damage your negative. With this method of printing I would always recommend using thin Mylar film between the negative and the coated paper. Coated paper should not be kept too long before use. If it is to be kept it should be put in a light tight pack with silica gel to keep it dry. If moisture is allowed near the paper, chemical fogging will occur over time.

HUMIDIFYING

This is the key to success and, to an extent, control over the final image. The image will only be formed in the presence of water. In the traditional process, this occurred during development. For a print out image to be formed, the level of moisture in the sensitised paper is critical. The level of moisture is measured as

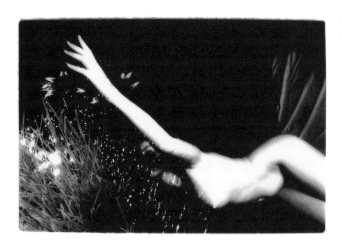

This was an image that was produced by multiple exposure in camera. The model was photographed against a black background in the studio on Kodak 35mm infrared film. The film was then rewound and images of water and rivers were then superimposed on the figure. The Palladium print right, on Cranes Parchment holds full detail in the skin tones.

Relative Humidity (RH). This will affect the colour, density, speed and contrast of the printed out image. In general terms the lower the RH the warmer the image. A higher RH value produces a more neutral image and allows for a greater degree of printing out and therefore greater density of the image. About 50-80% RH gives best results. The easiest way to control R.H. is to use two large developing trays, one inverted on top of the other to form a humidifying tank. In the lower tray place about a centimetre depth of water to provide humidity. I then use a rack (removed from an old fridge) supported on four film spirals in the lower tray. The sensitised paper can then be laid face up on the rack and covered with the second tray to form a lid. Using water will provide 100% humidity, but by timing between 20-30 minutes, a lower RH will be achieved. To be totally accurate, saturated solutions can be substituted instead of water. Saturated ammonium chloride provides an RH of 80% at 20°C. Calcium nitrate tetrahydrate provides an RH of 55%. A word of caution. Water vapour can condense on to the underside of the lid and drip back down on to the surface of the sensitised paper causing marks on the print so be careful when lifting the lid and wipe it regularly with a cloth.

EXPOSURE

Sunlight or UVA tubes are used in conjunction with a split back frame. As this is a print out process, you should expose to the level of detail that you require, paying particular attention to highlight details. Palladium prints tend to print out faster than platinum.

PROCESSING

Processing occurs at room temperature in trays. It is largely a matter of clearing the prints of residual iron salts and again Disodium EDTA is used. To speed up the process, Kodak Hypo Clearing Agent can be used as an intermediate bath. The sequence is as follows:

1. Disodium EDTA (5% w/v solution)		5 minutes
2. Wash in gently running water		30 seconds
3. Kodak Hypo Clearing Agent (working strength)		15 minutes
4. Rinse in water		30 seconds
5. Disodium EDTA (5% w/v solution)		15 minutes
6. Wash in running water		30-60 minutes

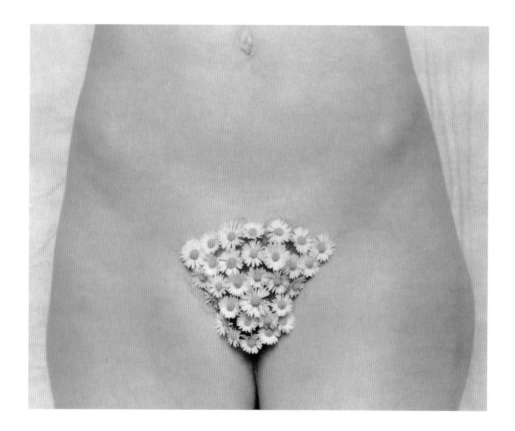

DAISIES

*This is a Pd/Pt print 3:1
on Cranes Parchment.*

The first EDTA solution will become yellow as prints are passed through it and after about twenty 10 in x 8 in prints have been through a litre of solution it will be exhausted. You can then replace it with the second EDTA bath and make up a fresh one to replace bath two.

If you are making a pure platinum print, particularly at low RH levels the print out may not be complete and therefore you may have to resort to the traditional potassium oxalate developer. It may also help to expose the print to water vapour from a tray of water at about 40°C for two minutes before wet processing.

After the final wash, drain prints, being careful not to touch the surface, and allow them to air dry. Prints are easy to retouch using good quality watercolour pigments. To display your work you should make a matte from archival mounting board – ivory, white or cream looks best. Framing under glass is probably inevitable, but will unfortunately detract from the surface quality. If possible I would leave out the glass.

The platinum print was often used in conjunction with other processes particularly gum bichromate. This can be used to add subtle colour, increase contrast or mask unwanted detail. Of course, a printing register system must be used if this is to be considered.

Platinum / palladium is not the ideal medium for every image, but it has a unique quality which combines subtlety with archival longevity. Ideal for that heirloom to be.

The Gum Bichromate Process

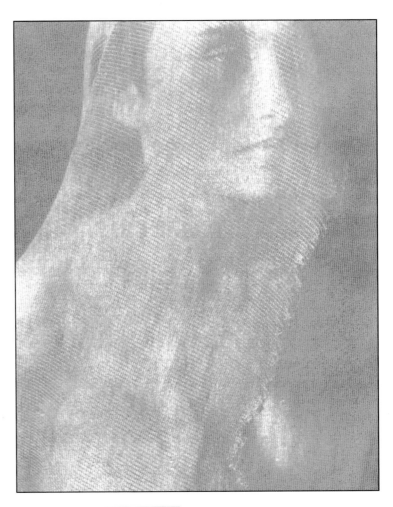

My taste in photography is fairly eclectic, but I have to admit to greatly admiring the so-called Photo Secessionists, formed by Alfred Stieglitz in the early part of the 20th century. Though the styles of work produced by this group went through many changes, finally moving from Pictorial to Modernism, the notion that photographic prints could be treated as a serious art form with aesthetic value, led to the production of some of the most beautiful pictorial imagery produced in photographic history. Stieglitz showed not only contemporary photography in his 291 gallery, but introduced artists such as Picasso, Rodin, Cezanne and Matisse to the American public. This attitude of putting photography, painting and sculpture on a par did not please some people and similar attitudes exist today. The early work of many of the Photo Secessionists involved interpreting their negatives by using techniques which had 'painterly' qualities. One such technique was the gum bichromate process. The works of Edward Steichen, Robert Demachy and Gertrude Kasebier are classic examples of this beautiful process.

WHAT IS A GUM BICHROMATE?

Also known as gum dichromate or simply gum prints, the technique is a non silver process in which watercolour pigments held in gum arabic are used to make a positive photographic image from contact printing with a photographic negative. The sensitiser which makes this possible is usually potassium or ammonium dichromate. This is mixed with gum arabic and a water-soluble pigment. When dry this is exposed to daylight or another source of UV light in contact with an object or photographic negative. The action of light is to harden the gum in direct proportion to its exposure, thus making it insoluble and holding on to the pigment. Development is in water which washes away the still soluble unexposed areas of the image and the final print consists purely of the pigments used, in the same way as a watercolour painting.

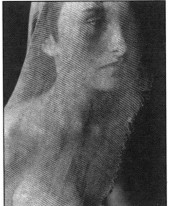

JOSEPHINE

This is a single coat gum print using Alizarin crimson watercolour pigment applied with a foam brush and burnished with a soft Hake brush. The print was developed by leaving it face down in water for 30 minutes and no brush work was added.

*Weighing chemicals on
a simple balance.*

The development of the bichromate process was initiated by the work of Scottish photographer Mongo Ponton who discovered that paper coated in potassium dichromate was sensitive to light. Later in 1852 Fox Talbot showed that gum arabic and gelatin became insoluble when mixed with potassium dichromate and then exposed to light. In 1855 Alphonse Louis Poitevin added pigments to the colloid and dichromate mixture, starting with carbon black and inventing the carbon process. The gum process was not widely used, however, as it could not resolve fine detail or give good tonal separation. Also, the development of the carbon transfer process gave far superior results. It was not really until the 1890s that the gum process was seized upon by the Pictorialists for the very qualities that had been its earlier faults. The French photographer Robert Demachy was probably the most influential in this field, using the painterly qualities of the process to marvellous effect. He was not without his critics, however, especially Emerson who was most derogatory about the "French and English amateurs whose process merely used photography as a basis for after hand work of a most fumbling or bungling description". Echoes of this negative thinking continue today in arguments between the 'isms' of the photographic world. After having experienced both success and failure in the process myself I can sympathise with the French photographer Marc Bruhat who stated that "gum printing is the least reliable trick there is".

The appearance of a gum print can vary enormously depending upon the technique used. It is individual to the photographer who can interpret a negative in may different ways, which is its great appeal. Selection of pigment/s determines colour/s. The method of washing will determine how much detail is revealed and can be selective. The use of brushes will impart typical brush marks to the image. It can also be used in conjunction with other processes such as platinum and cyanotype.

PAPERS

The gum process requires a paper which is dimensionally stable, has a neutral pH and has been well sized, usually with a gelatin size. Etching papers or good quality watercolour papers can all be used, but generally will need extra sizing. Use the front surface of the paper as this is smoother and less liable to mottling . It can be recognised by looking for the watermark. When read correctly you have the front of the paper. It helps at this stage to make a small pencil mark on the back. The size will prevent the paper from staining in the highlights during coating. As we shall see, multiple printing requires accurate registration. As papers tend to expand when they are wet and shrink as they dry (up to 15%), the paper must also be preshrunk. My method to achieve both of these ends is to soak the paper in a tray of hot water for about 30 minutes and allow the paper to dry. Make up your gelatin size solution by soaking 30g of gelatin in 1 litre of cold water for 15 minutes, and then gradually raise the temperature, stirring until it is dissolved. Adding the gelatin directly to hot water can just result in a lumpy solution. Then soak your paper in the gelatin solution for about 15 minutes. You can also soak in a 2% formaldehyde solution which acts as a hardener. As formaldehyde is rather toxic and carcinogenic I would suggest using Glyoxal instead.

The paper is then drained and hung up to dry again. You can of course size a number of sheets of paper at the same time, just ensure that you regularly rotate sheets from top to bottom and beware of any air bubbles on their surfaces. Harden for about ten minutes preferably outside if formaldehyde is used as it is rather nasty stuff and should not be inhaled. Apart from preventing staining, sizing also increases the sensitivity of the process.

HARDENING BATH	GLYOXAL HARDENING BATH
Formaldehyde	15-25 ml of 40% glyoxal
25 ml of 37% formaldehyde	Water to 1 litre
solution in 1 litre of water	Half a teaspoon of
	bicarbonate of soda

EMULSION BINDER

Gum arabic or acacia gum is the traditional material used. Fish glues, starch, albumen and even mucilage have been used. Ready-mixed gum arabic can be purchased (Lithographer's gum arabic), but I prefer to make it up from powdered gum arabic. This is a rather slow and laborious process, so must be done well in advance (try to allow a couple of days if possible). Always dissolve in cold water, as hot water changes its chemical composition and reduces its solubility. Gum can be affected by bacterial and fungal growths during storage, so some preservative is recommended. Either 37% formaldehyde or 2.5% mercuric chloride can be used. These are both very nasty substances so keep them locked away from children and use them with care.

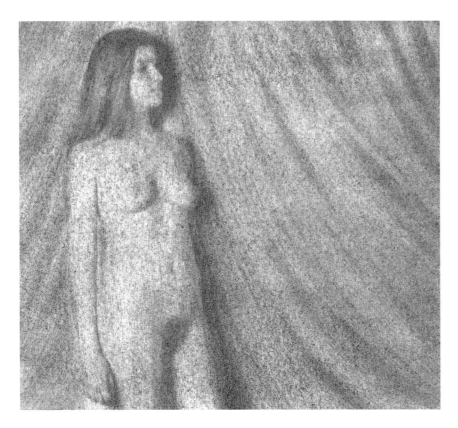

ALICIA

This was a single coat gum print using a mixture of gouache lampblack and watercolour pigment Alizarin crimson. This was applied with a cotton wool ball and the print developed for ten minutes in still water. Then the print was carefully brushed to create a curtain effect in the background.

GUM SOLUTION

Though the dissolving takes some time, the gum should keep for many years without deterioration.

> **GUM SOLUTION**
> 300 g powdered gum arabic
> 2.5 g mercuric chloride
> (or 15 ml of 37% formaldehyde solution)
> 100 ml cold water

PIGMENTS

Any water soluble paint can be used. Oil based or casein paints will not work properly. Transparent watercolour pigments are usually used, and to achieve the best results use good quality pigments such as those produced by Winsor and Newton. However, if you wish to experiment and are not concerned with archival quality, any water soluble pigment such as food dyes or extracts from plants can be used (these may stain the paper). If you use normal watercolours, pigment is sold either in tube or powder form. Initially tube pigments are easier to use but powder is more economical. In order that you achieve repeatable results it is important to measure the amount of pigment used accurately.

Gouache can be used to give solid colours and is good to start with in the initial stages where you are learning with single printing techniques. The make-up of certain pigments makes them chemically incompatible with the sensitiser, but a good selection to start with would be:

> lamp black or ivory black
> alizarin crimson
> monastral or winsor (thalo) blue
> cadmium yellow
>
> burnt and raw sienna
> burnt and raw umber
> zinc white

With tube pigments I use empty plastic 35 mm film canisters which hold about 30 ml of pigment solution. Place one on each pan of your balance and simply squeeze the required amount of pigment directly into the canister.

I would recommend starting with about 5 g of pigment made up to 30 ml with gum solution. As pigments will vary, some experimentation with amounts will be required. If you measure correctly and keep simple records in a workbook, you won't go wrong. Mix the pigment and gum well before use. Use a soft round brush to mix and do not try to make up too large a volume in one go. It is also worthwhile keeping some of the mixed gum / pigment if you need to spot your prints afterwards.

MULTIPLE COATING

In this print a single coat of gum with Alizarin crimson was exposed and water developed for 30 minutes. The print was then dried and half of it was given a second coat of gum / pigment. After exposure this was again water developed. The second coating has produced a denser colour and increased detail in the highlight areas.

RC PAPER PRINT

One problem with gum printing can be preventing the pigments from staining the paper and not washing out in the highlights. It is worth experimenting with different papers and alternative surfaces. This is a print produced on the reverse side of a piece of resin-coated photographic paper. Being plastic coated, the pigment did not stain the paper and washed out of the highlight areas leaving a white base. This was a two-coat print using a brush part way through development.

SENSITISER

The sensitiser used is either potassium or ammonium dichromate.

Ammonium dichromate 27 g Water 100 ml Potassium dichromate 13 g Water 100 ml	Dissolve in warm water about 50°C to form a saturated solution at about 20°C.

You now have stock solutions of gum pigment and sensitiser. To use them you simply mix equal quantities as required. Do not mix too much, however, as the sensitised solution will harden with time, even if kept in the dark. This is a good starting point, but you can alter the ratio of gum/pigment to sensitiser. If you add gum, it will increase contrast, more sensitiser and it will lower contrast.

COATING THE EMULSION

The emulsion can be coated in weak tungsten light. The emulsion becomes more sensitive as it dries, so should really be dried in the dark or if using a cool hairdryer in safelight conditions.

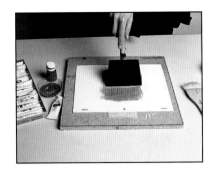

Using a foam brush to apply the gum/pigment to the paper.

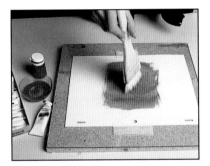

Burnishing the gum/pigment with a Hake brush.

There are many methods of coating, all of which will affect the end result. Whichever method you choose you should initially aim for an even coat which is neither too thick or too thin. The coat must be thin enough for light to penetrate the highlights and mid tones. If the emulsion is too thick you will lose highlight detail and get blocked shadows.

BRUSH COATING

Two brushes will be needed, a spreader and a blender. Use flat artists' brushes of good quality. An oil-painting brush (hog bristle) for spreading the emulsion and a watercolour brush (squirrel or ox hair) for blending. Mark out the area on your paper to be coated and reasonably quickly use both vertical and horizontal strokes to spread the emulsion. Then use a dry blender brush immediately to form a smooth coating and remove excess emulsion. Remember to wash your brushes before they dry out.

Foam brushes and applicators work well. Slightly dampen a foam brush and dip it into the emulsion. Holding the brush almost vertically, paint onto the surface fairly rapidly.

As soon as the surface is coated use a dry Jaiban brush to smooth the surface by flicking across it in all directions. This will produce a burnished appearance. The trick is not to put too much emulsion on at a time, you only need barely enough to cover the surface.

Cotton wool balls can be used as an alternative. This produces an even coat, but care has to be taken with stray fibres sticking in the emulsion. Glass rods and air brushes can be used as spreaders but a separate blender is needed. Dry Jaiban or Hake brushes are ideal.

If the paper is coated correctly it should air dry in about 15 minutes, or you can use a cool flow of air from a hairdryer or fan. Be careful when applying heat as this can fog the print. The paper should be used as soon as it is dry. Storing for longer than 24 hours will produce inconsistent results due to the dark reaction which starts to harden the emulsion.

EXPOSURE

Daylight, photofloods or UV lamps can be used. The emulsion is relatively sensitive and fairly short exposures are needed (30 seconds to five minutes) but this will have to be determined by test. Different batches of gum arabic may have different speeds. You can use a hinged printing frame or simply a piece of glass on a board. Unlike other alternative processes it is difficult to gauge the exposure before development because of the masking effect of the pigments. The exposure will also vary due to the pigment density used and again a little experimentation with different densities and colours is advised. An image may be seen depending upon the pigment being used, but it is not a good guide to exposure. This is a contact process which uses negatives of normal density and continuous tone, though you can experiment with half tone or high contrast copy negatives, or use objects as in photograms.

DEVELOPMENT

The action of light on the emulsion is to cause hardening in direct proportion to exposure and thus affect solubility in water. Water is the only developer required and the exposed paper is usually left face down in a still tray of water for about 30 minutes. Make sure that there is plenty of water in the tray to prevent it touching the bottom. Look at the print occasionally to make sure there are no air bells. This should produce a print containing a good range of tones and shadow and highlight detail. However, the clearing of the image can be assisted by using flowing water, jets of water and brushes. These can also be applied selectively to different areas of the image. These treatments will produce characteristic markings within the image which is an attraction to many people. The use of a brush will depend on the size and hardness of the brush and whether it is used with the print still under the water (softer effect) or partially dried (more pronounced effect). Demachy used glycerin on the print surface to soften the effects of his brush strokes.

When development is complete the print is air dried as normal.

CLEARING

After drying, the print may contain some residual chrome salts. These will cause a yellow staining which will harm the print with time. The print must therefore be 'stabilised' or 'cleared'. Potassium metabisulphate is usually used. Presoak your print in water (or do this directly after development). Then soak in a 1% solution of potassium metabisulphate until all yellow staining disappears. Two minutes is usually sufficient.

Your first attempts should produce acceptable results, especially if you use gouache, but you will soon find that a single print is just the starting point. To achieve the best from your negative and your imagination you need to consider multiple printing.

MULTIPLE PRINTING

Though a satisfactory print can be made in a single step, it is likely that you will have to consider a multiple print to get the best out of your negative. One problem with a single print especially when using transparent watercolours is that the density of the image can be relatively weak. To build up a reasonable density and tonal range, multiple printing is the only answer. Another feature of the process is the ability to use a variety of tones or colours over all or part of the image. This obviously necessitates the build up of the image in layers. Many artists have made use of combining the gum print with other techniques such as cyanotype or platinum. Edward Steichen was a prime example especially in his landscape work.

REGISTRATION

To produce a multiple print it is essential that the image is printed in register at every stage. The first consideration is the paper. Presoaking is essential to prevent changes in the dimensions of the paper during alternating wet and dry processes. Registration ensures that the negative is placed in exactly the same position on the paper at each step. Registration can be achieved in a number of ways. A cheap, simple, but not always precise, method is simply to mark the corners of the negative on the paper base, or measure the position of the edges of the negative and realign each time. Also if the original image is still visible through the second coat, the negative can be aligned on a light-box and simply taped. The light from the box will not be strong enough to fog the image during a relatively short exposure. A more accurate method is pin registration. The simplest way to do this is to position your negative on your paper, over a cork mat. A pin can then be pushed into the rebate of the negative in the top or bottom left corner, through the paper and into the cork. This can then be repeated with a second pin in the top or bottom right corner. Use the pins

Placing sensitised paper in the back of a register hinged-back printing out frame.

to re-register at each stage and then fix with tape and remove the pins for printing. Your eyesight needs to be pretty good for this as it can sometimes be difficult to see the pinholes in the paper.

Some printing frames come fitted with registration pins or self adhesive registration pins can be bought. Animation supply companies such as Chromacolour specialise in these. Ask for Acme Peg Bars and self adhesive registration header strips. These are usually placed at the top edge of then frame, out of the margin covered by the glass.

To use these it is usually necessary to attach a registration header strip, or a piece of acetate to the top edge of the negative and punch holes in the acetate to overlay the pins.

You can also make a home made version by using two small pieces of doweling set on the board of your frame, the same width as a normal hole punch.

BORDER MASKING

Many workers in alternative processes like to show the technique they are using by leaving the evidence in the form of the rough edges produced during the hand coating technique. Though this can add to the appeal of an image, at times it can be a distraction. Of course, over matting conceals the evidence or you can trim your prints, but crisp edges to your image can easily be produced by masking at the exposure stage. There are various masking materials that can be used, but ruby lith film is probably the most

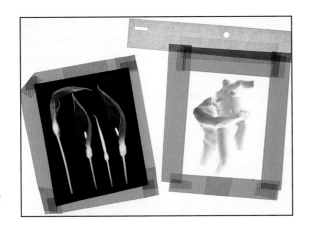

Ruby lith masking film taped to the edges of the negatives to produce a clean-edged print.

convenient. With care and a sharp scalpel you can take a single sheet and cut out a rectangular aperture which can be taped over the negative. Alternatively, single strips can be taped to each edge separately.

Obviously, the width of the film must be sufficient to cover the total area of the sensitised emulsion. The same masks can be used for other processes and are particularly useful for platinum / palladium printing.

MULTIPLE PRINTING TO ACHIEVE CONTRAST

A normal negative at its first printing will usually produce a soft image which lacks density. By recoating and re-exposing exactly as the first time, you will achieve greater depth and contrast. This process can be repeated as many times as required to achieve the desired effect. In most cases the tonal range of the negative will be too great to achieve a satisfactory print with a single coating, and recoating and re-exposing can be tailored to achieve the desired effect. The commonest technique is to recoat in the same way each time, but to reduce exposure times for subsequent exposures. Try halving the exposure time for each stage e.g. first exposure four minutes, second exposure two minutes, third exposure one minute.

TONE SEPARATION

An extension of the process is achieved by using different amounts of pigment at each coating, again halve the amount for each coating and reduce exposure at each stage. This effectively gives you an exposure for shadow, mid-tone and highlight areas akin to a tone separation technique.

By now it should be becoming obvious that there is an almost infinite variety of coating and re-exposing techniques. Here are a few more:

USE OF COLOUR

By coating with different watercolours, the addition of one translucent tone on top of another can produce very subtle colour variations. Start with warmer strong colours and modify these by printing cooler transparent colours on top. You can be selective about the areas to be coloured and only paint on emulsion in these areas. By carefully using your brush during development you can reveal more or less of the underlying colour as desired. When an image is produced, a subsequent coating can be exposed through the back of the paper, thus the image becomes its own negative.

It is possible to produce a full colour gum bichromate, approximating to a normal colour image by using a tri-colour technique. This involves making separation negatives for highlight, mid tone and shadow detail and printing successively with Yellow (cadmium yellow), cyan (Windsor blue) and magenta (Alizarin crimson).

COMBINING TECHNIQUES

By using gum printing in combination with other techniques such as cyanotype, platinum or even modern silver gelatin, the individual characteristics of each process can combine to produce some unique effects. Again the combinations are endless, but the clarity and tonal range of a platinum print can be wonderfully modified by successive gum printing to add both colour and slight softness. If you want to use contemporary images and materials, the gum process can be used with photocopies or solvent transfer where the image from a magazine is transferred by moistening with white spirit and rubbing onto a receptive surface. Gum can also be used with care on other surfaces such as plastic, canvas, wood etc.

As multiple printing of the same image is possible (and usually necessary), it is fairly obvious that one can use two or more negatives to produce a combination print. Just remember that you need to consider areas of corresponding light and dark tone for each image to show clearly. This is an excellent way to incorporate some text into your work.

Though the gum bichromate is linked mainly to early traditional pictorial images it is worth looking at it with a contemporary eye so once you have got to grips with the basic process don't be afraid to use and abuse them. If it works it's right.

GUM ON PALLADIUM

A light toned palladium print was first made on Cranes Parchment using a Kodak register frame. Two coats of gum / pigment (Winsor blue and burnt sienna) were then used to add colour to the image. I would normally mask off the edges but by leaving them here, you can see the pigments used.

Above: multiple gum prints with brush development.

Left: Print from original negative.

Chapter Twelve

Hand Tinting

Toning and tinting monochrome images has become very popular over recent years. I suspect this is largely because some photographers wish to introduce into their work a 'handicraft' quality, which digital imaging threatens to eradicate. Also there is a great deal of personal satisfaction in being able to determine which colours you want in your photograph and where to place them. By tinting your photos, not only can you control which colours you use, but you can also determine their intensity. No doubt many photographers have envied the artist's absolute freedom in these matters and yet as photographers it is possible to wrest some of this freedom for ourselves. Whilst hand colouring is often seen as a 'traditional' technique, it was still being practised until relatively recently, and even today there are numerous advertising photographers who still opt to work in this way. It has not escaped their attention that hand-tinting is very useful way of emphasising a particular product; as creative photographers, we should be encouraged to think in a similar way and aim to lead the viewers eye in the direction we wish it to go.

Some of you may question why I have automatically linked 'tinting' to 'toning' and rightly question why one should tone an image before one begins to add colour. The answer is, of course, that it depends on what it is that you are trying to achieve. From an aesthetic standpoint, added colour within a purely black-and white image can look a little artificial, but this might well be the author's aimed intention. I personally prefer either a warm-toned, or a cold toned base to work my colour from, which usually means using either a sepia, copper or blue toner, although as other equally reliable toners are now becoming available, one's options are greatly increased. There is also the alternative of splitting the image into both warm and cold tones by split-toning.

Applying Marshall oils to print. It is important that you work in your larger areas first.

PRE-VISUALISING WORK TO BE TONED AND TINTED

It is important to pre-visualise an image you wish to tone and tint, which is when the role of filters becomes so important. No doubt all serious monochrome workers are aware that yellow, orange and red filters darken skies in varying degrees, but perhaps have not appreciated that these same filters have the capacity to lighten colours of a similar hue. That is to say, a red filter will lighten any red areas of the picture whilst a yellow filter will lighten areas of yellow. This principle will apply to any coloured filter; once you have appreciated this, you are able to control the outcome of your tinting. For example, if you photographed a red car, in monochrome terms it will come out dark in your print, and will not be a suitable subject for colouring. By using a red filter, you automatically lighten the car, which then becomes far more receptive to tinting .

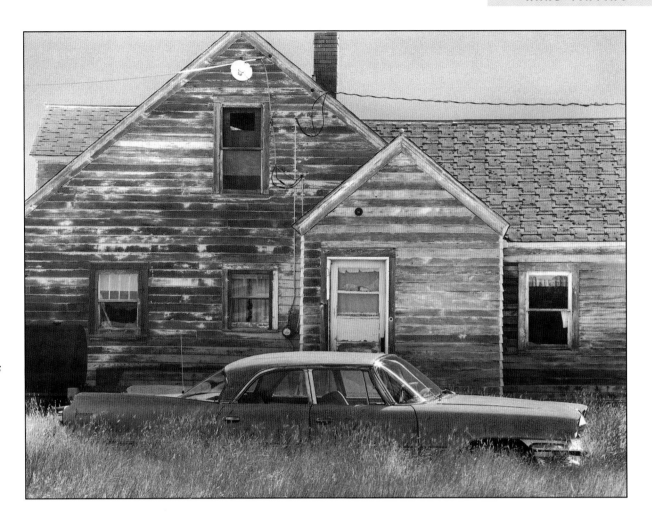

PIONEER IN MADOC

This is a classic situation where using photo-oil pencils is far more convenient than any other medium; the problem is created by the grasses on the side of the car. It would have been particularly difficult to have used photo-oils, without the colour of the car bleeding into the overlapping grasses, whilst air-brushing could only be done after some very difficult and time-consuming masking.

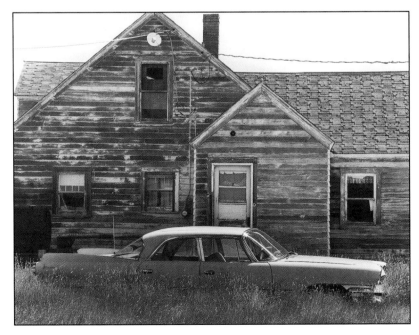

PREPARATION

It is essential that any print you wish to hand-tint is sufficiently light in tone. If the elements you wish to tint are too dark, the tone can overwhelm the colour. Controlling this through the use of filters is one method, but it can also be tackled at the printing stage, and after. If we consider our same 'red car', even having used a filter, it comes out looking too dark, then we can lighten it by holding it back during the printing. If that is not sufficient, it is possible to bleach the print by using either 'Farmers reducer' or iodine. This can be done generally or locally. Finally, you may wish to sepia-tone your print prior to tinting; this process will automatically lighten all your tones, especially your mid-tones and highlights. Try to keep a balance; whilst it is desirable to lighten your tones in certain 'crucial' areas, try not to eradicate all highlight detail completely, otherwise the introduced colour can sometimes look artificial and overwhelming. The aim is to tint photographic detail, not a bald area of paper.

PORTUGUESE FACADE

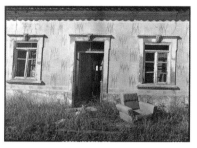

Above: This has been done using photo-oil pencils. Larger areas can prove difficult, but can be achieved by using the side of the pencil. This image was initially sepia-toned whilst the door and the window shutters were selectively toned with copper.

Left: Interesting, but lacking in photographic 'charisma'.

Right: Sometimes it is useful to take an endprint shot, which you can refer to if you wish to retain the authenticity of some of the colours.

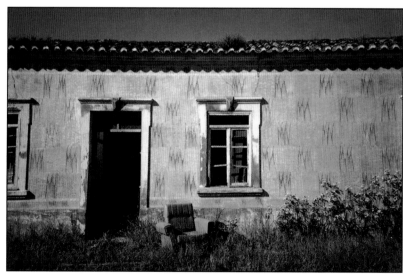

SPEEDGLAZE

Above: It is important to keep your original black-and-white print reasonably light, otherwise the darker tones can overwhelm your attempts to put in colour.

Left: Because the colour oils clean so very easily, it really is possible to work in very fine detail, without too great a reliance on skill. Only the small areas of rust were applied using the oil pencils. This is often far more effectively done after the colour oils have completely dried, which can take up to a week.

WORKING FROM END PRINTS

Whilst the purpose of tinting photographs is to liberate the photographer from the colours of the real world, there are nevertheless occasions when you might wish to faithfully record the colours in part of your print. Unless you have an extraordinary good memory, one solution is to take a snap-shot at the same time as the taking of your negative; I keep a compact camera loaded with colour negative film specifically for this purpose.

CHOOSING A MEDIUM

Hand-tinting can be achieved with virtually any colouring medium, which is almost a subject for a book in itself, so perhaps it is wiser just to confine ourselves to four of the most popular methods: Marshall oils, photographic dyes, watercolour and gouache.

MARSHALL OILS

Whilst you can obtain very acceptable results from using standard artists' oil paints, Marshall's oil colours are designed specifically for hand-colouring photographs and have certain distinct advantages. They also come in two forms, either in tubes, or as pencil crayons.

The oil colour tubes come in kit form, ranging from an introductory kit which comes with a limited number of colours to a Master Oil Set which is a very comprehensive package indeed; but irrespective of which kit you opt for, they all work on the same set of principles.

PISCES NO. 1 – FISH ON SAW

One of the main advantages of photo-oils is the translucency of its colours, which allows all the subtle photographic detail to show through. It is important to maintain the highlights and to work purposefully from the darker to the lighter areas. To increase the density of your colour, work in more layers.

All the kits come with tubes of colour which can be applied directly, or can be mixed.

All come with a solution of Prepared Medium Solution (PMS), which can be used for all kinds of tasks, although its primary aim is to clean the print before the application of the paint.

Most of the kits come with Marlene, which is used to clean up the print after the application of paint, and Extender, which is used to thin, and therefore lighten the pigment. However, if you do not have either of these two substances, the PMS will do the trick. Kits also come with little wooden skewers (looking very similar to blunt toothpicks) which one wraps cotton wool around, and serves as a colour applicator.

SUITABLE PHOTOGRAPHIC PAPERS FOR MARSHALL OILS

Most papers are suitable, although some are more suited than others. It can work on glossy papers, but it is difficult to establish any real depth of colour unless the paper has been pre-treated with Marshall's Pre-Color Spray. It seems to work far better on a pearl or matt surface, as the surface texture of these papers seems to 'grip' the pigment more effectively. They can also be used on art papers such as Kentmere's Art Classic and Art Document, but the technique does greatly exaggerate the textured surface of these papers. You can also, if you wish, apply them to standard colour photographs, but once again the results are far better on a non-glossy surface. It works well on both RC and FB papers.

COTTON-WRAPPED SKEWERS.

All the application of colour is done using various pieces of cotton wool, and certain skills need to be acquired. The larger areas are coloured with wads of cotton wool, however the detailed areas are done using cotton-wrapped skewers, or cotton-wrapped toothpicks. To make a wad, just twist the cotton wool into a rope, bend it in the middle and hold the ends together. To make a cotton-tipped skewer, moisten the end of the skewer and bend a

PISCES NO. 2

When using photo-oils, apply your colour fearlessly, as any overpainting can be easily cleaned up at a later stage. It is important to try and maintain your highlights if you wish to add depth to your work.

HOW TO WRAP A SKEWER

STEP 1 Tear off a wisp of cotton about 2½in long and ¾in wide. Split this so that it is not too thick. Shape it by drawing it between the fingers so that in general the fibres are parallel. Lay this on the left index finger. Then moisten the tip of the skewer with the lips to make the cotton adhere and place the skewer on the cotton.

STEP 2 Bend the end of the cotton over the skewer with the left thumb.

STEP 3 Roll the cotton and the skewer part way with the left thumb and finger.

STEP 4 Fold the cotton down over the point of the skewer and hold it there with the left thumb.

STEP 5 Now squeeze the cotton with the left finger and thumb, and with the right hand turn the skewer, at the same time pushing the skewer upward to make the spiral wrap.

STEP 6 Keep on with this spiral motion and the cotton-covered tip emerges further.

STEP 7 Continue until the last remains of the cotton are wrapped on the skewer. Now you are ready to start colouring.

piece of cotton wool over the end. Then remove the skewer with your right hand and guide the cotton over the end with the left. You can repeat this process several times in order to build up the thickness of the wad. You can also use cotton buds, which you can easily twist the cotton wool around. Finally, if you find using skewers just too much of a hassle, you should be able to twist small pieces of cotton wool into useful applicators.

WORKING SURFACE

Some care needs to be given to this part of the process, as carelessness can quite easily ruin a good print. Your working surface needs to be very smooth and clear of all grit and debris otherwise you could well damage your print when working in the colour. A sturdy sheet of glass, a flat piece of marble or a clean sheet of melamine would make an excellent working surface. Attach your print to your working surface with masking tape. If you have been working up to the edges, you will find that when you take the tape off an excess of colour has built up. This can be

FACADE AT ROCK SPRINGS

This is a good example where a judicious use of colour can transform an otherwise sepia print into a colour print. All tinted areas were coloured with photo-oils and were applied with cotton buds and small swabs of cotton wool. The very gentle, faded colours suggest the faded glory of this once busy commercial hotel.

removed, with care, using a cotton bud. Another alternative, if you do not wish to attach your work to a working surface but need to keep your edges clean, is to mask your edges with a removable sheet of paper or thin card. Butt the paper up to the edge of your print but make sure that when you apply the photo-oils you are not working against the paper. In these situations always work from the edge inwards.

APPLYING THE COLOUR

Squirt a small amount of colour either directly onto your cotton wad, or onto your 'palette' (an old dish or saucer will do). Then apply the colour in a firm circular fashion as evenly as possible showing no regard for the edges. This is important because you cannot establish the evenness you require unless you are prepared

Presented as a straight monochrome, this is just too 'matter of fact'.

MANGO, STARFRUIT, GUAVA, MELON

In common with all skills, it is important that we start with something easy.
Try using your photographic oils on simple organic shapes such as leaves or fruit.
Whilst as individual images these can look rather unexciting, they do greatly improve
when grouped together, which is something we can easily do in photography.

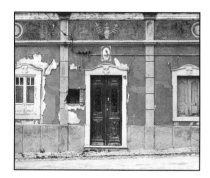

PORTUGUESE FACADE

What caught my eye, when taking this shot was the wonderful quality of texture in this facade. However, some of this is lost when printed as a monochrome.

By selectively hand-colouring the richness of the texture can be dramatically emphasised. This has also been coloured using oil-pencils; normally such expansive areas are far better covered using photo-oils, but in this instance it was important to retain the whiteness of the peeling wall. Using photo-oils would have required either masking the whites, or cleaning them out at a later stage. Faced with these two options, I decided that pencils provided the best alternative. Whilst photo-oils work well on most photographic surfaces, oil-pencils seem only to work on matt papers.

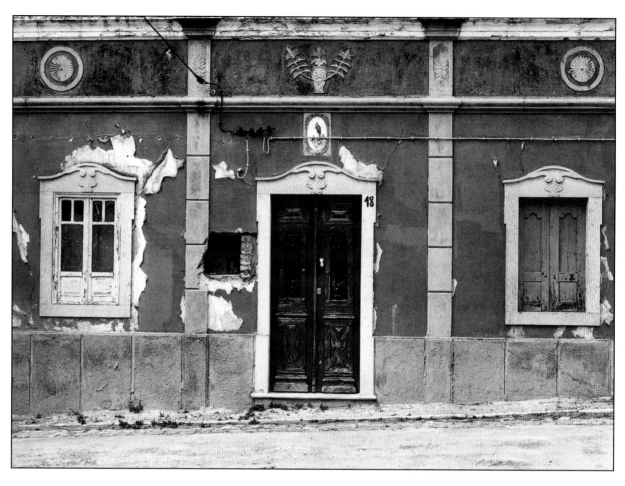

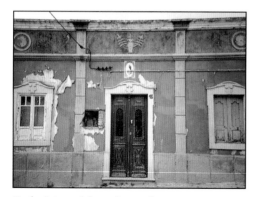

Endprint used for colour reference.

to work over the margins (going over the line is just not a problem with this particular medium, which is why it is so suited to hand-colouring). Once you have coated the area you wish to cover, gently buff-the surface with clean cotton wads, but take care not to remove all the colour; this is especially problematic with glossy papers. Always work your large areas first and make sure that each area is rubbed down before going on to the next. As you move into other areas, and begin to apply different colours you will quickly appreciate why you are able to work 'over the line'; as you apply the second colour, it neutralises the first without mixing with it; the one exception is yellow over blue. If you do experience a problem, just carefully clean up the edges with PMS. When you are mixing colours for large areas, make sure that you have sufficient mixed, as matching the colour might prove to be difficult later on. The working time is at least 24 hours, so you have plenty of time to play around. However, the drying time can take up to a week (depending on heat and humidity), so you will need to have a secure area where you can leave your print whilst it dries.

THE ALTAR

This strange little still life was discovered in a deserted property in Portugal. I suspect that it had been arranged by somebody previous to my visit, but judging by the undisturbed layers of dust, it clearly was a long time ago. Glancing briefly, the symmetry of the design reminded me of an altar. Whilst most of the colour has been created by sepia-toning the print, the specified areas of colour have been applied using oil-pencils. This is an ideal sort of subject for oil-pencils as the areas requiring attention are localised, but detailed.

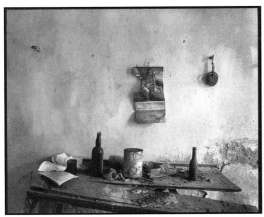

As a monochromatic image this does look rather uninteresting. However, once colour has been added, it appears transformed.

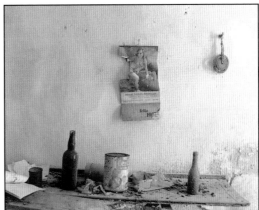

Endprint used for colour reference.

127

STILL LIFE IN BOXES

Print positively to ensure detail throughout.

CONTROLLING THE TONE OF COLOUR

Controlling the tone of your print is as important as controlling the colour and this can be easily done. To increase the density of your colour, work in more layers. If you want to lighten your tone carefully rub out your colours until you have got what you are after. A useful exercise is to find a spherical object in one of your prints, such as a ball, apple or orange, and to apply colour, but to leave a highlight in some appropriate part of the object.

Remember, the gradation up to the highlight should be a very gentle one. You can also use the 'extender' to lighten your colour, and if you have none, then try using PMS, although do not put your cotton wad directly into it, as it will remove all your colour from your print. Finally, whilst working in the colour gives you great control over the final appearance of your print, it is important that you have a regard for the highlights that appear naturally in your print, and that you do not obscure them, otherwise your final image could appear just a little too flat.

If at the end you are unsatisfied with your results, and wish to start again, you can easily wipe out all the colour with the Marlene, providing they have not dried.

COLOUR PENCILS

Some photographers are put off by the bold approach required of the photo-oils, and opt instead for photo oil pencils. Each approach has its strengths. Working with pencils is excellent for detail, although you can work in larger areas as well. Always begin by cleaning the area with PMS, but make sure that any remaining residue is soaked up with cotton wool. Whilst the PMS is still damp on the print, apply the colour, using more or less pressure depending on the tone you require. For larger areas use the side of the pencil; it does not matter if you do not get a perfectly even finish, because you can smooth the colour out with a wad of cotton wool slightly dampened with PMS. For more detailed areas, use the point of the pencil. Mixing the colours is easy; just over-lay one colour over the other. Even if you have only a restricted range of colours, it is relatively easy to mix the others.

For example, if you have red and yellow, they mix to make orange. Red and blue make purple; yellow and blue make green.

Thereafter, you should be able to mix up any other colour you require. These coloured pencils look like any others and can be sharpened as normal. If you are using them for the first time, try a

If you are inexperienced at hand-tinting, large regular areas can prove to be especially demanding. You are less likely to hit difficulties with smaller, organic shapes and forms.

PISCES NO. 3; FISH AND CALLIPERS

Setting up still lifes can be very enjoyable, but they can also be thought-provoking. As a youngster I would often play with my dad's callipers, and imagine that they were the open jaws of some imaginary fish. This is precisely the idea in this bizarre study. Photographic dyes are a very accessible medium, as they are easy to use, and can be bought from most photographic stores.

**PISCES NO 4;
FISH AND CLIPS**

My attention was initially drawn to the clip-boards, as they offered a strange rhythm which suggested various analogies such as moving water, slanting rain, etc, and opened the opportunity for a surrealistic interpretation. When applying the dyes, use soft watercolour brushes, as they are ideally suited to putting on the colour in a smooth and seamless way.

relatively small area at first, such as a plant or flower stem. It is a skill that needs to be mastered, but it is easily learned, and can give great pleasure. Unlike photo-oils, they are very difficult to use on glossy papers (especially RC papers), but work extremely well on matt. It is important that you resist the temptation to press hard in order to strengthen the colour, as you can easily indent the surface of the paper.

Having used both methods, I think that the best results are often to be gained by using the photo-oils to fill in the large areas, and the pencils for more of the detailed work.

USING WATER-BASED PHOTOGRAPHIC DYES

Using water-based photographic dyes is another extremely useful way of tinting images as they have a delicacy and luminosity which make them the ideal choice for certain subjects. They are translucent, but can be mixed to produce virtually any colour. They dry quite quickly, and the intensity of the colour is built up over a succession of layers. The applied colour does not just lie on the surface of the paper, but is capable of staining the gelatin layer of the print resulting in a durable and heightened finish, but without obscuring the photographic detail. They are available from most good photographic stores.

WHAT EQUIPMENT DO I NEED?

❶ Photographic dyes in kit-form. This usually comprises a box with a variety of colours and a bottle of reducing agent, which facilitates even colour application.

❷ A range of soft brushes, ideally watercolour brushes as they seem most capable of absorbing and applying the water-based dyes. Try to get a range of brushes between 00 and 8.

❸ A small watercolour type mixing palette, although a clean plate can do equally as well.

❹ Blotting paper.

PREPARING THE PRINT

It is a good idea to soak your print in clean warm water for up to 15 minutes before starting work, ideally with a few drops of wetting agent in it. Place your wet print on a clean smooth working surface. Using the blotting paper, soak up the excess water, but do not try to completely dry your print as the colour goes onto a damp surface far more smoothly.

Black & White print.

Sepia toned print.

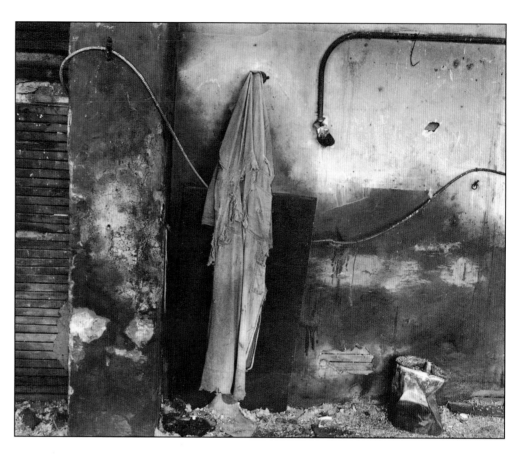

ABANDONED GARAGE AND OVERALLS.

I intended to sepia tone this image, so it was important that I printed about 10% darker than normal. I have chosen Kentmere Art Document paper, which has a surface texture akin to water-colour paper. It is, however, susceptible to over-toning, so great care needs to be taken at this stage. Art Document paper is thin and is prone to cockle, therefore it was necessary to stretch the paper. It is important to work the larger areas first, when the paper is still damp, and concentrate on the smaller detail as the paper dries.

Whilst much of what we have discussed so far relates to technique, as we move on to hand-tinting we are talking about skill. In common with most skills, this needs to be developed and practised; but once mastered, it does open up all sorts of creative opportunities.

It is important when starting not to become too ambitious, perhaps restricting yourself to hand-colouring just a small element of the picture. It is usually a good idea to start with your lighter colours first, and slowly progress to the darker ones. Even though your print is still damp, it is a good idea to dilute your dye with reducing agent, as this facilitates a light and even application of the colours.

Colour intensity is built up by successive layers, but in common with other hand tinting methods it is important to maintain the highlights to avoid the print looking 'flat'. When starting tinting for

the first time, try experimenting with organic forms such as leaves and rocks, as they can often prove less demanding than man-made forms.

It is often tempting to use all the available colours, but this can often lead to an unsatisfying result; try and restrict yourself to three or four colours, and only introduce further colours if there seems to be no alternative. Wads of cotton wool can prove to be particularly useful for tinting in 'soft' areas such as trees and clouds, but beware, as this method of application can leave unwanted textured marks.

WATERCOLOUR AND GOUACHE PAINTS

This is a method which is particularly demanding of skill. Experience of painting watercolours is most certainly helpful, although not essential. This technique is very similar to working with photographic dyes, but it does differ in several ways:

❶ This process works far better on art based photographic papers such as Kentmere Art Classic and Document Art. It is also ideal for hand-made photographic papers, i.e. liquid photographic emulsions on watercolour paper.

Black & White print.

Split toned print.

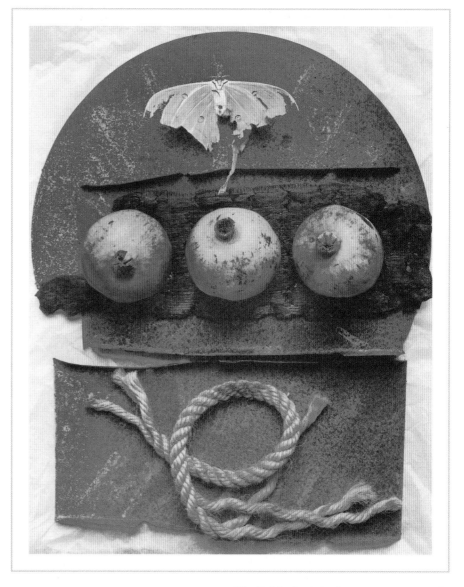

The finished print, also appears on page 2.

STILL LIFE WITH THREE POMEGRANATES

I initially printed this image considerably darker than normal, as the subsequent split-toning process, firstly in sepia and then in copper noticeably lightens the tones. I have printed this onto Kentmere's Art Classic paper which not only provides the right textural surface for gouache or water-colour, but also split-tones particularly well. When using either gouache or watercolour, it is important to work in a disciplined way and carefully gradate your tones from dark to light. It is essential that you are aware of where your highlights should be and that you work your colours up to them without a sudden break. If you find that you have accidentally gone over some of your highlight detail, this can be remedied in two ways;

1) By 'lifting' the colour out. You can achieve this by placing a drop or two of clean water over the area you wish to lift. Work the area carefully with a small brush in order to remove any colour and then soak it up with a paper towel. This will create a natural highlight often revealing just a vestige of the original colour.

2) By painting in an opaque white; the effect is immediate, although unless it is carried out with great care, it can look rather obvious.

2 After soaking, it is a good idea to tape your paper onto a clean drawing board, or other flat surface, and incline your board at about 30°. Work your large areas by loading your brush, and applying the colour in broad horizontal sweeps starting at the top. The sloping board will encourage the pigment to seep downwards. Continue in this fashion until you have reached the bottom; this method ensures an even wash. Continue to repeat this process until you get the correct intensity of colour you require.

3 To work smaller areas, less saturated colours are required, but once again, work from the top downwards. In order to avoid smudging your work, rest your hand on a small piece of card, to protect the photograph's surface. Do not be afraid if one colour slightly bleeds into another; this is part of the watercolour idiom and can lend a certain charm to the work.

4 Highlights are created by not being painted, so work towards your lighter areas with great care. If you work over them, they can be lifted; carefully 'paint' the required highlight with water, and then mop it up with a very small piece of tissue paper. If this is done carefully, you will remove the colour and thus create a highlight. If you are using gouache, you can paint the highlights back in with the white.

CHAPTER THIRTEEN

Printing Out Papers

Not until I saw the original prints that Lee Friedlander had produced from the large negatives of E.J.Bellocq did I discover probably the oldest photographic product still on the market. The Bellocq prints were contact printed onto printing out paper (POP) and there was a quality which was quite unique. Another attractive feature was that it was a process which was free from the darkroom. It allowed me to produce prints whilst sitting in the sun enjoying a cool glass of Chardonnay and time for contemplation.

Printing out paper as its name suggests, produces a direct image by exposure to daylight and does not involve any development process. Initially, photographers used albumenised papers which they sensitised as required. By contact printing in daylight the image would gradually appear and was then usually toned in gold chloride, fixed and washed. This produced a print with a rich chestnut colour which could not be matched by later silver bromide papers. During the 1880s albumen papers were gradually superseded by collodion chloride and gelatin chloride printing out papers. Collodion papers were often called 'aristotype' and the term POP was used for gelatin chloride papers as a trade name by Ilford in 1891, but later became a generic term. The late 19th century saw a boom in American and European companies producing printing out papers. A variety of surfaces and colours – matte, glossy, pink, white or mauve tinted bases – could be purchased. However, as photographers gradually shifted to enlarging papers, the use of POP gradually declined until in 1987 Eastman Kodak ceased the manufacture of the last POP. However, the demise of POP was short lived and within a year it was being manufactured once again by the French company R. Guilleminot, Boespflug & Cie and POP is available to this day known as 'Berger' paper. An alternative is a Kentmere product which goes under the name of Centennial 'POP' Paper.

The use of POP by many studios was in the manufacture of 'studio proofs' which were unfixed and therefore not stable. Though this

This is an original portrait taken by an unknown photographer in Skipton in the 1890s.

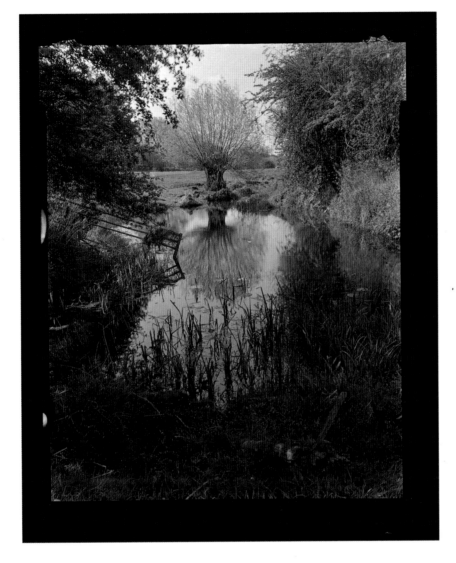

THE RIVER LEAM

A tranquil rural scene of my local river which caused devastation to property and loss of life in the floods of 1998. Appearances can be deceptive.

was practised until relatively recently, it is to deny the true potential of this type of paper. An interest in the history of photography and the contemporary printing of older negatives and plates must be allied to the use of materials which were originally designed to produce the prints. Many glass plates have an extended tonal range that cannot be satisfactorily reproduced on modern papers. Also, though toning processes can get close to the original colours of POP it is not the same as the real thing. Therefore, for archive and aesthetic purposes, the use of POP (and other alternative processes) is essential to recreate the true spirit of the original.

This is not to deny the use of the material in a contemporary context. The unique nature and subtlety of the process have been used to great effect by the American photographer Linda Connor, whose large format soft focus images rely on POPs to produce a range of colours within the print. By combining a large format camera (10 in x 8 in Century), long soft focus portrait lens and Kodak POP she has produced a range of beautiful still life images. The colours range from red to purple to green depending on the exposure to sunlight and the exhaustion of the gold chloride toner.

EXPOSURE

POPs are made with a high level of silver nitrate and were initially successful because their characteristics and appearance were very similar to the original albumen papers. Because of the high level of silver nitrate, old papers may suffer slightly from mottling effects, so it is best to keep them in the fridge or the freezer until ready to use. I have an unopened pack of Seltona collodion self-toning paper containing gold. I doubt that it is still usable, but it would be almost sacrilege to open it. As with other contact processes it is

Interesting domestic still lifes by Warren Wood ARCA c. 1945 which show an artist's eye for form and design.

best to use a split backed frame so that the negative can be held in register as the image is checked periodically as it prints out. Depending upon the density of the negative, an exposure of between five minutes in full sun (for a normally exposed negative) to several days in winter light (in the case of Linda Connor who produces extremely dense negatives), will be necessary. UV light-boxes can be used as an alternative, but exposure to natural sunshine is far more pleasurable. Processing will tend to lighten the image, so a denser image must be aimed for at the exposure stage. As exposure increases the paper will change from white to pink to maroon to reddish brown to olive green.

PROCESSING

Processing is achieved by washing in water for about five minutes and fixing for about ten minutes in a 15% plain hypo solution. This will yield a very warm chestnut image. Normally, gold toning is used between the wash and the fix. This lessens the amount of bleaching by the fix and changes the colour of the image. The effect is determined by strength and timing of the toning bath, but generally produces a cooler image – violet black or purple grey, with a degree of split between cool and warm shades. As the toner is depleted with use, warmer browns or oranges may result. After fixing in plain hypo, you would then wash and air dry as for a normal fibre-based paper.

*POPs are ideal for making prints
from old glass negatives. These were
all printed from original negatives
on Berger POP.*

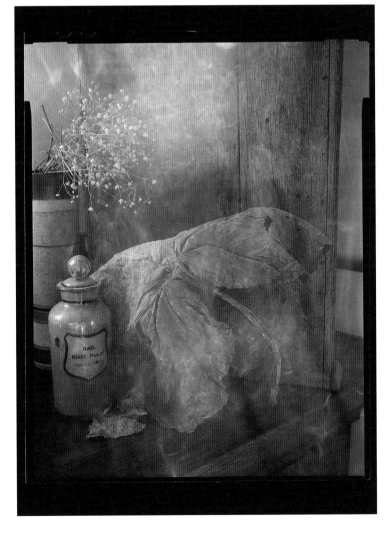

*A timeless still life. The jar of
medicinal powder is an extract from
the rhubarb leaf which also appears
in the picture. This is from a
5 in x 4 in negative taken at a
workshop at Peter Goldfield's
Duckspool residence.*

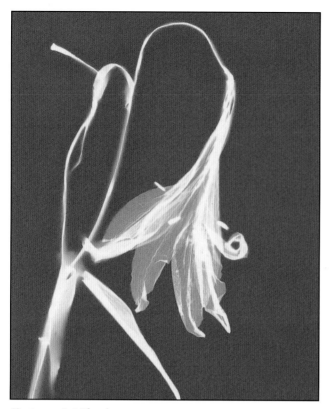

Kentmere Art Classic

Ilford MG FB Warmtone

Kentmere Kentona

Kodak Elite

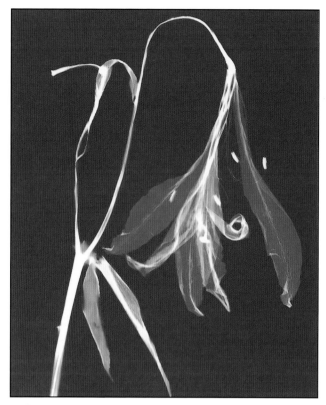

Ilford MG 4 RC

Agfa Record Rapid III

The prints opposite and above are all Photograms produced by laying a dried specimen of a lily on normal photographic paper and exposing to bright sunlight for up to 30 minutes. The coloration produced is a consequence of the paper used.

USE OF MODERN PAPERS FOR PRINTING OUT

Though modern RC and FB papers have been designed for brief exposures and subsequent chemical development, anyone who has accidentally left a sheet of paper out in the darkroom will know of the change in colour which occurs on exposure to light. Subsequent fixing often removes this coloration, but if the exposure is prolonged enough, some of the original colours are retained. By experimenting with a variety of papers a whole range of colours and tones can be produced. This is particularly effective when making photograms. Objects displaying different densities are placed in contact with the paper and exposed to light. An exposure of 30 minutes in bright sunshine may be needed to produce a variety of tones. Again the print needs to look quite dark before fixation (no development is used), as the image will lighten appreciably during fixation. Some examples of the difference that can be achieved by using the same subject with different papers are shown here. Kentmere Art Classic produces beautiful lilac tones whilst Ilford MG FB Warmtone induces a rich magenta coloration. Agfa Record Rapid has a subtle sepia tone whilst Kentona has a mixture of purple and gold.

Of course, the images produced can subsequently be toned, particularly in selenium, which cools the tones considerably. However, the tones produced in the printing out process are beautiful in their own right and are not generally improved by other toning. This technique is particularly suited to natural objects such as leaves and flowers, particularly if they are well dried first, but can be used for a combination of objects, e.g. paper negatives, strips of 35mm negatives, old glass plates. Other photosensitive materials can also be used such as old photocopy paper, for example. In fact, it is an interesting way to experiment with all those old packets of paper you never got round to finishing or you find languishing in the bin-ends of your local photographic retailers.

CHAPTER FOURTEEN

Airbrushing

O f all the methods one might opt to use for hand-tinting, airbrushing most certainly demands the most skill, but once mastered the results can prove most rewarding. There are various 'brushes' on the market, but it is essential that you use one which allows you to adjust the nozzle to a very fine spray. All airbrushes need a source of compressed air in order to work, but I would strongly advise anyone entering into this not to use aerosols. They are expensive, and they have a tendency to freeze, often quite unpredictably. The best solution is to buy a compressor, however, a cheaper solution is to use an old car tyre, inflated to a pressure of 40 pounds per square inch. Some airbrush manufacturers sell compressor leads which can be attached. If you are new to airbrushing it is a good idea to do a few tests on a scrap of paper, so that you can get a measure of the density of the colour that can be achieved. Most newcomers over-spray, creating unrealistically deep colours.

MASKING

The key to using an airbrush is to mask those areas you do not want affected by the colour. This will invariably mean cutting several masks. For larger areas it is better to use a low tack masking film, which is known commercially as 'frisk'. It looks rather like heavy-duty cling-film which is rolled onto the surface of the print. You then need to carefully cut away the 'frisk' to expose the area you wish to spray. Ironically, you are far less likely to cut the surface of the print when using a new scalpel blade, as little pressure is required to score the film.

Masking fluid is far better for small or irregular areas. You simply brush it on and once it has set (normally only after a few minutes), you can airbrush the print in the normal way. Removing the mask is easy, although you do need to ensure that all applied colours are thoroughly dry; one tip I found useful was to remove the mask with a strip of sellotape. This way you avoid touching the print.

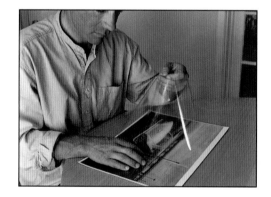

LAYING THE 'FRISK'

Measure and cut out a piece of 'Frisk' slightly larger than the area you wish to mask and carefully remove the backing paper. Working from one end, gently lower the 'frisk' onto the print. If you have trapped any air bubbles, peel it up and then reposition it.

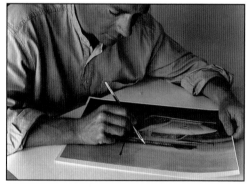

CUTTING THE MASK

Cut carefully around the area to be masked with a sharp scalpel blade. Press gently so as not to cut into the surface of the print.

REMOVING THE MASK

Gently peel away the area of mask where you want to spray. Take great care at this stage. It is so easy for a dangling piece of 'frisk' to drag across your print, with the obvious potential for damaging it.

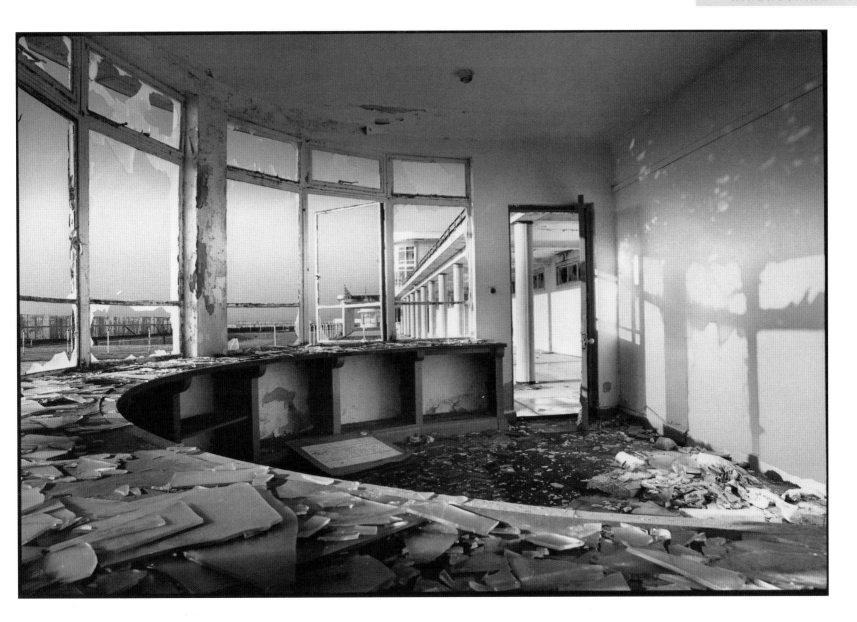

SHATTERED KIOSK

Whilst I naturally deplore the vandalism that has occurred here, I nevertheless admire the strange beauty it creates. But what especially caught my eye were the areas of light on the right-hand side of the interior, which echo the light passing through the broken glass. By using the toning and tinting technique, I feel that I am able to emphasis this. This image has been strongly bleached in a sepia solution, and blue-toned before airbrushing.

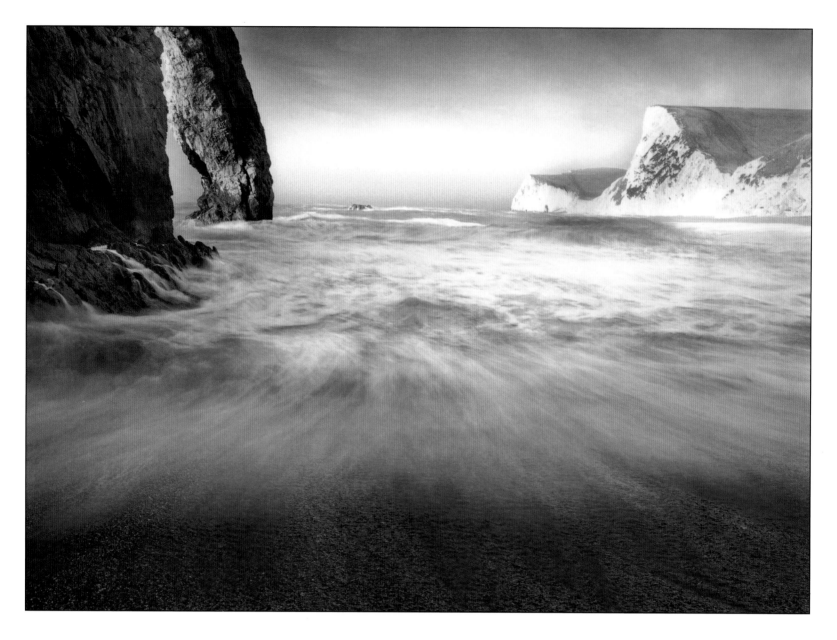

DURDLE DOOR

A winter shot of this famous Dorset location; I have chosen to use a slow shutter speed ($1/2$ second) in order to capture the force of the receding tide and its capacity to shape the land. The print was very briefly sepia bleached and then toned in a weak but fresh blue toner. The arch and cliffs were then masked, and the sky was carefully tinted by airbrush, with the magenta quietly bleeding into the yellow dye.

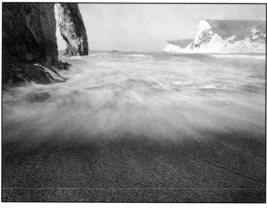

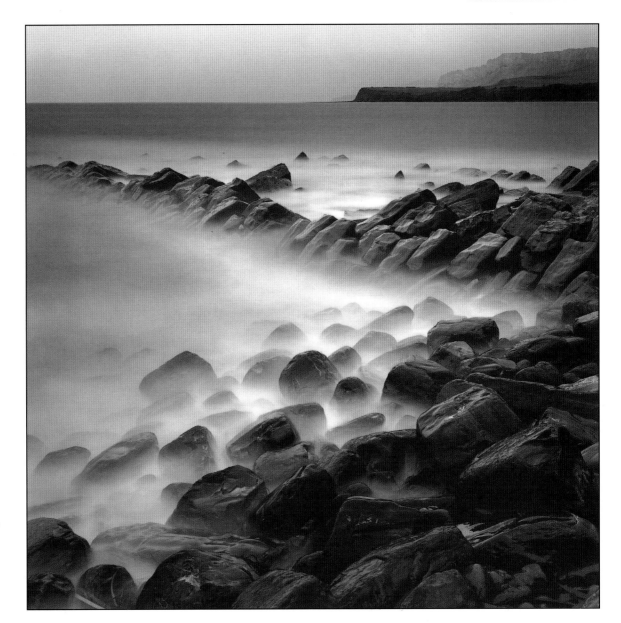

KIMMERIDGE AT DUSK

An even longer exposure was required to achieve this shot (40 seconds), hence the mist-like effect of the water. This print was also briefly sepia bleached; however, a jaded blue-toner solution was used in order to achieve this distinctive stoney blue. I regularly take colour photographic 'sketches' so that I can accurately simulate the colours of the sky. Printing in the bottom of the sky has proven helpful here, as it increases the sense of tonal perspective.

USING AN AIRBRUSH

There are two main types of airbrush, the single action and the double action. The single action is probably the easiest to use initially, as you simply pre-set the flow of the air and off you go.

If you opt for a double action airbrush, not only are you controlling the airflow, but the flow of colour as well. This demands a fair measure of dexterity, but if you wish to work small and intricate detail, a double action airbrush may well prove to be the best option. Using an airbrush may seem difficult at first, but as with all things, it does improve with practice. It is important to find out what your airbrush can do, therefore it is useful to devise certain basic exercises. Practise airbrushing horizontal lines, and then try varying its thickness. Try airbrushing simple shapes, initially aiming to achieve an even density of colour, and then progressing to a smooth gradation of colour. Finally, try vignetting your shapes, by increasing the density of the colour in the middle of the shape, but decreasing it towards the edges. Quickly you will gain important skills and confidence in your own abilities. Hand-tinting using an airbrush can prove to be especially rewarding not only because the results can be so visually stunning, but also because the mechanistic nature of the medium so closely parallels the natural grain of the print.

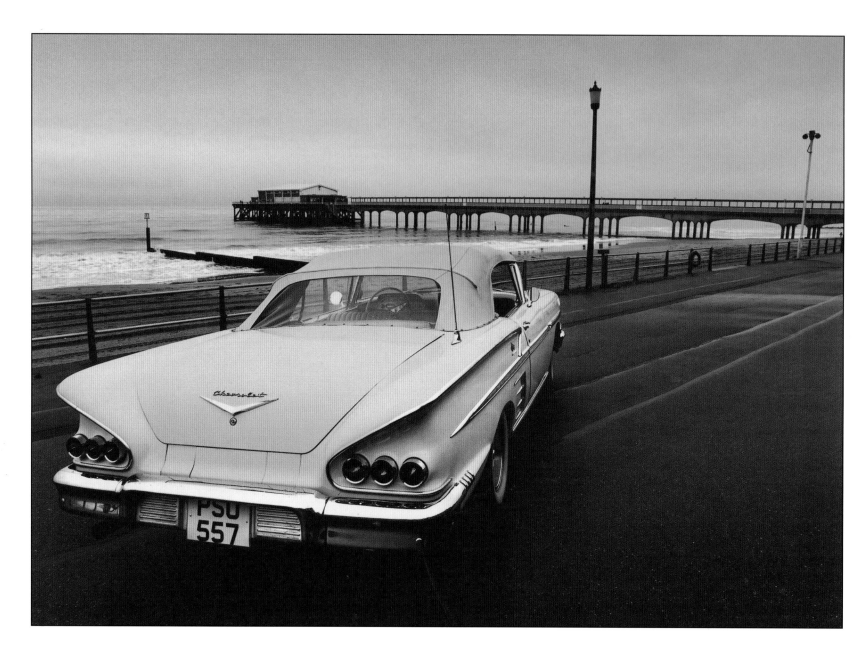

IMPALA ON BOSCOMBE PIER

This photograph was originally taken on a murky morning in January. Even when this image has been split-toned, it ceases to reflect the warmth of the final version. But the moment the blue is added to the sky and water, and colour is introduced into the car, the month appears to change from January to July.

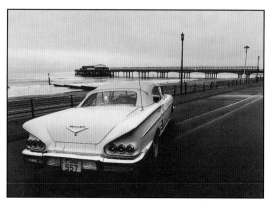

BRIGHTON'S WEST PIER

I have photographed this wreck of a pier on a number of occasions, and have always found a different element to feature. On this occasion, it was this little white kiosk which had been temporarily erected as a focus for donations. I found the mini-grandeur of this construction mockingly reflective of the old Victorian pier in the distance. I carefully cut a mask around the pier and kiosk, thus exposing the sky, and then airbrushed the warmer tones into the horizon. The colour in the pier and in windows of the kiosk were added by hand.

TOKEN

I used infrared film for this image, as the low clouds had completely blocked out the sun (infrared film has the capacity to cut through thin cloud). Having split-toned the image between sepia and blue, selected areas were tinted using an airbrush.

WHAT MEDIUM CAN I USE WITH AN AIRBRUSH?

This is an important consideration, because in theory at least, an airbrush should be able to take most colouring media which are in liquid form. It has been principally designed for the advertising industry, and with care you should be able to use watercolour paint, gouache, poster paint or oil paints. However, you do need to appreciate that all paints will be propelled through a very fine jet (not dissimilar to a jet in the carburettor of a car), therefore it is essential that if you are using artists paints, you ensure that the solution is sufficiently thinned to go through the system without blocking it. There is also the question of how opaque you want your medium to be; most certainly if you use oils or gouache then you are able to cover existing photographic detail. If, however, you wish to retain it all, then opting for dyes might be the best answer; there are a variety of alternatives which are sufficiently thinned and are unlikely to block the jets.

1 Food-dyes. The advantage is that they are very cheap, can be bought in virtually any supermarket and come in a variety of colours including red, yellow and blue (which are the 'primary' colours from which all other colours are mixed).

2 Photographic Dyes. Whilst these can be very easily applied by hand, they can equally be used through an airbrush. The kits come with a variety of colours, but this is an expensive process as most of the dye will be lost to the atmosphere. It is worth noting, however, that these dyes are permanent (which food-dyes are not), and if you intend selling your work, really you have little option but to use something like this.

3 Kodak E-6 Transparency Retouching Dyes. These come in three colours: yellow, magenta and cyan. The archival quality of these dyes is not in question, and in the long term may well prove to be the best medium to use, if only because it does not come in kit-form, so that you buy the colours as you need them.

There have been some interesting innovations within the manufacture of suitable inks and dyes which would work on the surface of a photograph, but undoubtedly the best of these are the Daler-Rowney FW Artists' Inks. This is an acrylic-based pigmented water-resistant ink, and virtually all the colours are permanent. The range of colours is very broad (up to 30), and there is a choice of opaque or transparent. Because the inks are pigment-based, they are strong and bold, but they can be diluted if required. These inks really do offer some very interesting creative possibilities.

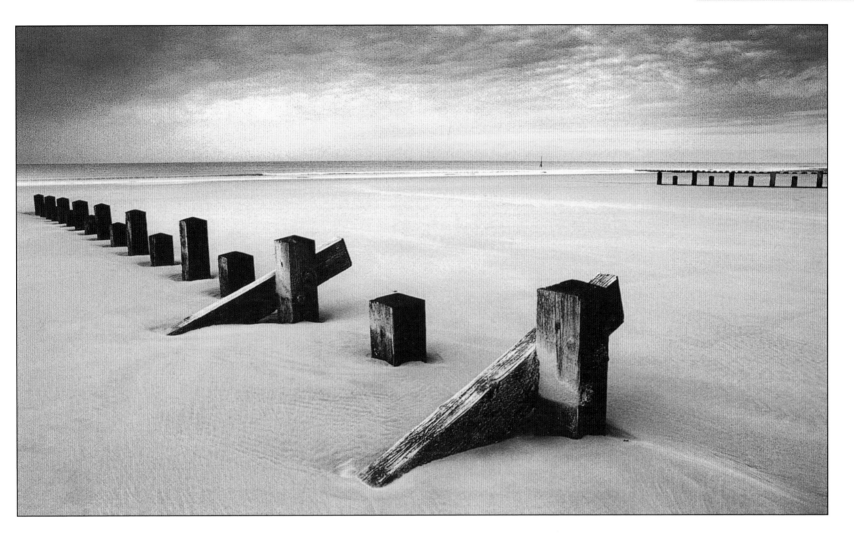

BEACH AT BARMOUTH

What initially attracted me to this scene was the absolutely flawless beach; not a mark or a piece of debris to be seen anywhere. The groynes take on the role of a piece of modern sculpture, whilst the sky adds to its drama. This photo has been split-toned, and the lower part of the sky has been briefly airbrushed. Because there is no interruption on the horizon, a straight piece of card served as a temporary mask.

MIXING COLOURS WHEN AIRBRUSHING

Unlike most other methods, airbrushing with photographic dyes requires that you mix your colour on the surface of the print, and not in a palette beforehand. So, if you require a green hue, you firstly spray on the yellow followed by the cyan. The precise green you require will be determined by the proportion of yellow to cyan. If you are unfamiliar with colour mixing, then you may need to refer to a 'colour wheel'. The big advantage of working in this way is that it does encourage subtle gradations which can make your colours extremely plausible. As your dyes virtually dry on contact, 'mixing' colours in this way should not pose any real difficulties.

Here are some of the 'dos' and 'don'ts' for those who are new to airbrushing.

1 Always try to work on a vertical surface; attach your print to a wall or some other suitable surface. If you are using masking fluid, give it sufficient time to dry.

2 Always start and finish your spraying off your work, otherwise you will see an unevenness in the spraying.

3 Build up your colours gradually, don't be in a rush to finish. Because the pigment is atomised, it usually dries very quickly, allowing layers to be built up fairly easily.

4 Avoid 'arcing'. The natural tendency of the arm is to move in an arc and thus the airbrush moves towards and away from the work. It is essential to try to always keep the flow of the arm parallel to the print.

5 When working large areas, avoid the temptation of localising the airbrush otherwise unwelcome 'hot-spots' will appear. It is essential that you keep the 'brush' moving.

6 Always wash the airbrush thoroughly, both between colours and after use. If your brush shows a tendency to splatter, it is probably because it is dirty, or because you have damaged the needle. If your airbrush has blocked up, remove the head and needle and let it soak in water and detergent for a short while.

7 Remove the 'frisk' with care; a hanging piece can so easily drag across your print with the irritating potential for ruining it.

Finally, as with all things, don't get carried away with the enjoyment of the process. The aesthetic appeal of the final image has to be the driving force; toning and tinting without regard to its suitability to the subject can often look misplaced.

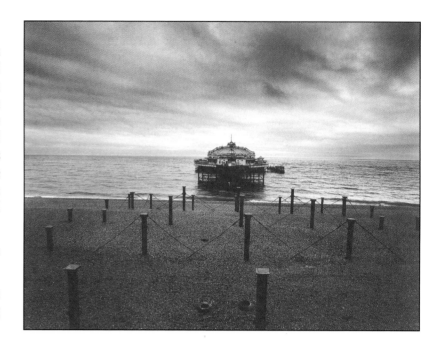

BRIGHTON WEST PIER

Top: As a straight monochrome image.

Above: Split-toned sepia and blue, but with a strong bias towards the blue only the sky has been tinted, yet despite this, the image assumes the quality of a 'colour' picture.

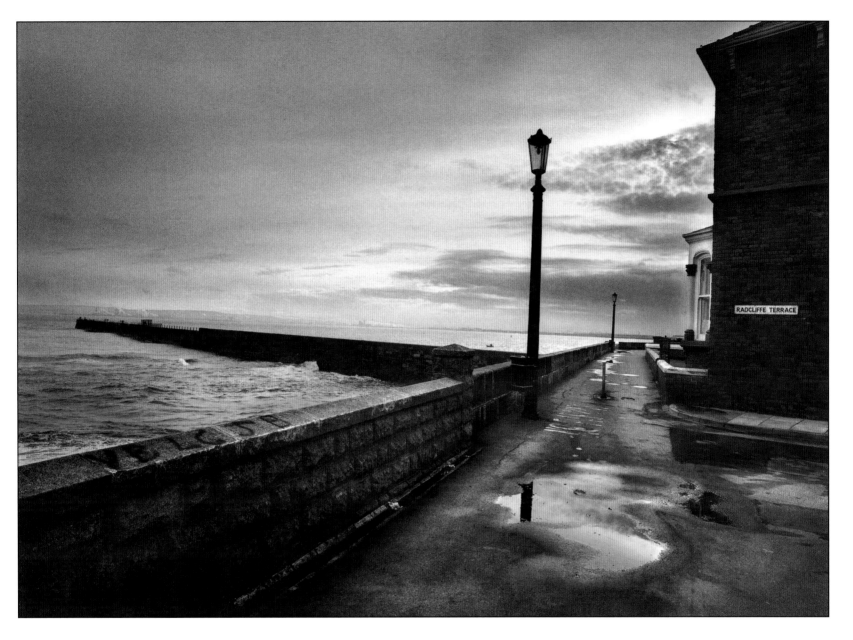

RADCLIFFE TERRACE

I took this cheerless shot one cold afternoon in November, and have used the toning and tinting techniques to emphasise the weak autumnal sunshine one gets at that time of the year. The bleakness of the scene is somewhat relieved by the presence of light coming from the house on the corner of Radcliffe Terrace. Once again, this image has been split-toned, the horizon has been airbrushed, whilst the light in the window has been added by hand.

CHAPTER FIFTEEN

Lith Printing

Whilst this process has the appearance of being a fairly traditional technique, it has only been understood and developed comparatively recently. Already it has attracted the attention of many printers in both the professional and amateur sector. The lith effect is created by heavily over-exposing the paper and then processing it in a very diluted lith developer solution. This technique is dependent on a process called 'infectious development' which causes the darker areas to develop faster, so pulling the print at precisely the right time becomes a critical part of the process. If the print is allowed to develop beyond this point, eventually all areas will become dark.

It can prove to be a fairly frustrating technique, as it is notoriously unforgiving of sloppy workmanship, but if you do have the patience to persevere you will be rewarded with aesthetically appealing images. Its main characteristic is the capacity to reveal powerful and punchy shadow detail alongside wonderfully delicate highlights; however, its real beauty emerges when you tone these images. In certain toners prints are transformed displaying a range of colours which belie their monochromatic beginnings.

SUITABLE PAPERS

The lith process only works on a limited range of papers, namely chlorobromide and bromochloride papers, which during the early stages of development are very fine-grained and are capable of producing very warm tones; the longer the paper is processed in developer, the darker and colder the tones become. Exploiting this characteristic is how the printer is able to control the lith process. The following papers are particularly suited to this technique:

❶ Kentmere Kentona. A chlorobromide paper available in both glossy and stipple, which gives a warm peach/pink when lithed.

❷ Kentmere Art Classic. A chlorobromide paper, which gives a very similar peachy/pink hue when lithed, but the rough matt texture has the appearance and feel of a watercolour paper.

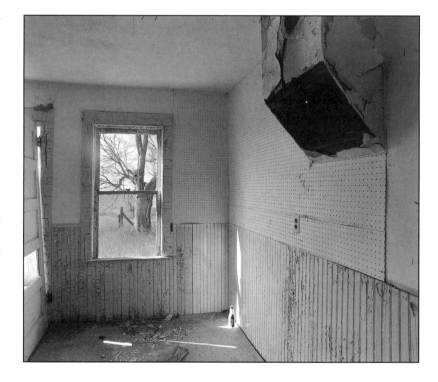

ILLUMINATED BOTTLE

An unlithed monochrome image of an interior.

❸ Fotospeed Tapestry. This is a very warm chlorobromide paper, which like the Art Classic has a distinctive 'fabric' texture.

❹ Fotospeed Premium F Lith. This is a purpose-made paper designed especially for lith printing, which has a very attractive caramel colour when lithed.

The characteristics of these papers vary both in terms of surface texture, and their reaction to the lith process. Discovering what each can do is part of the joy of this interesting process.

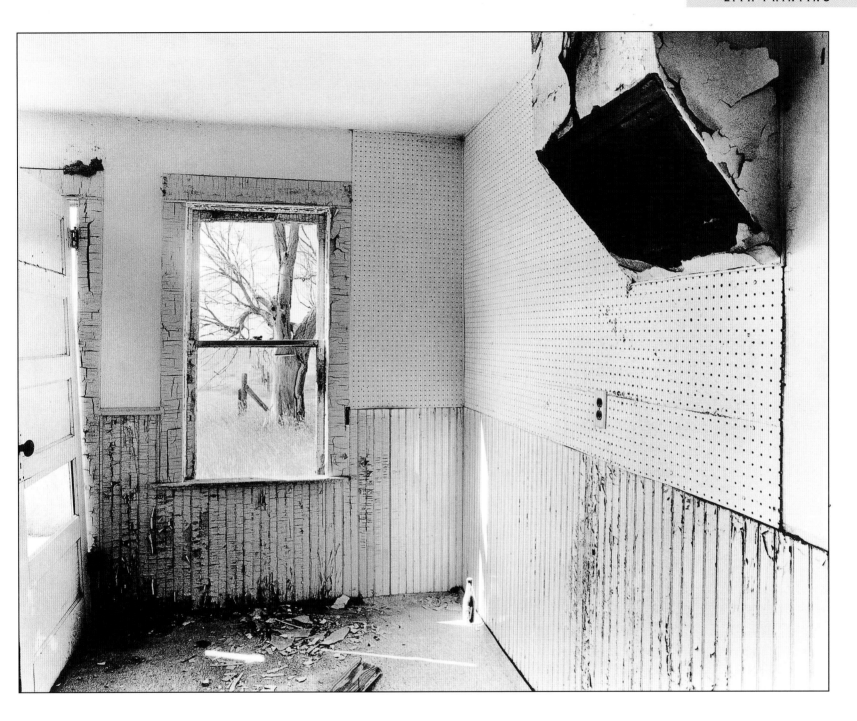

Lith printing can reveal some wonderfully exciting qualities, but when you begin to tone these, then truly remarkable transformations occur. This print was initially lith printed onto Kentmere Kentona paper and then toned in a weak solution of selenium; the changes can be quite dramatic.

MOSAIC CANYON

This is a 'typical' lith print revealing strong shadows and soft highlight detail. Printed on Sterling paper, it shows the characteristic biscuit colour of this paper when it has been processed in lith. As it closely parallels the original colour, there was no need to change it through toning. It was important to capture the rich and intricate texture of the rock, therefore the contrast was increased by reducing the exposure time.

THE LITH PRINTING PROCEDURE

As I have already suggested, this is an exacting process which frequently punishes sloppiness, and there are various precautions one needs to take:

1 It is absolutely essential that you handle the paper as little as possible, if at all, as the natural oils on the surface of your hands can dramatically mark your final print. Wearing latex gloves is a must.

2 When developing your print the paper seems to need space, otherwise marks can appear on the edge of your print, so use a developing tray one size larger than the paper you intend using. For example, if you want to make a 12in x 16in print, use a 16in x 20in tray.

3 Equip yourself with a pair of print tongs; ideally those with rubber tips, as handling the paper is anathema to lith printing.

4 One of the characteristics of this process is the incredibly long exposure and development times, and so it is important to ensure that your safe light is sufficiently distant from your working surface, and that there are no leakages of light into the darkroom.

SUITABLE DEVELOPERS

Kodalith liquid

Kodalith Super RT, which is a powder form of the above

Champion lith

Fotospeed LD20

Speedibrews Lithoprint, which has been developed as a purpose designed developer.

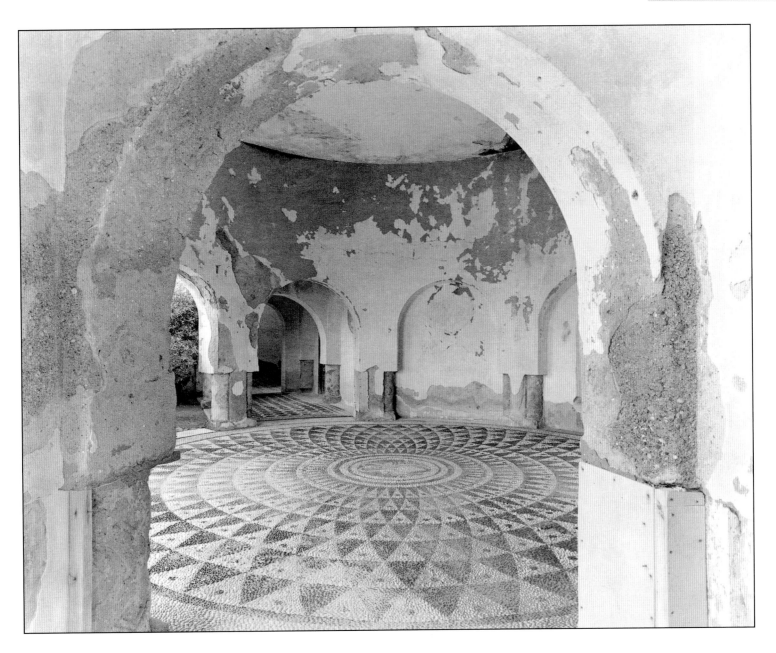

ABANDONED SPA, RHODES

Left: A detailed, but rather lacklustre monochrome print.

Above: This is a good example of what can be achieved when employing the lith printing technique, which can be characterised by delicate highlights, punchy shadow detail and dramatic colour shifts. In order to reduce contrast in the final print, I needed to expose the paper for up to 6 minutes.

BACKLIT INTERIOR
WITH RED CHAIR

Above: As a straight black-and-white print. This was a particularly thin neg, and it was difficult to get any life into the mid-tones.

Right: When first experimenting with the lith process, the colours achieved with certain papers can be a very pleasant surprise. This is the characteristic orangey/red of Kentona. The light filtering through the net curtains creates a sense of warmth which the natural tone of the paper reinforces. The lith process can prove very effective with thin negatives; as this process demands that you expose for the highlights controlling the shadows at development stage. The chair has been hand-tinted.

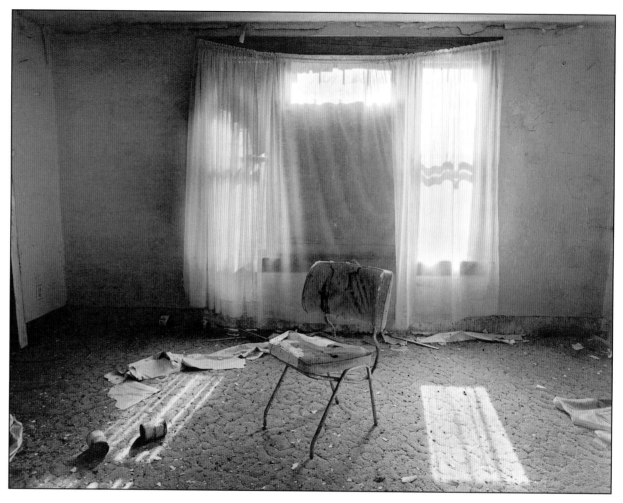

PREPARING THE DEVELOPER

Initially, it is wise to follow the manufacturer's instructions regarding the dilutions you require. However, you will discover that this is variable, and can dramatically affect the results you finally get. The developer comes in two solutions, A and B, and the required amount should be mixed with water. In common with most print developers, lith developers seem to improve as the printing session goes on; if it is too fresh its effectiveness appears to be reduced. In order to overcome this, it is recommended that you add 'Old Brown' to your developer; that is, that you save some of your previously used developer, and add this to the new. This is an imprecise science, but as a rule of thumb, add the same volume of 'Old Brown' as your undiluted developer. If you are mixing 100ml of A and 100ml of B to your water, add 200ml of Old Brown.

THE EXPOSURE

The rule when lith printing is; expose for your highlights, develop for your shadows.

As implied, the lith process works by grossly over-exposing your paper and then processing it in a weak solution of lith developer. The over-exposure can normally be two to three stops longer than a normal exposure, but you also need to understand that the longer the exposure, the greater the reduction of contrast. (This depends on the density of your negative, and your enlarger, but it is possible to expose for five minutes or more, even whilst your aperture is wide open.) This has an outcome not just on the final tonality of your print, but also on characteristics it will adopt when toned. Generally speaking, the longer the tonal range of the print (the less contrasty it is), the more likely it is to show dramatic colours at the toning stage.

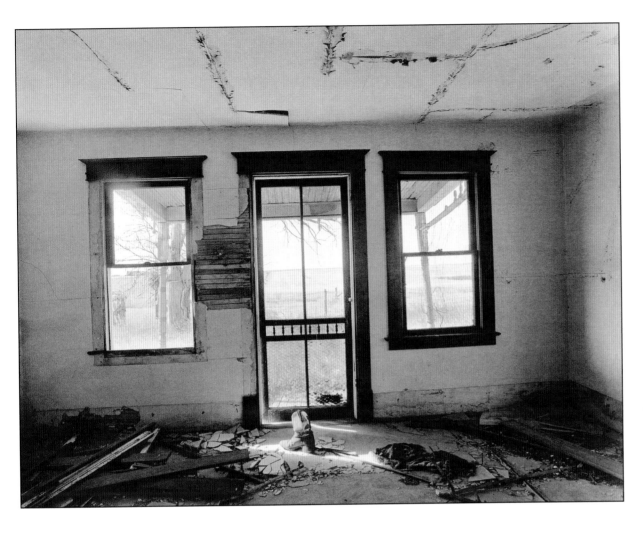

DISCARDED BOOT

It was important to establish an exposure which gave me detail both for the interior and the exterior. It is also important to appreciate that the longer the exposures the lesser the contrast, which was an important consideration in this instance. The boot has been hand-tinted.

THE TEST STRIP

This can be done in two ways:

1 Make a test-strip using the lith paper but develop it in a normal developer. This will require having another tray of solution available. Once you have established your time, increase your exposure by two further stops; the advantage of this method is that it is considerably quicker. It should be noted that the timing of your test-strips are not as critical as they are with normal printing methods, because you do have the choice of when to pull your print, and thus determine its darkness.

2 Make a test strip, but develop it in the lith developer. Whilst this method does take longer, it illustrates the control that you have. It must be appreciated that a test-strip not only determines the optimum time, but also the contrast you require. It is useful having these test-strips, especially if you want to experiment with toning later in the process.

THE DEVELOPMENT

This is the second part of a potentially very time-consuming process, as you must expect the development to take anything between 5 to 25 minutes. Initially nothing seems to be happening and doubts begin to occur. After several minutes, the faintest of images start to emerge, but it is still a long way before your print has fully developed; remember, you are developing for the shadows and need to keep a keen eye on these. Be warned, this process accelerates (this is the characteristic of 'infectious development') and towards the end, development occurs very quickly indeed. Some photographers choose to use a darkroom torch, to check on the shadows, whilst others prefer to judge by eye; either way, once you have decided that your print has reached its maximum development, you really have to react quickly and get it into the stop-bath.

**DIVING BOARD; SALTHILL,
GALWAY BAY**

*Above: Whilst this image is rich in detail,
it does appear to lack something when seen
in only tones of black and white.*

Right: A straight lith print on Kentona paper.

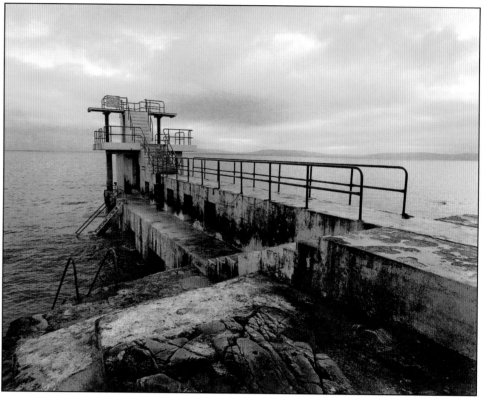

PEPPER FOGGING

Pepper fogging is a problem which can haunt all printers; it is the appearance of little black dots across your print, as if somebody has shaken black pepper over it. It is caused by the oxidation of the hydroquinone present in both the developers. The solution is to add sodium sulphite to your lith developer, either on its own, or in combination with potassium bromide. Most developers which are effected by pepper-fogging come with little sachets of sodium sulphite and potassium bromide, together with the required instructions. Tests show that approximately 20-25 g per litre of A+B concentrate is required to inhibit pepper fogging. Speedibrew has recently introduced a developer called Lithoprint, which is a purpose-made developer especially for lith printing; I am sure other manufacturers will follow.

STOP BATH AND FIXING

After development, stop and fix your print as normal. It is important to ensure that your stop bath is not too strong, otherwise you risk getting marks on your print. When you transfer your print to the fix, do not be surprised if the mid-tones dramatically lighten after several seconds; this is normal. When you finally put on the light, you will discover that all your tones are warm in colour, some dramatically so, depending on the paper you are using. It is also to be recommended that you use a two-bath fixing process to ensure that your print is adequately fixed. Similarly, it is essential that it is thoroughly washed, as any residue of fix will not only significantly reduce the archival permanence of your print, but will also mark any prints which are subsequently toned.

TONING

Lith prints are warm-toned by their very nature; Sterling is a warm biscuity colour, Kentmere's Kentona, Art Classic and Tapestry display a most attractive range of reds and pinks. In many instances these colours are sufficient, and there is no need to take it any further. However, should you wish to experiment, the possibilities seem endless and can lead to some spectacular results. It must be emphasised that this not only varies from paper to paper, but also from print to print, depending on its overall tonality, its tonal range and how long it has been developed for.

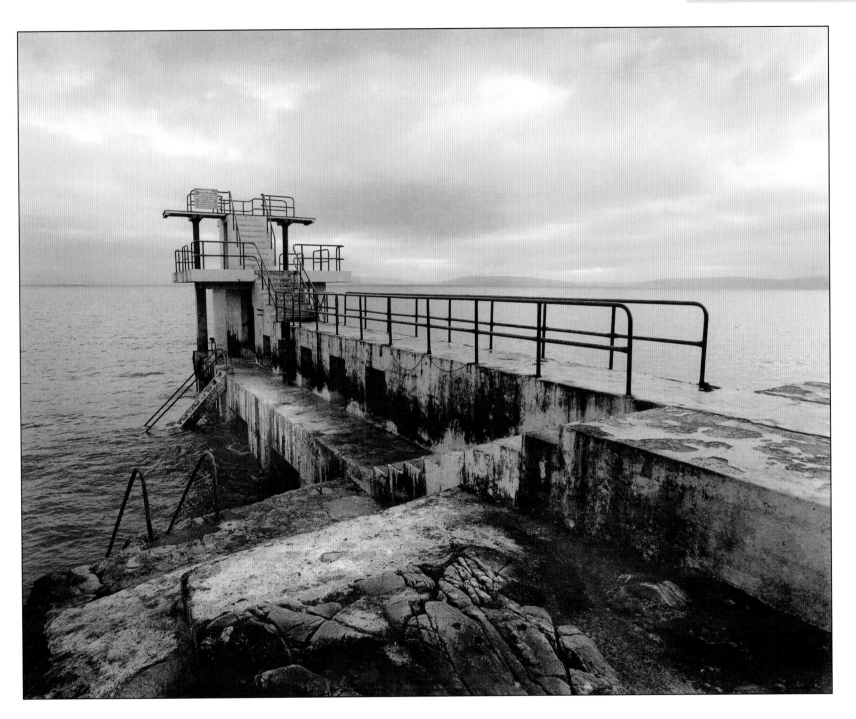

Wonderful things can happen when you tone your lithed print in a weak solution of selenium. This toner will always begin to show its effects in the darker areas of the print first, therefore if the print is snatched at the appropriate moment the darker areas will reveal grey/blue of the mid stage of this toning process, whilst the lighter areas will still retain the warmth of the original lith print.

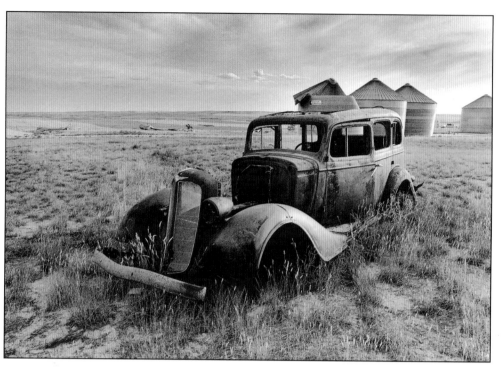

CAR AT ANGELA

Above: An interesting black-and-white print, but perhaps the car needs to be distinguished from the background.

Right: A straight lith print.

SELENIUM TONER

This can prove to be a particularly useful toner, especially with the very warm-toned prints one gets with Kentona and Art Classic. The natural tendency of this toner is towards a cool brown, however in order to get there, it needs to change from an orangey red, through to a rusty red, on to a grey/blue and eventually on to a brown. Because the tones in your print vary, the changes in these colours are not consistent, therefore whilst a darker area is changing to grey/blue, a much lighter area may still be in its orangey/red stage. This characteristic can be exploited by:

1 Using a very weak selenium solution (dilute it 20:1) so that the 'metamorphosis' occurs much more slowly, allowing you time to pull the print at precisely the right moment.

2 Pulling the print out of the selenium at an early stage and putting it on a clean flat surface (a sheet of thick glass or melamine will do), then trickling a small amount of water over the areas you wish to prevent changing grey/blue. The areas unaffected by the water will continue to be affected by the selenium and will continue to change colour.

With other papers such as Sterling, the results are not quite as dramatic. This paper initially changes to a subtle pink, before taking on the characteristic 'selenium ' brown.

GOLD TONER

This can prove to be a particularly beautiful toner. Most warm chlorobromide papers show a tendency to change to a cold blue colour when toned in gold, however the results are even more dramatic when the print has been lithed. The blue becomes far more lively, rivalling the intensity of a blue toner; but when you consider that gold toning greatly increases the archival permanence of your print (which contrasts with the instability of blue toners), lith printing, in order to establish a blue, is to be strongly recommended.

SPLIT-TONING WITH GOLD AND SELENIUM

This can prove to be a particularly attractive process giving you delicate blues in the highlights and deep rich browns in the shadows. As with any split-toning technique, it is all about getting the balance right. As the selenium appears to tone the darker areas of the print first, it is useful to initially selenium tone your print, and then gold tone it afterwards. Once again, try using a weak solution of selenium, as this gives you the control you require. It allows you to see the changes occurring in the darker areas of the print, so that you can decide at which stage to put the print into the gold toner. It is essential that you give your print a good wash between toners, otherwise the selenium will contaminate your expensive gold toner. Wash for at least 30 minutes between toners.

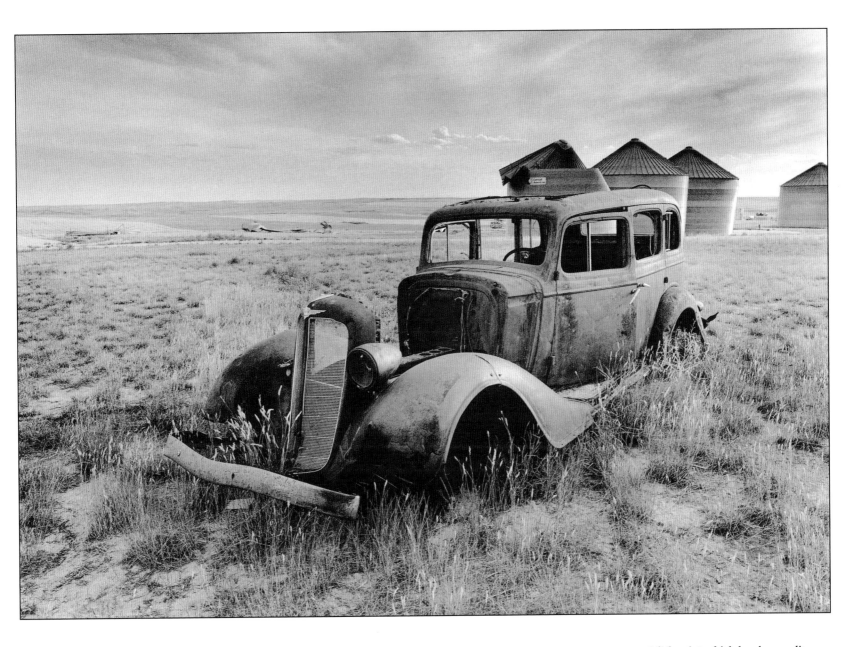

A lith print which has been split-toned between selenium and gold. Small parts of the car remained blue in the toning process, so these stubborn lighter areas were hand-tinted using an airbrush.

PORTFOLIO

Ray Spence

Folklore, myth and legend abound with the tales of mystical creatures. The siren or mermaid has had a particularly fascinating place in the imagination and storytelling of writers and artists for many centuries. The beauty and fatal attraction of the sirens and their song has been said to have led many a foolhardy man to his watery end. With a love of both the sea and beautiful women, it was probably fated that I should eventually return to the recurring theme of mermaids. It was not a totally conscious decision – it was a developmental process which finally led to my siren series.

These are four images that I managed to produce over a two year period. I hasten to add that I was also involved in other projects. In fact if I hadn't have been I may have gone completely mad – or at least have given up photography. This was a real test of putting a vague idea or vision into reality. I knew that I was trying to achieve something different from my previous work but the final form was not evident at the beginning. From preliminary ideas followed by many failures in translation, I eventually developed a working practice which I was satisfied with. Living in the Midlands it seems ludicrous that I have so often returned to images of the sea, coastal rock and algal forms and now mythical marine figures. Finding mermaids in Birmingham sounds doubtful, but I have proved it can be done. As far as possible I have always tried to use the camera to solve my problems rather than relying upon complicated printing techniques. Though I admire the work of Jerry Uelsman and others of the same vein, I have as yet not been tempted to make much use of multiple printing techniques. Instead I would rather produce a single negative to print from. So with this project I attempted to combine several exposures on the same sheet of film. The result – disaster. I had to register three or four different exposures at varying scales and f stops and any slight error was only too visible. Eventually I decided to photograph each element separately and combine the negatives to produce a single printable negative. Easier in theory though still difficult in practice. Each element had to be positioned within the frame carefully and photographed against a black background. The edges which would merge together e.g. the mermaid's body and the fish tail were soft edged by placing a piece of card close to the lens to mask the area to be hidden. It was important to keep the direction of lighting in mind, considering that when negatives were combined, they would be placed emulsion to emulsion. It was also important to realise that the aperture of the lens e.g. f8 would produce a markedly different depth of field when photographing a full female figure than it would on the close up of a gurnard's tail. Therefore the aperture would have to be considerably smaller on the close up details to give an accurate representation.

When the final negative was produced, I printed it on normal FB paper. It was fine, but lacked that feeling of antiquity and surface structure that I really wanted. I had two weeks to go before the work was due to be exhibited at a gallery in Birmingham, and as usual the pressure of a deadline led to some concentrated thinking. Liquid photographic emulsion came to my rescue and turned out to be the ideal medium and barely dry they were successfully exhibited. I find that the use of the liquid emulsion on Fabriano paper has allowed me to create a hand crafted feel. The larger the image is produced the better as the texture of brush strokes, air bubbles and slight inconsistencies in coating become more evident. The final images were slightly bleached and toned in thiourea toner.

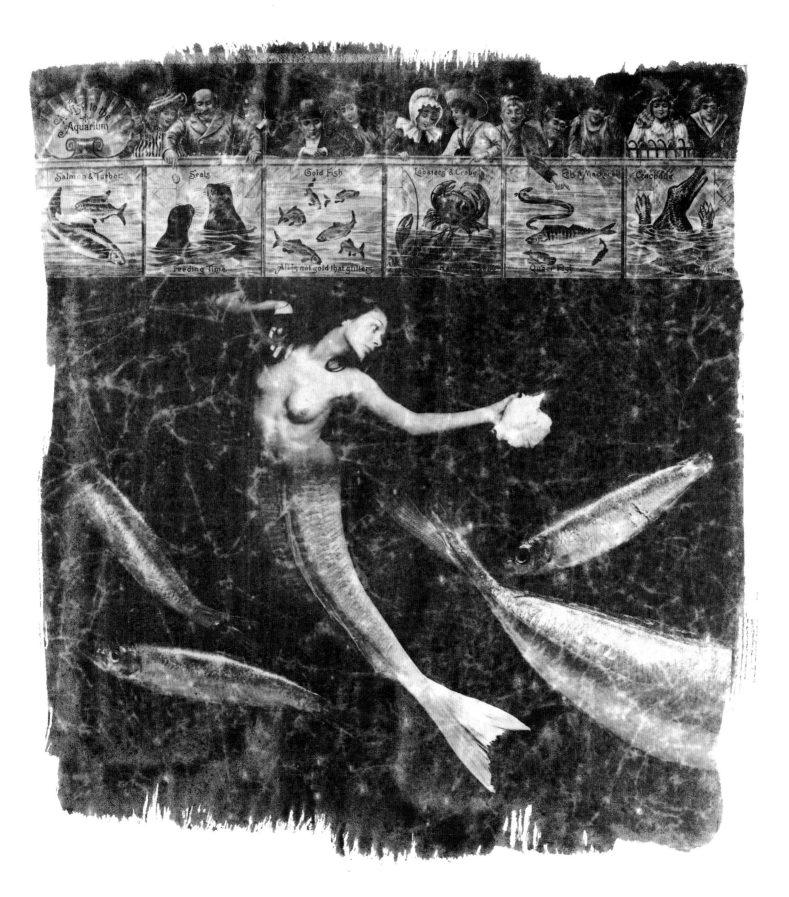

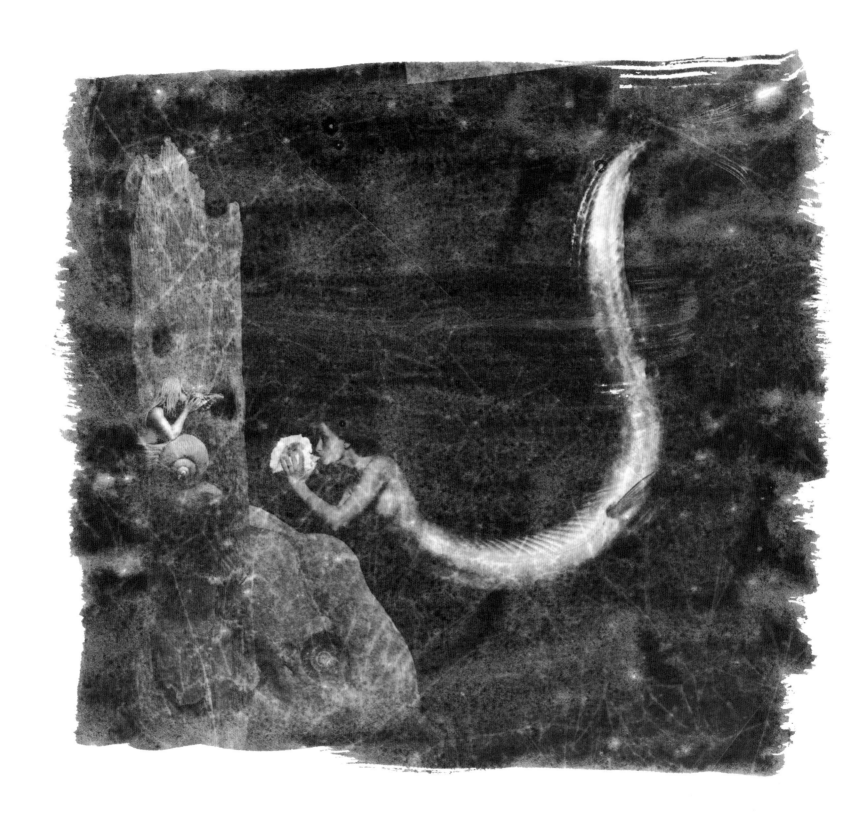

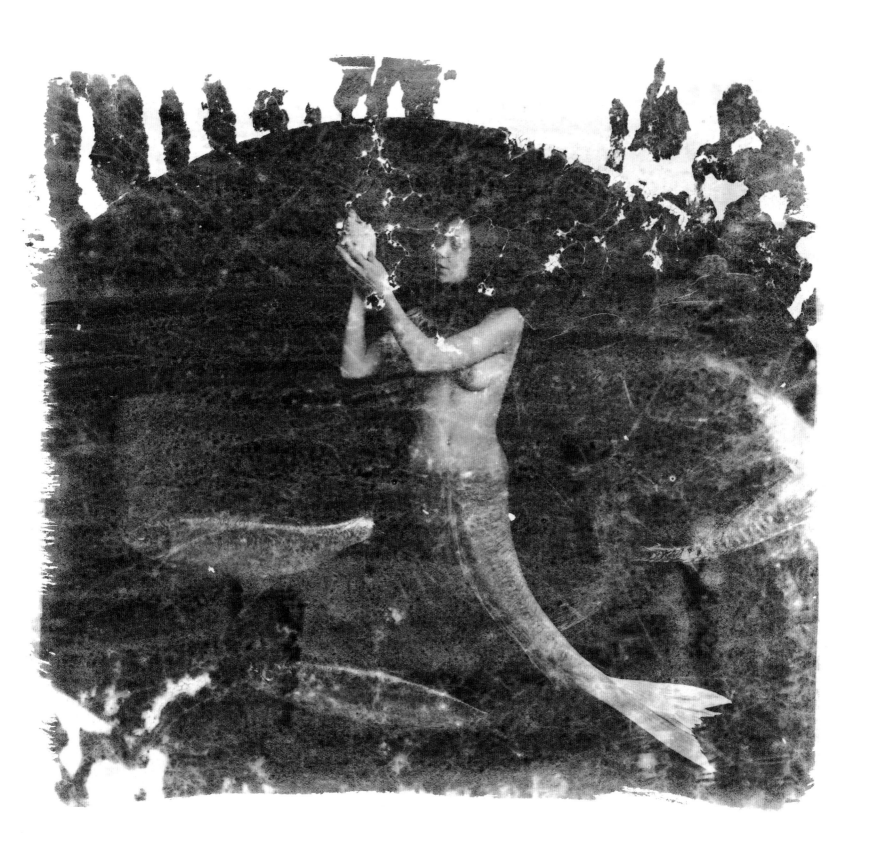

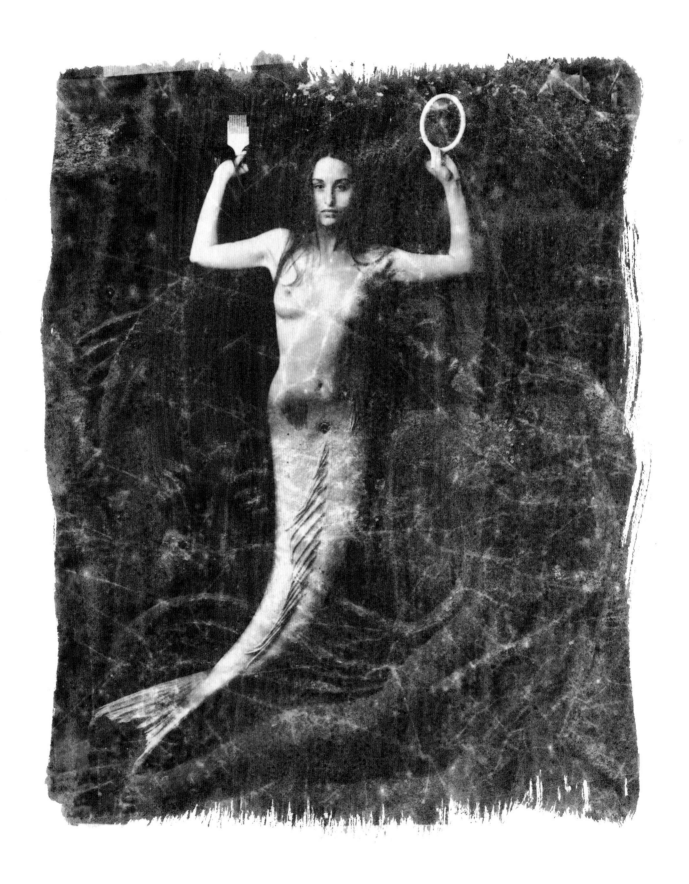

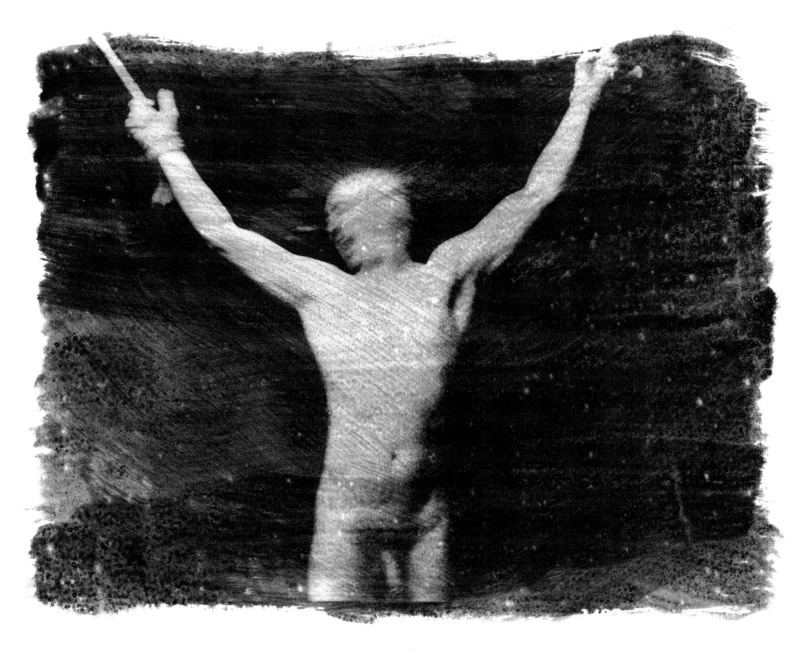

SELF PORTRAIT

I have only ever produced two serious self portraits but on both occasions have found it a cathartic experience. I very much admired the photo-therapy work of Jo Spence and though I have not used my image-making in the same way it made me realise that there are many reasons for taking photographs and some can be quite personal and self indulgent. The first self portrait I produced was at a crossroads in my life – a career change and separation from my first wife. The image reflected my deep sense of loss of a secure and comforting lifestyle and a fear of what my future direction would be. Some twelve years later pressures from a variety of external influences have resulted in this image of middle-aged stress and turmoil. It hasn't removed any of the stresses of everyday living, but it has allowed me to articulate in an image what I would have difficulty in expressing in words.

On a technical note, the image was taken on a Mamiya RB67 and printed using liquid gelatin silver emulsion on Fabriano paper. Two coats of emulsion were used to provide sufficient density and to allow brush marks to be produced in different directions. The resulting image was then toned for a brief period in Kodak rapid selenium toner before being bleached and toned in thiourea.

LUCINDA AND SUNFLOWER

This photograph has a special meaning to me. It is my wife Lucinda, eight-and-a-half months pregnant with our first son Josef. Unlike some people I find the human body interesting and beautiful in its many different ages and forms, and pregnancy is certainly a special state which I feel is worth recording. The sunflower is an obvious symbol of fruitfulness and the actinomorphic form provides a way of concealing identity yet is a representation of the face. Therefore, though it is a very personal image, it also serves to represent a universal state.

It was taken using daylight from a single window to the side and a white reflector to fill in the shadows. The wall behind was roughly plastered to form a textural background. The sunflower absorbed a surprising amount of light and my first attempt at this image was lacking in detail. I therefore repeated the session, adding extra light to the sunflower using a honeycombed light to add detail to the seeds in the sunflower.

Some time after producing this image I was looking at the work of Japanese photographer Eikoh Hosoe and was amazed to see an image of an avenue in the palace of Versailles with a row of women all holding a sunflower in front of their faces. I'm sure that I had never seen this image before, but the coincidence is amazing. There must either be some 'photographic ether' that people tap into when they are in the right mood or you just have to accept that very little is original. Myself, I don't think originality is that important. It is the integrity of the original intention and the personal interpretation that counts.

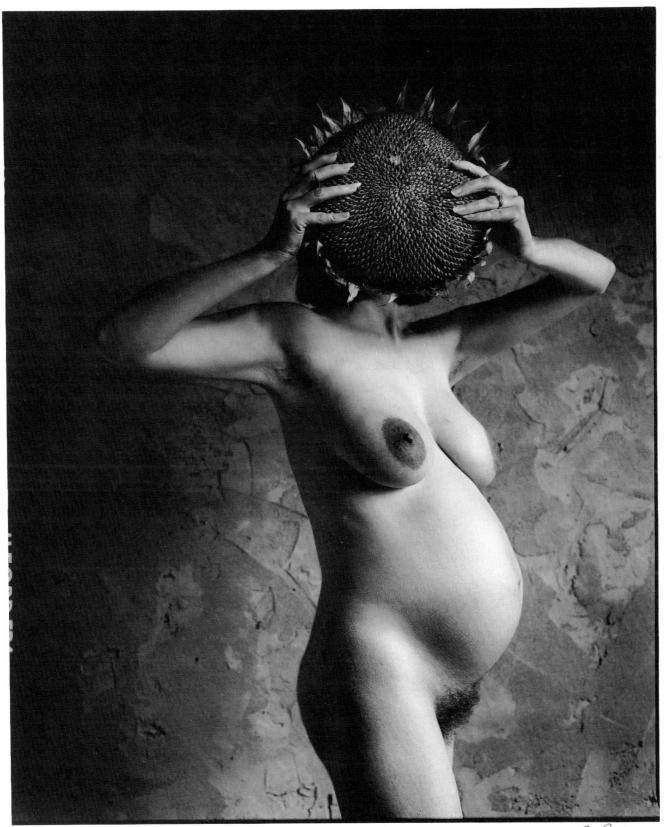

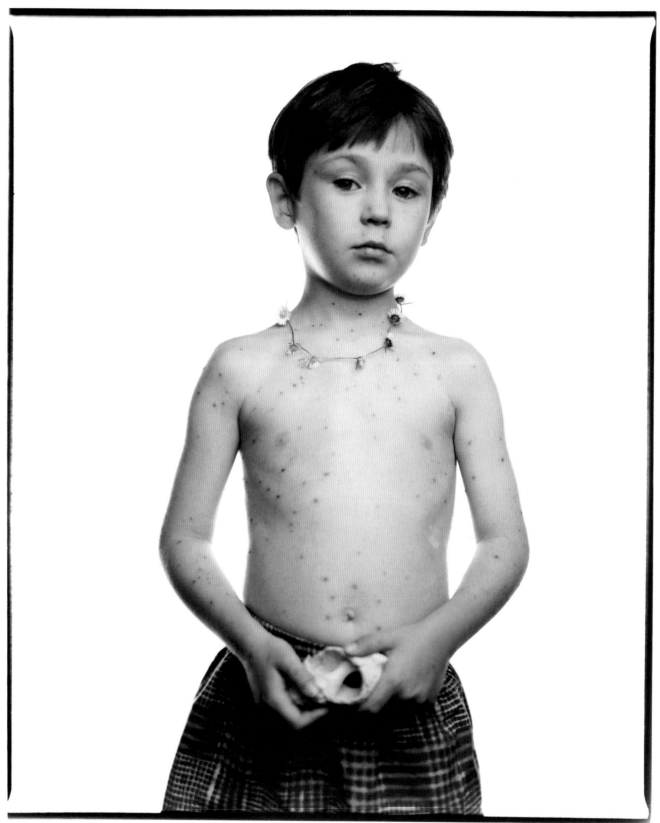

Josef with chickenpox 1.6.98

JOSEF WITH CHICKENPOX

Unless you are like photographer Sally Mann you are probably like me in that photographs of the family usually fall very much into the snapshot genre. However, there are usually times or events that require a more considered approach to producing an image or portrait. This would usually be a significant occasion such as a birthday, first day of school, engagement or marriage. In most cases family photographs reflect happy times which probably give a rather false view of our lives in general. On this occasion both of my young sons had been suffering from chickenpox and we had decided to spend a couple of days away in a caravan. On such occasions I usually do not take a camera, otherwise the temptation to take photographs to the detriment of quality family time is too great. My son Josef had been playing with my wife and came into the caravan with a daisy chain around his neck. He laid down by the window and the soft light on his white skin emphasised the chickenpox marks. The effect was surprising. It made his body seem both beautiful and vulnerable. On our return home I tried to capture this feeling by photographing Josef as I had seen him using very simple lighting and background. A white screen lit by two tungsten lights was used as the background and the main light was a single soft box on an Elinchrom head, using the modelling light to make the exposure. I usually work on a Mamiya RB67 and keep things simple. This was no exception and produced the effect I was after – very much in the Avedon vein.

The print was made using split grade 0 and 5 on Kodak Polymax FB paper. This enabled me to produce the required amount of contrast whilst still retaining detail in the skin tones. The image was finally toned in Kodak rapid selenium toner 1:9 for one minute. The edge of the negative was included to contain the image with the black line.

TORSO SERIES

This started out as an exercise in classical figure study. Having visited Greece and seen the wonderful statues that had been ravaged by the elements and the hand of man, I tried to recreate some of these in the studio using live models. The principle was quite simple. By wrapping parts of the anatomy in black hoods, stockings and various other pieces of material and photographing against a black background, I could isolate and concentrate on the torso. After reasonable success I developed the idea further by using the torsos to say something about relationships between individuals. The ideas came both from classical art and my imagination. The prints were produced by combining the resulting negatives with a crumpled negative sleeve to add texture in the shadows. They were printed on Kentmere art classic paper at about one stop overexposure. This obviously produced very dark prints. A ferricyanide bleach was then used to reveal background detail and also to change the colour. The figures needed separate fairly light bleaching. The prints were finally selenium toned. As is often the case with my work it didn't stop there though. I was involved in an exhibition at a large municipal gallery and it was the ideal opportunity to work on a large scale which I felt the these images really needed. Discussions with my local processing laboratory, Stoneleigh, led to them allowing me to use a horizontal enlarger and providing me with enough large rolls of Kentmere art classic to complete the project. Using these facilities the prints were printed as 3 x 2 metre images. I then hand bleached and selenium toned them. This was probably the most frightening part as a mistake at this stage would cost a great deal in both time and money. Fortunately only one of the eventual five prints had to be reprinted. They were then mounted on board and cut into 1 metre square sections and assembled in the gallery. Even though I had been working on the printing for several weeks the impact of the scale was still overwhelming.

CREATION OF WOMAN

As a lecturer, I find that their is a symbiotic relationship between lecturer and student. Ideas and information flow both ways and I am often inspired by student work. On one occasion an ex-student of mine had returned to show his work to current students. During his presentation he showed photographs of the Sistine Chapel ceiling painted by Michelangelo. I was interested to see a small figure of a woman pleading for life from the Creator. Man of course had taken a central role in the Great Design. Being perverse I therefore decide some role reversal was in order.

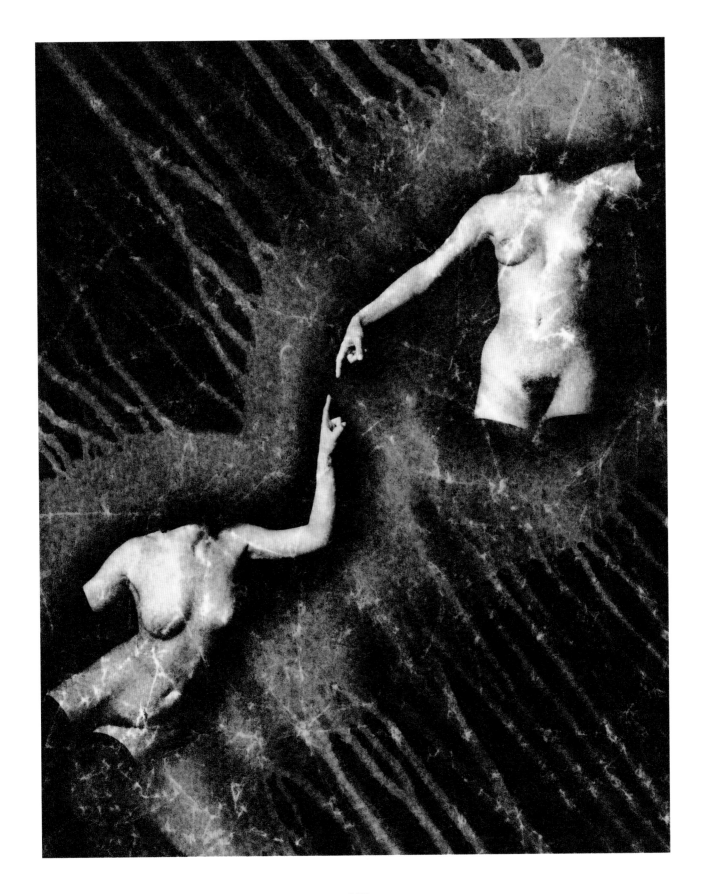

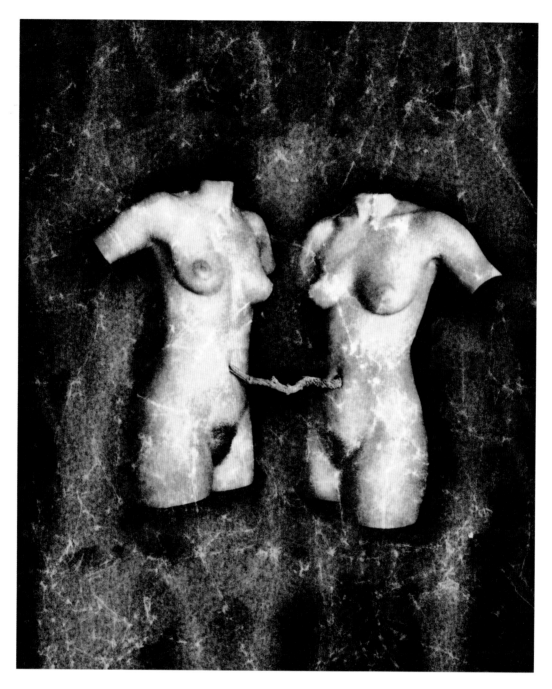

TWINS

Most of us understand familial relationships – children, parents, brothers and sisters. Identical twins, seem to have a special relationship however. Originating from the same fertilised egg, having identical genetic information and sharing the same embryonic sac for nine months, the bond is inevitably something very special. I have used the umbilical cord to represent such a close physical and spiritual relationship.

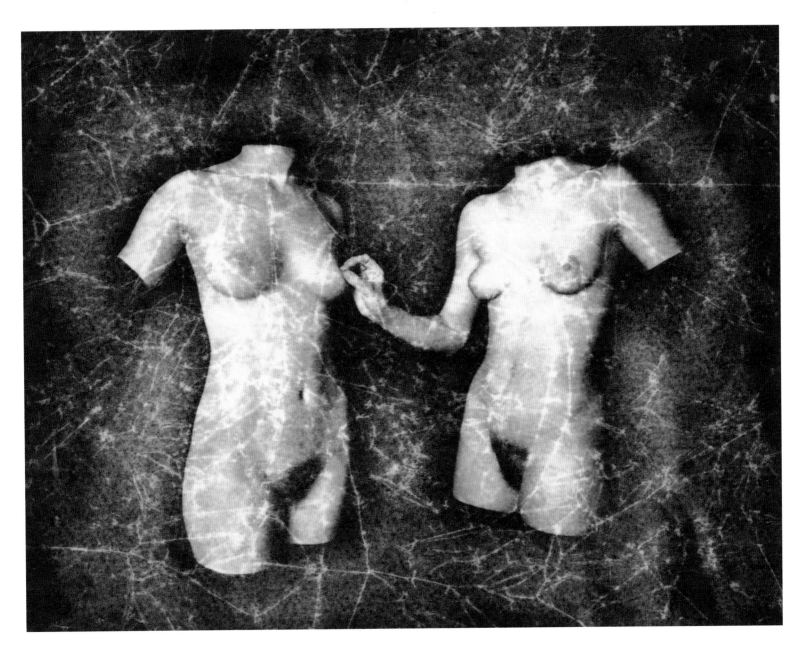

SISTERS

This is inspired by the rather unusual painting of the Sisters of Fontainbleu. The painting has always puzzled me. The idea of one woman nonchalantly holding another one's nipple as though it was the most ordinary thing to do I find very strange. The relationship is familiar but totally sexless. There is no eroticism. It is a puzzle.

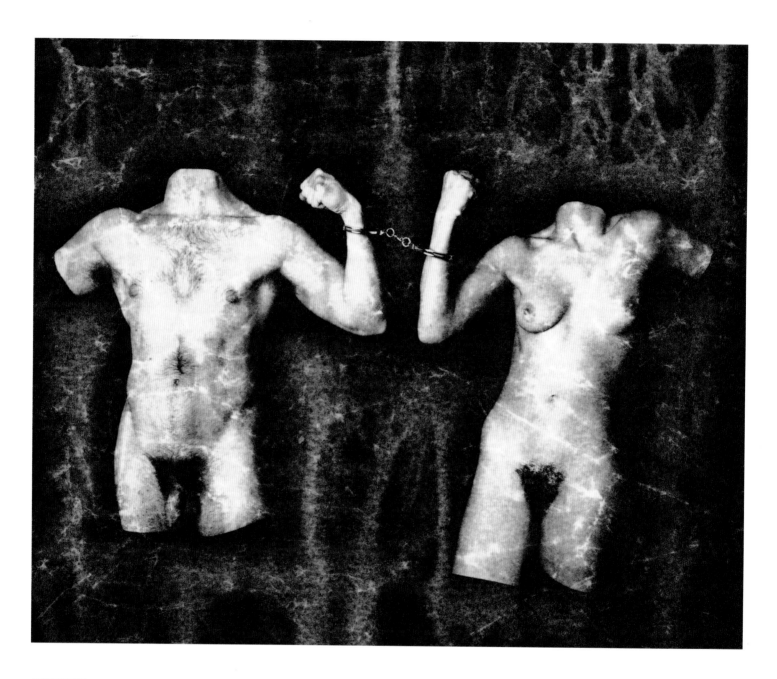

DIVORCE

It is always painful when a close relationship ends, especially marriage. However the divorce rates show that this is familiar territory to many. Here I have used the hand cuffs to symbolise the way that marriage has turned into an unwelcome trap from which the partners are trying to escape.

RAPE OF THE SABINE

One of my major influences for this series of work was the artist Rodin. The Rape of the Sabine has been a familiar and reoccurring theme in classical art. This image uses Rodin's famous sculpture as its model.

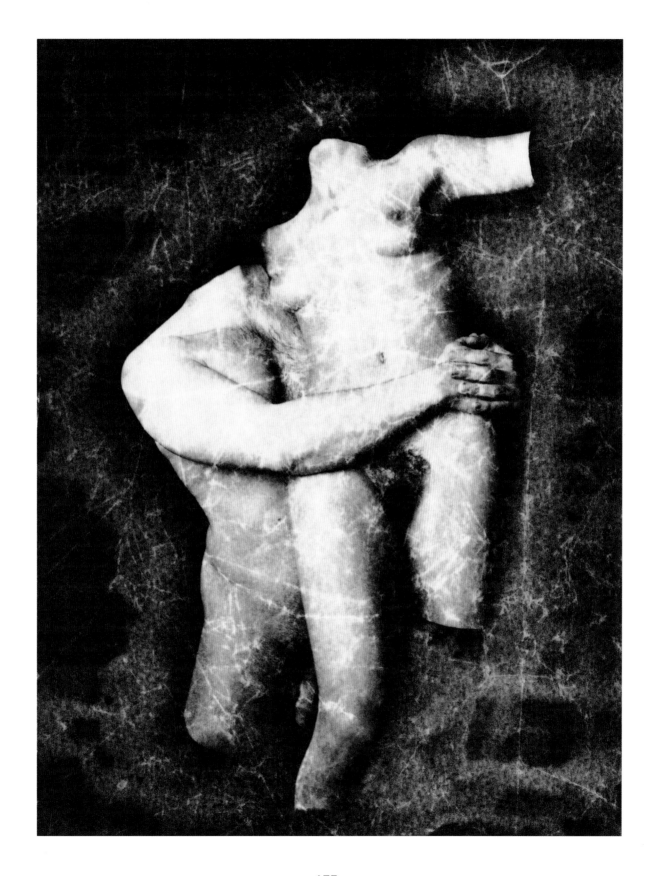

GHOSTS IN THE WILDERNESS

Tony Worobiec

I first travelled to an area of America between eastern Montana and western Nebraska in the summer of 1996. Whilst this area had previously been called the North Western Desert, because of its unpredictable rainfall, I was nevertheless surprised to see just how neglected farms, homesteads and some communities had become. I frequently came upon buildings which had been bowed under the tonnage of the winter snows, but as a photographer, I was initially drawn to the old abandoned cars, preserved by the arid climate, which seemed to litter the fields. Once I appreciated that the buildings were completely abandoned, I began to investigate those as well, it was a sobering experience; the fact that these homes were still filled with furniture, books, clothing and toys prompted me to question why anybody should wish to desert their home and leave so much behind.

After talking to various farmers, I began to understand why abandoned cars were littering the fields; it was a form of self-sufficiency. If a vehicle broke down, these farmers lived too far from town to call for assistance, and would remove workable parts from discarded vehicles in order to keep others on the road. But why were the farms abandoned? Shortly after my return to England, I stumbled upon a publication by the travel writer Jonathan Raban called Bad Land. In it, he graphically describes the plight of many of these homesteaders, especially those from south-east Montana. Prior to homesteading, the land had been used for ranching; however, throughout the early 1900s, various railroad companies decided that they wanted to extend lines through the area, and therefore made the decision to establish communities along the railroad. As land was being offered at minimal cost, they had no difficulties in attracting potential homesteaders, especially from the large cities in the east, and from Europe, whose farmers were experiencing fierce competition from mid-west America.

Whilst the summers are very hot, and the winters are breathtakingly cold, most of the newcomers set about establishing their farms with admirable zeal, and in the main they deserved to succeed. Initially many enjoyed successful harvests and were encouraged to borrow money in order to mechanise. What they had not bargained on was the unpredictability of the rainfall which can be as little as 15 inches a year. After a succession of poor harvests and mortgaged beyond their limit, many were declared bankrupt, and so they abandoned their homes and moved west. As this cycle of good years and bad seems to go decade by decade, the farming population gradually thinned out as the century progressed.

When I enter the wreck that was once someone's home, to peruse books which had formed the bedrock of their culture, examine farming financial sheets, read discarded essays on English literature and touch aged garments as delicate as a spider's web, I still have a passion to travel to and photograph this harsh, yet beautiful, forgotten pocket of America, in order to record as much as I can before the evidence disappears forever.

SHOVEL

I saw this shovel in an abandoned interior and viewed it as a final gesture of defeat. It is easy to imagine the previous occupants tidying up after removing what furniture and goods they were able to take with them, and then carefully placing the shovel up against this wall should it be required by others in the future. In no way had this property been vandalised; however as a result of a sequence of hot summers and cold winters, the processes of nature have accelerated the structural deterioration of the place.

This print has been lithed and I chose to use a relatively short exposure in order to increase contrast. It has then been slightly toned in selenium.

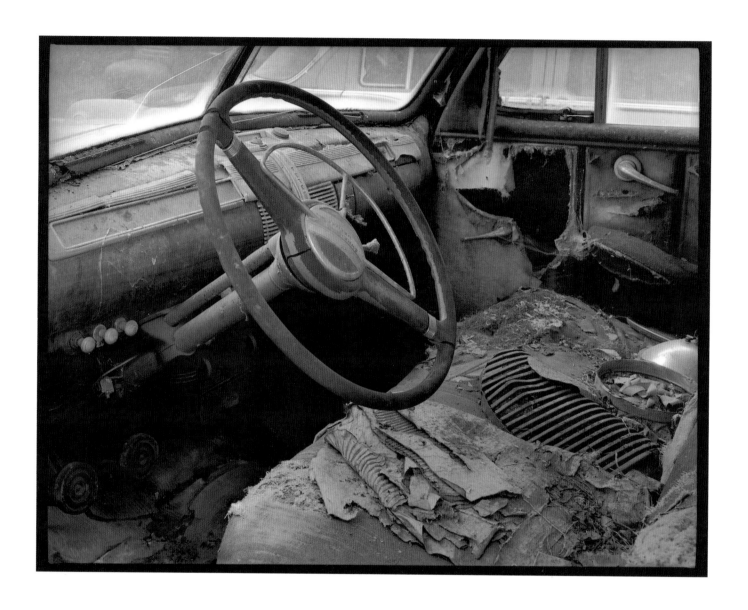

STEERING WHEEL

There are many occasions when our light meter tells us that
a particular viewpoint is likely to exceed the latitude of our film,
as was the case with this shot. But by using a two bath
developing technique, I was able to take a light reading from
the car interior, and then cut back on the highlights at the film
development stage. This is, unquestionably a rather nostalgic
shot, recalling an earlier era. By split-toning this print, firstly
in sepia and then in selenium, not only does it serve to widen
the mid-tones, but gives the print a rather dated feel.

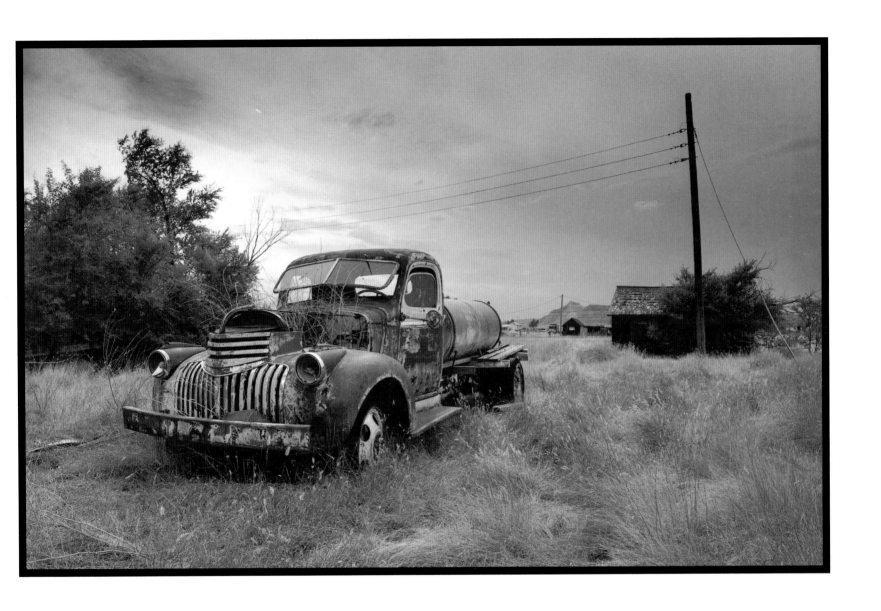

DISCARDED TRUCK; THE BADLANDS

I had previously photographed this vehicle two years earlier, and was amazed to see that in that period of time, nothing had changed. Whilst I was satisfied with my earlier attempt, this negative offered a far more interesting sky as it was more sympathetic to the subject matter. The print was sepia toned and hand-tinted. I used an airbrush for the larger areas, whilst the finer detail was added using marshall oil pencils.

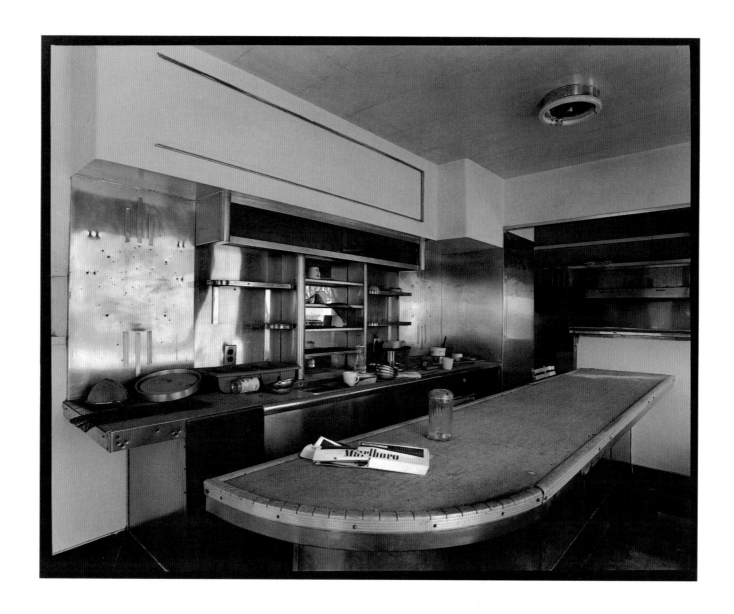

MARLBORO

It is very easy to imagine that this shot has been 'set up', but this is exactly how I found this abandoned diner. Mindful of my accompanying 'Marlboro Country' image, I decided to treat it in a similar way; my major concern was to draw the eye to the empty packet. The print was strongly sepia-toned, although a limited amount of localised bleaching was applied. The red in the Marlboro packet was applied by hand.

MARLBORO COUNTRY

We are all, no doubt, aware of a much extended advertising campaign on behalf of Marlboro cigarettes, which aims to celebrate the American good life. This image serves as a stark reminder that not all areas of America are successful; it can also be seen as a parody where the Marlboro logo is linked with failure. Whilst the original monochrome image uses tone to draw the eye, the added colour serves to attract it even more.

THE SINK

*This abandoned interior has a cold utilitarian look about it.
Even when it was inhabited, I sense that it lacked frivolous creature
comforts. Whilst the property had been boarded up, there was
sufficient light coming in from various cracks and open doors so
as not to make exposure a particular problem. I have chosen to lith
this in order to exaggerate the textural decay in the walls and on
the floor. I deliberated printed this a little darker than normal in
order to promote a sense of dour neglect, a mood which is
reinforced by the cold blues and browns, the hallmark of prints
split toned in selenium then gold.*

SEWING TREADLE

This property had been boarded up with the exception of this one window. My attention was initially drawn to the net curtain, and then towards the treadle. The contrast was excessive, so once again I decided to use a two bath film processing technique in order to redeem the situation. The contrasting textural qualities between the cobweb-like delicacy of the curtains and the brittleness of the deteriorating walls was a feature I was anxious to retain, therefore I have decided to lith print this image as it exaggerates the difference between the gentle highlights and gritty shadow detail. The print was then toned in a weak solution of selenium, but removed before the toner could affect the mid tones and highlights.

SOFT WHISKEY

When entering an abandoned home what you are able to photograph depends on what the last occupants choose to leave behind. I felt especially fortunate when investigating this property as the discarded radiogram so eloquently draws to mind an earlier decade whose culture and values are so very different from now. Searching for a visual foil, my eye was immediately drawn to the words 'Soft Whiskey', which only serves to reinforce that inescapable sense of nostalgia. It was tempting to rearrange certain elements, but to have done so would have disturbed the chaotic order which is such an important facet of this picture.

This print has been sepia-toned; the wall has been lightly air-brushed, whilst the radio and skirting-board have been tinted using Marshall oils. The area around the 'soft whiskey' text has been coloured using oil pencils.

LES KROLL'S CHAIR

A feature of many of the farms that I visited was that whilst many had been stripped bare of all goods and furnishings (although it was surprising to discover how many had not), there seemed always to be a single chair abandoned in the corner of a room. The relationship between this chair, and the tree outside is important, as it graphically illustrates what a lonely existence some of these homesteaders lived. I was able to establish the name of the previous occupant from papers which were strewn across the floor.

The colours have been applied in a variety of ways; the window frame and skirting board were airbrushed using acrylic inks, whilst the remains of the blind, the chair and the blue patches on the walls were applied using photo-dyes. The subtle areas of orange in the walls were applied with cotton wool using photo dyes.

HOTEL ROOM

It was impossible to gain entry into this abandoned hotel, as all the doors had been boarded up; fortunately one of the ground floor windows was still open. Using a table-top tripod, it was possible to balance the camera on the window ledge. Despite the veil of debris littering the room, some of its former glory was still clearly evident.

This print has been lithed, and later split-toned, firstly in selenium and then in a gold toner.

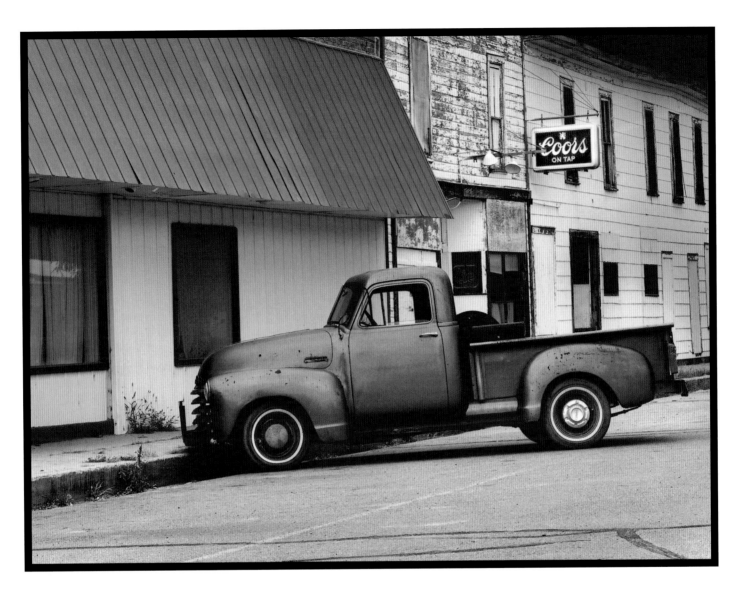

COORS

What initially caught my eye was the relationship between the 'Coors' sign and this interesting old pickup parked in main street. It was tempting to use colour film, except that there were other strong and conflicting colours which would have proven to have been a distraction. Without question the trickiest part was going to be the red sign, so I decided to use photo oil-pencils; this required using a matt photographic paper. Whilst the pickup has been air-brushed, the areas of 'rust' and the 'Coors' sign have all been applied using the pencils.

POLLING STATION

When I entered this polling station, which had previously served as a school, all the windows had been boarded up and it was virtually impossible to see anything. As my eyes slowly adjusted to the darkness it became evident that this interior had genuine photographic potential, revealing this wonderful old sofa covered in dust and cob-webs. The only source of light was from an open door to my right; after making various light readings, and taking reciprocity failure into account, I calculated that I would

need an exposure of 3 minutes. I was very conscious of the darker areas to the left of the sofa and decided that a twin bath development would be required to balance out the lighter and darker areas.

After printing normally on grade 2 paper, this print has been toned briefly in sepia and then in a copper toner.

ABANDONED FARM WITH HOLE IN FLOOR

It was quite a sobering experience entering some of these abandoned farms, as evidence of the past was often strewn across the floor. It was not too difficult to imagine the kind of lives the recent inhabitants led. The featureless landscape outside was particularly eerie; in order to reinforce this impression, I decided to dramatise the sky by airbrushing colour into the horizon.

CARHENGE

*This is a rather humourous spot in eastern Nebraska which
serves to draw a parallel between this contrived heap of cars
and a famous English monument. In common with Stonehenge,
it needed to be viewed either early in the morning, or late in the
afternoon. In order to give this photo a sense of dawn, I gold
toned the print, giving it an overall grey/blue, and then
airbrushed in the emerging 'sun'.*

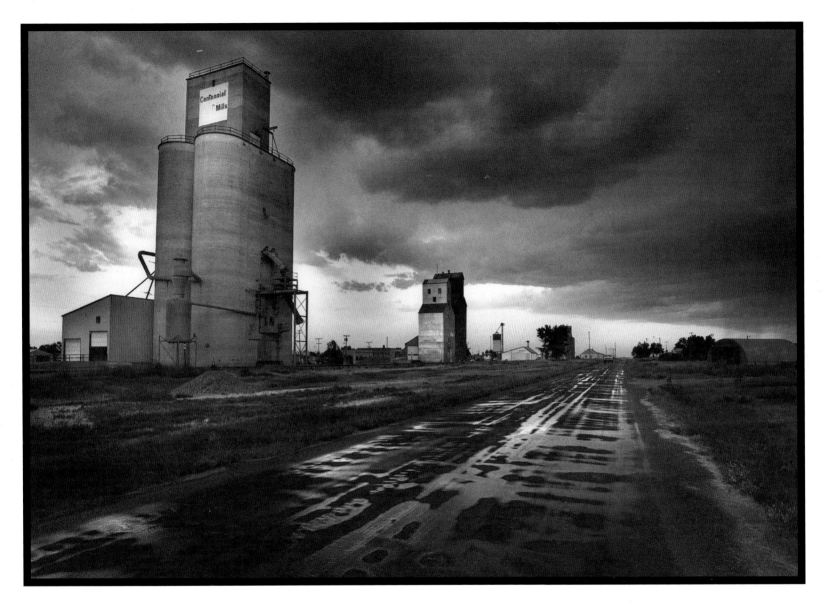

CENTENNIAL MILLS

A strong feature which afflicts this part of America are the dramatic, hurricane-type storms, particularly throughout late summer. I have chosen to blue-tone the print which has served to increase the tonal range of the print and has also added a sense of menace. This has been heightened by the fiery horizon which has been airbrushed; the subtle pinks in the sky has been applied using Marshall oils.

We would like to acknowledge the following suppliers.

CM Direct, Creative Monochrome Ltd,
Courtney House, 62 Jarvis Road,
South Croydon, Surrey CR2 6HU
Mail order suppliers of most photographic papers, toners and raw chemicals.

Daler Rowney Ltd, PO Box 10,
Bracknell, RG12 8ST
Suppliers of artist materials and airbrushes.

Epitome Photo Services,
17 Chaucer Avenue, Weybridge,
Surrey, KT13 0SS.
Mail order agents for Speedibrew

Fotospeed, Fiveways House,
Westwells Road, Rudloe, Corsham,
Wiltshire SN13 9RG
Makers of Fotospeed toners and lith papers, Cyanotype and Argyrotype kits.

Ilford UK, 14-22 Tottenham Street,
London W1P 0AH
Manufacturers of an extensive range of black and white materials, especially films and printing paper.

Kentmere Ltd, Staveley,
Kendal, Cumbria LA8 9PB
Producers of specialist black and white printing papers including Kentona, Document Art, Art Classic.

KJP, Promandis House,
Bradbourne Drive, Tilbrook,
Milton Keynes MK7 8AJ
Importers of Marshall Oils and oil pencils.

Kodak Ltd, Kodak House,
Station Road, Hemel Hempstead,
Hertfordshire HP1 1JU
Makers of film, papers and chemicals.

Luminos Photo Corporation,
5 Wolffe Street, PO Box 158, Yonkers,
NY 10705, USA
Suppliers of Fotospeed toners, developers and photographic papers, especially for hand-colouring.

Marshall Manufacturing Co,
701 Corporate Woods Parkway,
Vernon Hill, IL 60061, USA
Manufacturers of Marshall Oils and pencils.

Rayco Chemical Co,
199 King Street, Hoyland, Barnsley,
South Yorkshire S74 9LJ
Supplier of ready made and raw photographic materials.

Silverprint, 12 Valentine Place,
London SE1 8QH
Chemicals, paper and specialist materials for alternative processes.

Speedibrews, 10 The triangle,
Triggs Lane, Woking, Surrey GU21 1PP
Suppliers of Speedibrew Chemistry, including Resofine.

Tetenal Ltd, 9 Meridian Village,
Meridian Business Park,
Leicester LE3 2WY
Manufacturers of a wide range of toners.